ENGRAVING
ON
PRECIOUS
METALS

ENGRAVING ON PRECIOUS METALS

by

A. BRITTAIN

and P. MORTON

Illustrations by E. A. AYRES

With additional illustrations by
P. MORTON, S. WOLPERT and L. M. LANGFORD

N.A.G. PRESS LTD., LONDON, ENGLAND

First published serially in
GOLDSMITHS JOURNAL

First Edition	.	.	. 1958
Reprinted	.	.	. 1964
Reprinted	.	.	. 1971
Reprinted	.	.	. 1973
Reprinted	.	.	. 1975
Reprinted	.	.	. 1980

I.S.B.N. 0 7198 0022 6

Printed and bound in Great Britain by
Fakenham Press Limited, Fakenham, Norfolk

FOREWORD

ENGRAVING is one of the few arts at which the English have really excelled. It is also one in which the best modern work can bear comparison with the best of any age. But all skilled engraving is not, alas, beautiful. If engravers want to earn the name artist as well as craftsman, technical efficiency alone is not enough. Craftsmen must continuously experiment with new ideas, enterprising, vigorous and unashamed : and they must have a sense of artistic good manners. Very few people have genuine creative ability ; but most people, certainly those who learn to practise skilled crafts, can and should develop an instinct for style and proportion and scale. Without this artistic discernment, good works of craft become bad works of art. To create is noble, to imitate is dull ; a bold experiment which is criticised is better than a timid copy which goes unnoticed. So, in reading this useful and instructive book, it must be remembered that technique is hideous without art.

Many ancient crafts are in danger of dying, but engraving is so decorative and useful in so many fields of production that its future seems secure. The machine is, indeed, used with good results for some types of work, but the hand-made letter remains supreme in its own field. The demand for high quality hand engraving is encouragingly big because no machine-made substitute has yet been evolved to replace it. This craft has a good future ; nobody who shows the right talent for drawing and for meticulous workmanship need be afraid of becoming an engraver. To do fine work is always rewarding in a broad sense, and one can predict with some confidence that skilled engraving will continue to offer adequate rewards financially as well, even in the present highly mechanised times.

The authors are representatives of two well-known metal engraving workshops, one in England, one in America ; and an English specialist in lettering cut in other materials. Among them their knowledge covers a very wide field, some of which has never before been dealt with in print. They speak with experience and authority, and their instructions will surely be helpful to

amateur and professional alike. There is a mistaken tendency to scoff at imperfect amateur attempts at craft work; but the amateurs themselves would be the first to admit their failings. In fact, it is only by attempting oneself to do a difficult piece of engraving that one realises that what the professionals achieve is almost impossible. Let us then praise the amateurs for trying, and the professionals for succeeding. The maintenance of traditional high standards of workmanship, which are now being challenged in so many ways, has never been more important than it is to-day. This book will help to gain public recognition for a craft that is much used, but strangely little known.

GRAHAM HUGHES,

Art Secretary,

December, 1957. *The Worshipful Company of Goldsmiths.*

CONTENTS

INTRODUCTION

ENGRAVING is the oldest art of mankind. In prehistoric times it was more simple to scratch the side of a rock with a hard and sharp flint stone than it was to find pigments and chalks with which to paint or draw designs. Down through the ages examples of crude engravings are found in caves, tombs and monuments. All the glyptic arts spring from that of scratching or cutting a design on a plane surface—in fact, using a hard material to make marks on something softer.

At a later period the engraver was the only man whose skill could be called on to cut the type from which books were printed and to engrave wood blocks or metal plates for illustrations. Thus, the sciences, arts and all our learning owe much to the engraver.

Before studying the engraver's tools and methods, it is well to know a little about the art itself: it is actually the elder brother of painting. It is certain that engraving exactly as we know it to-day was practised as far back as 1,000 years B.C. It is mentioned in the Old Testament, when Moses is directed to take two onyx stones and grave on them the names of the Children of Israel. " With the work of an engraver in stone, like the engravings of a signet, shalt thou engrave the two stones with the names of the children of Israel " (Exod. xxviii, 11).

ENGRAVERS OF THE PAST

The Egyptian hieroglyphics on monoliths and on the walls of tombs are so engraved. The tools, weapons and ornaments of the Egyptians were often laboriously engraved too. Chasing, carving and sculpture, which are allied arts, flourished among these people. When the Israelites went out of Egypt, among them were many skilled in the art of engraving, as frequent allusions show.

The Greeks learned the art of engraving and chasing metals and it was much practised and considerably advanced in the time of Homer. Many specimens of Grecian engraving show the excellence which the art had attained. Among ancient peoples, the Etruscans seem to have reached the highest degree of skill in chasing, and their vases and other works of art are still unsurpassed for beauty of form. The principal engraving and chasing was done on armour, weapons, goblets, dishes and articles for personal adornment. The Romans engraved their laws on brass plates.

In the past engraving was sometimes used for making impressions in plastic material such as wax or clay, in the same way that seals are now used. Maso Finiguerra, a goldsmith, engraver, and niellist,[1] of Florence, is credited with having made the discovery of copperplate printing in 1452. The legend is that Finiguerra had just put the finishing touch to the engraving of a Pax,[2] and, wishing to see the effect of his work, he filled the lines traced by his graver with a liquid composed of oil and lampblack. By chance a pile of damp linen was placed on the prepared plate and, on removal, the lines filled with black substance were found to be reproduced on the linen.

ENGRAVING PRECIOUS METALS

But for our present trade purpose the instructions given in this book on the art of engraving is confined to that section of it used in cutting designs, pictures, lettering or figures on metal, wood and other substances on both flat and curved surfaces, keeping mainly to the skills of the engraver used in the jewellery and allied trades. The book deals specifically with engraving on the comparatively soft metals such as gold, silver and metals used in the manufacture of jewellery and goldsmiths' and silversmiths' wares, which include watch cases, cigarette cases, lighters, cups and salvers, trophies, prizes, presentation pieces and similar articles purchased from time to time from the average jeweller's stock.

Of the people who saunter into a shop, select a cigarette case and, as an afterthought, ask for the case to be engraved with a monogram, facsimile-signature, or a long inscription, few realise that a great amount of thought, artistic effort and labour will go into the actual execution of the work and this charge of, may we call it, nonchalance, can also be laid at the door of many salesmen behind the jewellers' counters. It is time the jeweller realised the importance of fine engraving in his business and the part it plays in adding to the personality, indeed to the preciousness, of most of the goods he sells. A cigarette case, for instance, taken out of stock, is just a few pieces of metal put together in a certain fashion, a useful article, but inanimate and cold. As soon as it has a little note indelibly engraved inside it which says, perhaps, " With all my love to Bill," then it acquires a personality. It has life and it carries sentiment. Further, it is cherished and shown with pride to the people who should see it. Also, be it noted, the engraving adds a little to the turnover and profit of the jeweller.

[1] Niellist—One who decorates silver with niello. A design is deeply engraved and filled with a lead-oxide compound providing a black pattern similar to inlay. Also known as tulla-work, from Tulla, a Russian town where the work originated.

[2] A crucifix for personal use.

Engraving is neither simple nor easy, but it can be learnt if one has a little artistic talent. The book aims to give a complete, practical and comprehensive guide to this difficult art. It explains the principles to the practical man who wishes to add engraving to his ability and to the salesman who wishes to use his salesmanship to the very best advantage. The student is introduced behind the scenes into an up-to-date engraving workshop, going thoroughly into the details of the tools that are used, and how they are used, and then he is initiated into the composition of the designs and lettering generally employed. Additionally, a considerable amount of space will be devoted to the methods used by the skilful engraver in tackling the many tricky or difficult jobs required of him.

The book is profusely illustrated by drawings made from sketches in the workshop and methods of working prepared by the authors and by others doing the same type of work. Particularly in the early stages, the tools are illustrated and the methods of holding and handling them. Keep in mind that engraving, being an art, the skill is in the hands, not in the tools, but it is imperative that good and properly shaped and sharpened tools are used.

In addition to forming a complete text-book on engraving, these writings will we hope, bring some healthy publicity to the craft and result in a certain amount of long overdue recognition of the hard-pressed engraver.

THE ENGRAVER'S TOOLS AND EQUIPMENT
By A. Brittain

TOOLS for engraving metals are quite cheap compared with the cost of tools necessary to practice most other crafts. For a matter of a few pounds, a boy is able to fit himself up for life, leaving only the cost of occasional replacements from time to time. The tools are very simple and the whole job is probably one of the cleanest there is. There are no paints to make a mess, only a little oil for the oilstone, so the young engraver can find very little to dirty himself or his work.

In fact, in the trade it is recognised that the work should always leave the workshop in a cleaner state than when it was received. This may seem strange, but the work is usually cleaned thoroughly before it is despatched to the customer, to prevent any possible complaints.

THE BENCH

A good bench is essential; it must be strong and well made, and sufficiently high to stand at when a very large article has to be engraved, such as a large bowl or tray. It must be situated in the best light, preferably against a window facing north, when there will not be too much variation of light intensity during the day. The north light, because of sky reflection, is usually clear and white and not unduly influenced by the position of the sun.*

For night work there should be a lamp adjustable to suit individual requirements, that is, fitted to an adjustable arm and well shaded to throw an even glow over the work and bench. The drawing (Fig. 1) gives a good idea of the best relative proportions for a bench, which many engravers consider should have a footrest. The footrest will be found very useful when carrying out work on small articles such as signet rings and when engraving inside wedding rings. A firm, comfortable stool should be used, not a chair. The stool should, if possible, be adjustable for height so that the engraver may adjust it to suit his own requirements.

* In the Southern Hemisphere, of course, a south light should be used.

TOOLS

Gravers are the principal tools used and although when faced up by the different methods of whetting they take on various shapes, they are still essentially gravers. With half a dozen gravers, it is possible for an engraver to execute all the different cuts required in the execution of a piece of intricate ornamental work or inscription.

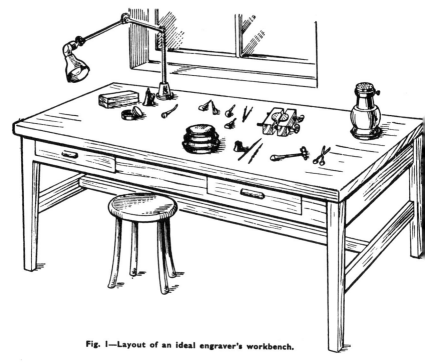

Fig. I—Layout of an ideal engraver's workbench.

Every engraver will have different ideas about the quality, number and variety of tools to be used—I have, indeed, heard many arguments on this subject—but the following list should be suitable for a boy just beginning :—

3 sandbags or cushions of various sizes (including ring and round) (Fig. 10),

1 best quality oilstone (Fig. 9),

1 dozen gravers, best quality (Figs. 2 and 3),

1 dozen graver handles,

1 tracing or etching point, or scriber (steel with a wooden handle) (Fig. 5),

1 oil can,

1 burnisher (steel with curved end and handle) (Fig. 6),
1 scraper (Fig. 4),
$\frac{1}{2}$ dozen shading, or stitch, gravers (D threads, 2, 4, 6, 8, 10, and 12 widths) (Fig. 8),
$\frac{1}{2}$ dozen plain flat gravers (2, 4, 6, 8, 10, and 12 widths) (Fig. 8),
1 pair of spring dividers (Fig. 7), cement block,
jewellers' cement,
oil,
turpentine,
pencil, indiarubber,
pounce bag (calico bag filled with French chalk),
practice plate of copper, polished and surfaced ready for use,
copper plate printing ink,
rubbing stick (bone or ivory).

Fig. 2—A long handled graver. Fig. 3—An ordinary graver.

Engravers do, of course, use more than half-a-dozen gravers for the simple reason that the more gravers they possess, shaped and sharpened to meet the requirements of special jobs, the less time they have to spend in putting a new face on another graver when a similar job is encountered in the future.

The bottom part of the graver handle is cut away to clear the work.

I shall not attempt to describe in the early stages each tool possessed by an engraver because, in the first place, a number of these tools have no ordinary designation as they are made up to meet the requirements of a single piece of work which may never be repeated. Also, no two engravers have the same idea or opinion on the shape or cutting angles of these special tools. Engraving inside a deep bowl is a good example of this. The straight tool as used for cutting on a flat surface is quite unsuitable for this type of work. The shaft of the graver has to be suitable curved in order to allow the hand to guide the tool in a horizontal direction. If an attempt were made to engrave with a straight-shafted graver, the tendency would be for the graver to dig straight into the metal without any forward movement.

The operation of engraving inside a bowl is very difficult and can only be satisfactorily executed by a really experienced engraver. The principles of making up special tools for this job and other difficult ones likely to be encountered are described in other sections of the book.

3

Fig. 4 shows a scraper and Fig. 5 a scriber, both essential to the beginner besides gravers.

Fig. 6—Two types of burnisher.

The remaining tools may be listed :—

Scriber : Used for marking in the proposed engraving after it has been roughly drawn on the article by pencil or wooden point (Fig. 5).

Burnisher : The burnisher is not a cutting tool. It has a polished face or rounded edge which can smooth the surface of the metal and is very useful for eliminating the burr, or rough edge, thrown up by gravers, or for removing scratch marks, guide lines, etc. (Fig. 6).

Scraper : This is used for removing engraving altogether. The surface is scraped by the tool until all the engraving is removed. The surface is then finished by another means, to be described in another paragraph, to restore it as far as possible to a virgin state (Fig. 4).

Spring dividers : For marking circles or comparing measurements (Fig. 7).

Fig. 7—Dividers.

4

Lozenge graver : This is so called because the cross-section is the shape of a lozenge. (For gravers and cuts *see* Fig. 8).

Square graver : The cross-section of this is square. The tool is used mostly for outlining.

Scorper : Used for removing the metal to the required depth, which is done quickly and cleanly. It is of especial value for lettering.

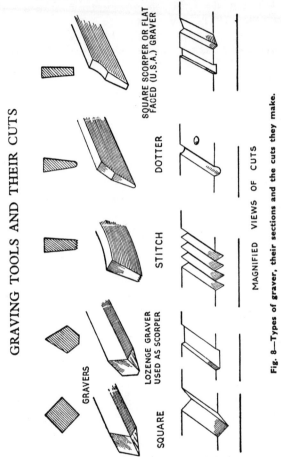

GRAVING TOOLS AND THEIR CUTS

GRAVERS

SQUARE

LOZENGE GRAVER USED AS SCORPER

STITCH

DOTTER

SQUARE SCORPER OR FLAT FACED (U.S.A.) GRAVER

MAGNIFIED VIEWS OF CUTS

Fig. 8—Types of graver, their sections and the cuts they make.

Threader stitch, shading, or line graver : Flat tool with a number of fine grooves running along its cutting face so that it cuts several parallel thin lines at the same time. It is used for shading purposes in lettering or design, such as for pictorial work, the crests of trees, foliage, and grass.

The *round nose* tool, or dotter (Fig. 15), is a graver generally used for cutting dots such as the dot over the letter " i " and full stops. This

5

is a thin tool, without the belly part curved, so that the groove it ploughs in the metal is part of a circle or half-round in shape, corresponding in width to the thickness of the tool. Several sizes, varying in thickness, will be found useful. These tools are ground on the face only; the belly should never be sharpened or the semi-circular form of the cutting edge will be destroyed.

The tool is a good stand-by for ornamental work such as that seen on old-fashioned salvers or Victorian cups. It is useful in that it can be used for covering a great deal of ground very quickly (in fact, it is used for cheap work as a great deal of " nonsense " can be achieved in a very short time, leaving the general appearance at least presentable). This type of work is not normally encouraged in the average engraver's workshop, usually being handed over to someone who specializes in ornamental work. The ornamental engraver to-day is certainly not overworked, as there is very little call for his type of work. Ornamental engraving really belongs to the Victorian era. There are, of course, objects which call for a little ornamentation, but this is usually now done during the course of manufacture.

The oilstone is an essential part of the engraver's kit. It is again a matter of opinion as to the quality and type of stone to be used. There are three principal types—the India, Arkansas and Turkey. India stone is an artificial oilstone which is sold in three grades : coarse, medium and fine. The other two are natural. For most purposes, Turkey or India stone are used, but some engravers prefer the

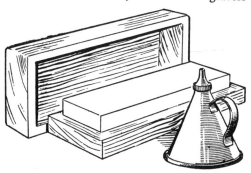

Fig. 9 —Oilstone and oilcan.

Arkansas stone for fine work. Only the fine grade of India stone should be used, however, although even this is considered by many to be much inferior to natural stone. A fault with Turkey stone is that it wears down quickly and after a short time presents an uneven surface with uneven edges. The Arkansas, being a harder stone, preserves its edges for a longer period.

The Arkansas stone is best when white as the veined variety is apt to work up irregularly on the surface. When set up in a wooden box and kept well oiled—in fact, constantly oiled—this particular type of stone will last for years, and will give a good polish to the facets of the graver.

A new stone may appear to be unsatisfactory to start with, but if the surface is roughed up with a rough soft stone using vaseline or plenty of oil, the gummy surface will be removed and the stone will be found to bite properly. A new stone will soak up oil greedily and must be kept covered with oil until apparent saturation point has been reached. It must be thoroughly cleaned periodically with a little paraffin oil. A good oil to use for sharpening on the stone is olive oil or a good quality thin machine oil such as Three-in-One.

There are several items of equipment or appliances that engravers find useful in the workshop. Only the main ones are given to begin with, and not the home-made variety that every engraver possesses and accumulates to meet unusual types of job. They are :—

Sandbags : These are circular pads made of leather and filled very tightly with fine sand. They are available in different sizes and also in the form of rings, and are used to place the work on so that it may be turned easily. The ring type is used for bowls or can act as a seating for another ordinary type sandbag when one is placed on another to raise the level of the work. They are illustrated in Fig. 10.

Fig. 10—Two types of sandbag, the round and the ring. They are leather covered.

Eyeglass : This is the usual standard watchmaker's eyeglass shown in Fig. 11. It can be obtained with one of several degrees of magnification, and care should be taken to select one to suit. The eyeglass is essential for working on small articles, but should be used with discretion in order to avoid undue strain on the eyes.

Fig. 11—A watchmaker's eyeglass.

7

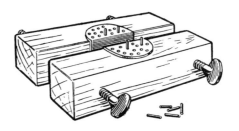

Fig. 12—A clamp for holding rings.

Clamps : There are various types of clamps to hold small or awkward work such as rings. They vary in shape and size. The most common type is the one which consists of two blocks of wood which act as a kind of vice (Fig. 12), with two screwed rods running through on each side to keep the jaws in position. The screws have butterfly thumb-piece ends. On the top centre are fitted two pieces of brass which turn over the inside edges of the jaws. The top parts of the brass together make a disc which is drilled with holes into which brass pegs may be placed to hold any particular job either on the inside or the outside. The position of the pegs is altered according to the size of the article to be engraved. These clamps are very easily made up and the most popular size is about 3 in. by 4 in. The clamps can hold a great variety of small articles.

Fig. 13—An American pattern engraver's
block for the same purpose as that in Fig. 12.

Chucks : The American type chuck (Fig. 13) is another method of holding small articles, and although it will not be found in every workshop it is an extremely useful article. The size is approximately $6\frac{1}{2}$ in. tall with a base diameter of 4 in. and top diameter at the broadest part of $2\frac{1}{2}$ in. The top section resembles a capstan and, in fact, revolves

8

freely in either direction on a pivot consisting of a steel rod which revolves in a socket (which must be kept well lubricated). The base rests in a piece of wood and acts as a ball-and-socket. Many engravers prefer to rest the top metal part of this in the sandbag ring, which prevents it from working too freely. The holding section consists of two half-sections—or rather half-circles—of metal which act as the jaws which are drawn in and out by means of a screw, on the principle of a vice. The jaws are drilled with holes for the purpose of holding brass pins in the same manner as the clamp. Although this chuck is very useful and should be in every up-to-date workshop, experienced engravers often prefer to use their own made-up gadgets for holding a small article, such as fixing it firmly on a block of wood by means of sealing wax.

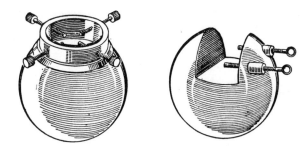

Fig. 14—Two types of bullet for holding work.

Bullet : This is another engraver's appliance for holding small jobs and is in the shape of a ball with the top section cut away, with two screws running through to hold the work in position. Two versions of the bullet are shown in Fig. 14, which is self-explanatory.

Universal engraving handle : This is alternative to a fixed handle, but not much used except for small special gravers (Fig. 15).

Planishing hammer : Although not essential, this is useful for flattening plates before engraving, but it tends to harden most metals, which must be annealed, by heating to red heat and allowing them to cool, to soften them (Fig. 16).

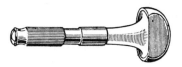

Fig. 15—A universal engraving handle.

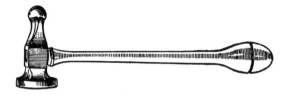

Fig. 16—Planishing Hammer.

GRAVERS PREPARED FOR USE

An engraving tool has to be of a length to suit the hand of the user. Held in working position (how to hold the tool will be described later), the end of the tool should project half to three-quarters of an inch beyond the thumb.

A graver, when bought, will perhaps be too long and will have to be shortened. If only a small reduction in length is required, a small piece can be broken off the tang before the handle is fitted. The tang is not so hard as the rest of the tool, and the broken end should be filed to a point so that it is easily inserted into the handle.

If a tool has to be shortened considerably, the end will have to be ground off by using a grindstone and care must be taken not to over-heat the tool and " draw the temper "—that is, to cause it to become too soft for use as a cutting tool.

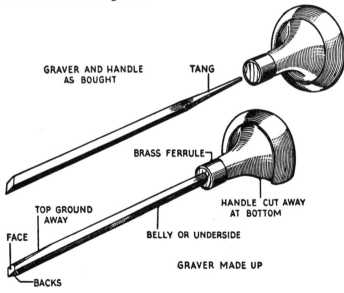

GRAVER AND HANDLE AS BOUGHT

TANG

BRASS FERRULE

TOP GROUND AWAY

HANDLE CUT AWAY AT BOTTOM

FACE

BELLY OR UNDERSIDE

GRAVER MADE UP

BACKS

Fig. 17—Graver as brought and as made up, with part names.

10

Gravers are normally sold without handles, which are obtained as separate items and have one side cut off to present a flat surface (Fig. 17). This is done to prevent the lower part from catching the edge on the article being engraved, to allow the graver to lie flatter than would otherwise be the case and cut more evenly and smoothly. The graver itself should be fitted to the handle before the flat is cut on the side of the handle nearest the work.

Gravers can, however, be bought made up and some are shown in Figs. 18 and 19.

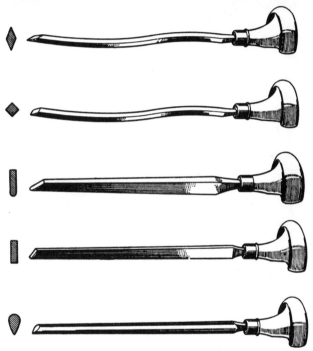

Fig. 18—Gravers are sometimes supplied made up like this. Top to bottom : lozenge, square, dotter, square scorper, spitzsticker.

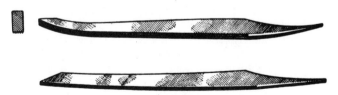

Fig. 19—Stitch gravers for cutting parallel lines. The top one has considerable bellying for cutting inside curves.

11

Before the graver can serve its purpose as a cutting tool it has to be given set-off so that it will cut smoothly without digging into the metal (Fig. 20). This is done by stoning the under sides of the graver to form *backs* (Fig. 17). The backs alter the cutting angle and by an amount known as the set-off, which is normally about 5° for flat engraving (Fig. 21).

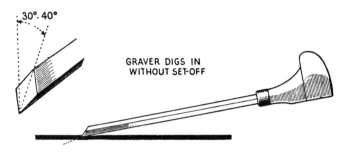

Fig. 20—A straight graver without backs (and therefore without set-off) is not satisfactory. The small diagram shows the usual angle of the face. For soft metals it is sometimes increased.

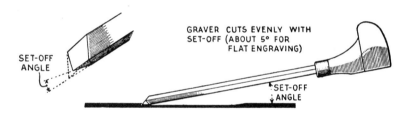

Fig. 21—Stoning backs produces the angle of set-off to give the correct cutting angle.

The set-off of a graver is the angle formed during the initial sharpening when the graver handle is raised to an angle of from 5° to 45° from the stone when forming new facets (Figs. 21 and 22). The set-off is necessary for different types of work—for example, when engraving a hollow surface the set-off is pronounced in order to prevent the handle of the tool from scraping the surface of the work, especially when the size of the article exceeds the length of the graver itself. When engraving a flat article, the set-off is probably only 5°. When engraving inside a bowl the set-off may be as much as 30°, 45° or even more, depending on the depth of the article.

When the set-off angle is increased, the backs—i.e., the facets being stoned—meet the top surface of the graver, as can be seen in the small diagram in Fig. 22. Although this increased set-off allows the graver to be used inside curved surfaces, it is awkward in use because of the

12

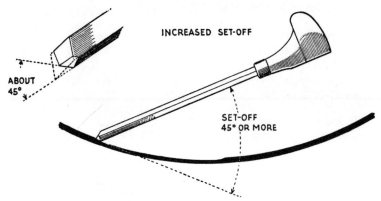

INCREASED SET-OFF

ABOUT 45°

SET-OFF 45° OR MORE

Fig. 22—Set-off can be considerably increased to increase the cutting angle for working inside bowls, etc., but this makes handling the tool awkward.

angle of the handle to the end of the tool and because it is difficult to see the cutting edge while using the tool. This difficulty is overcome by bending the tool (Fig. 23), which increases the effective set-off, and by giving it set-off as well (Fig. 24).

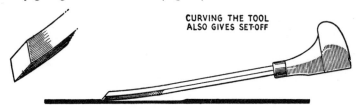

CURVING THE TOOL ALSO GIVES SET-OFF

Fig. 23—Bellying or curving the graver gives a correct cutting angle.

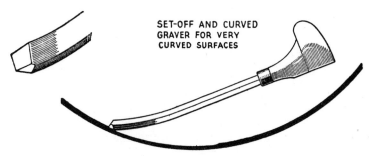

SET-OFF AND CURVED GRAVER FOR VERY CURVED SURFACES

Fig. 24—Curving the tool and increasing set-off is much better than set-off alone as shown in Fig. 22.

Using a short graver is also a help when engraving inside curved surfaces.

PREPARATION OF THE GRAVER

To produce the backs on the graver first oil the stone, which has been prepared as described, pouring on it a little oil from the can and smoothing it all over the stone with a finger. Then place one of the undersides of the graver on the stone, raise the handle slightly (Fig. 25) and, keeping the edge firmly on the stone with the fingers of the left hand (Fig. 26), rub until a facet appears, then turn to the other underside and repeat, taking care that the ridge in the centre is in line with the ridge on the shank of the tool (Fig. 27).

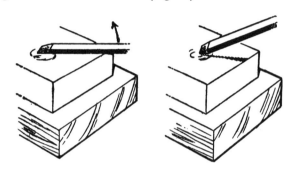

Fig. 25—To produce a back at the correct angle the graver is laid with an underside on the stone and the handle raised slightly.

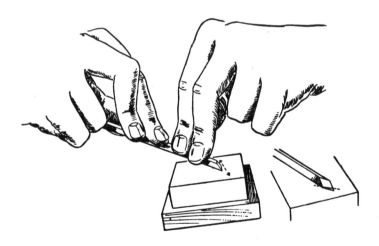

Fig. 26—How to hold the graver when producing backs. The small sketch shows where the metal is removed. If a large amount is removed to give a big angle of set-off, the new edge should be kept reasonably parallel to the original one.

14

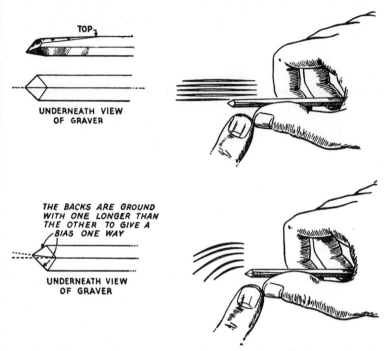

TOP

UNDERNEATH VIEW
OF GRAVER

THE BACKS ARE GROUND
WITH ONE LONGER THAN
THE OTHER TO GIVE A
BIAS ONE WAY

UNDERNEATH VIEW
OF GRAVER

Fig. 27—It is important that the backs meet in a straight line as shown at the top. A slight bias may be given however for cutting curves. The angle shown is exaggerated.

The graver should then be rubbed down on the upper side, i.e., the face (Fig. 28), keeping it at the same or original angle. Test the graver occasionally as the sharpening proceeds. This is done by

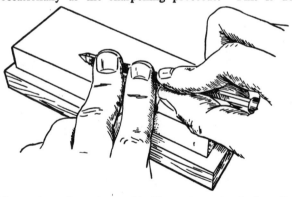

Fig. 28—All engraving tools are sharpened in this way, by stoning the face. To remove rough edges the face should be polished afterwards on a piece of rouged leather.

touching the point on the thumb-nail (Fig. 29). If the tool is sharp enough it will stick in the nail, but if not it will pass over the nail without catching.

GRAVER HELD
LIGHTLY IN
THE HAND

Fig. 29—The sharpness of a graver after it has been stoned is easily tested in this way.

The object is to make both facets converge in the centre so that the ridge of the facets is in line with the ridge on the shank of the tool (Fig. 27).

It is most important that the tool is sharpened properly with the facets at the correct angles, otherwise the beginner will be attempting the impossible by trying to engrave with a tool which is useless. If the process of sharpening is done properly, the end of the tool will be finished with two clear-cut facets for a distance of about $\frac{3}{16}$ in. up on each side and with the angle of the cutting face straight, bearing neither to the right nor the left. This is essential for engraving straight lines.

Should the angle be slightly out, then it is obvious that the tool will be inclined to follow its own path and will certainly not go in the required direction without a great deal of persuasion.

For engraving circles and other curves, it is advisable to sharpen the graver so that one facet is shorter than the other. If, for example, it is desired to engrave a curve to the left, then the left-hand facet should be shorter than the right. This will be found to be of great assistance and will avoid unnecessary forcing of the graver (Fig. 27).

To save time, experienced engravers will often use the ordinary straight-line graver for engraving a curve, but for the beginner it is better to start off in the right path and shape the graver in the proper manner.

The diagrams will show more clearly than a written description how the graver should be sharpened and how it should be held during the process. The preparation of the tool must be practised to perfection before proceeding with the actual engraving, and it is only with constant practice that the tool can be made to suit one's own method of engraving. Most engravers get used to their own backs, and what

suits one would not suit another. It would destroy the whole principle of hand-engraving if methods became stereotyped, as we should merely be attempting to imitate the machine.

After sharpening on a stone, the cutting angle of the graver may be found to be a little rough. To get rid of the roughness, the end of the graver should be polished by rubbing it on a piece of leather with a little rouge.

When an engraving tool is used for making bright cuts, that is cuts where the incision appears to be brightly polished, the edge of the tool must be highly polished because any imperfections on the cutting edges are reproduced in the work. The faces of the graver adjoining the cutting edges should be polished by using a little diamantine on a flat piece of box wood. The graver should be rubbed very carefully on this or the cutting edges will be rounded. Diamantine is a white powder much used for giving a fine polish to steel. It can be obtained from most material houses and should be mixed with the smallest possible amount of olive oil when used so that it is just dampened.

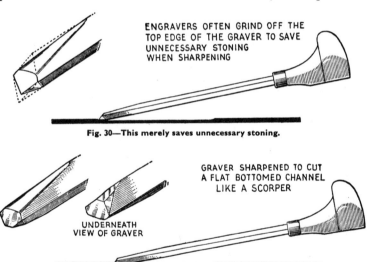

ENGRAVERS OFTEN GRIND OFF THE TOP EDGE OF THE GRAVER TO SAVE UNNECESSARY STONING WHEN SHARPENING

Fig. 30—This merely saves unnecessary stoning.

GRAVER SHARPENED TO CUT A FLAT BOTTOMED CHANNEL LIKE A SCORPER

UNDERNEATH VIEW OF GRAVER

Fig. 31—A scorper made from a lozenge graver.

From time to time the graver or scorper will require to have its point renewed. This is done by turning the belly of the tool upwards and rubbing the face up and down the stone at an angle of from 30° to 40°, according to the angle of the face of the tool (Fig. 28). In order to avoid unnecessary work in this stoning, experienced engravers often grind off the top, non-working part of the tool as shown in Figs. 17 and 30.

17

A lozenge graver can, by stoning another face, be turned into a scorper for making flat-bottomed instead of V-cuts as shown in Fig. 31.

This, as well as a true scorper is merely sharpened on the face, as is the spitzsticker (Fig. 18), a tool not commonly used for precious metals.

In the case of a line or stitch graver, in which the cutting face is already prepared by being cut with a series of fine parallel lines as already described, it is only necessary to sharpen it on the face by holding it on the stone at an angle of from 30° to 45°.

The round-nosed engraving tool, which is used for making dots, is also sharpened on the face only. The shaft is usually slightly bent. This is done by the method described below.

No more need be said at present about the sharpening of gravers, as other points arising later will be described as the actual job is in progress.

It is often desirable to alter the shape of the tool by bending the shaft or bellying it out. This is done by rubbing soap on the graver to prevent subsequent scaling and heating it in a flame until it is red hot, which removes the temper. The graver should be put into a hole (about $\frac{1}{4}$ in. diameter and about $\frac{1}{2}$ in. deep) in a wooden block held in the vice and, while still hot, bent to the shape which is required. The handle of the graver should be removed for this operation and the graver itself held in a pair of pliers.

Fig. 32—One method of bending a graver. The tool should be hot.

Fig. 33—A curve can be produced in this way.

Another method is to hold the graver, after softening, over a metal cylinder or other suitable cylindrical article and tap it with a wooden mallet until it takes the required shape (Fig. 33). No doubt the student will think of a method even more convenient to his own equipment. The method is unimportant so long as the heating and cooling are done correctly.

The graver should then be hardened by making it cherry red hot and plunging it quickly into cold water or preferably sperm oil.

Next the reshaped tool must be tempered by heating gently until the metal is a light straw colour and then again immersing the graver in cold water. This operation requires great care, as it is possible to damage the tool by heating it too much.

It will often be found that the end of the tool will become useless after damage by over-heating. In this case it is far better to break it off altogether and start again. This may be done by fixing the shaft in the vice with just a quarter or a half inch of graver showing and then giving the end a sharp blow of the hammer. This will make the end fly off fairly cleanly.

GRINDING

It sometimes happens that over-heating is caused by the actual grinding on the stone if a proper grindstone with water is not used. It will be found that the point will blunt very easily. This can be overcome by rehardening and tempering.

It has no doubt already become obvious that to be able to engrave is not merely a matter of going to a shop, buying a few gravers, and then starting straight away to engrave. The gravers which one buys in the shop are only the raw materials.

It is now assumed that the student is in all respects ready to begin engraving. He is able to draw a fair sketch of anything from a monogram to a battleship and has a practical knowledge of the art of lettering, which will be more thoroughly gone into in later chapters. Lettering is an art in itself and, to judge by the average shop signs and other forms of advertising, it is obviously becoming a lost art. The student knows, then, what a graver is and how to temper and whet it, and he knows the essential tools of the trade. He can now make a start.

CHAPTER 2

FIRST CUTS

By A. Brittain

IT is best for the beginner that his early exercises are carried out on a piece of copper. This is a comparatively cheap metal and most suitable for the job. A piece about 8 in. square will be quite satisfactory. The plate should be prepared by stoning down with a piece of Water of Ayr stone and a little water. Pour the water on the plate and then rub down with the stone. When a sufficiently smooth surface has been obtained, the plate should be buffed to give it a good polished surface.

For engraving one of the soft white metals or aluminium, the graver must also be well polished, of course, and should also be lubricated by dipping it frequently in paraffin, methylated spirits or turpentine.

Because they are comparatively soft, pewter and other such metals, are sometimes used for practice work by beginners. This, however, is *not* a wise plan because the lack of resistance offered by soft metals makes the beginner inclined to dig too deeply with the graver in places. Copper or silver are ideal metals on which to learn.

The graver should be held firmly but not tightly. With the graver at a fairly steep angle to the work the point will sometimes plough into the metal and make a ragged uneven cut. Running a finger over the cut will indicate if any burrs are present, but one knows instinctively whether burrs are present. The highly polished surface usually associated with silver articles should be fingered as little as possible, because the hardness and roughness of the fingers will cause scratches which will be difficult to remove.

Do not be misled into thinking that all engraving is mechanical or mathematical. Engraving depends largely upon the use of illusion as indeed does all pictorial art and the skilled engraver can produce many beautiful effects by employing this knowledge. An appreciation of the fact that illusion is part of art is very important, for instance, when engraving a picture on a curved surface.

The best design for a beginner to practice is a circular one. I suggest that circles of different diameters be struck on the plate with dividers and circular cuts practised to perfection.

A knowledge of elementary geometry is necessary in engraving if only for the purpose of assisting in the accuracy of design. For example, in drawing the circles on the plate it is first of all necessary to find the centre of the plate by drawing in the diagonals. Where they intersect can be made the centre of the circle. Care should be taken to see that the centre point for the dividers is not made so deep that it cannot be removed when the circles are complete.

CUTTING EVENLY

Before actually beginning to cut, a few words on the principle of the cut may be found helpful. The graver may in some respects be likened to the plough in that they both have to be held at a certain angle in order to perform a cut of a certain depth. The angle that the graver makes with the face of the plate governs the depth of cut and also the tendency for the graver either to run out of or into the metal. This may be controlled by either altering the angle at which the graver is held or, if this is not possible owing to the shape of the article, then the graver itself must be either shaped at the shaft or the two under surfaces must be stoned away, as explained, to increase set-off.

When the tool begins the cut, the character of the cut is governed by the way the tool is held. Should it be driven forward with the belly straight under the upper corner, the cut will have both its sides equally inclined; but should it be held at an angle, i.e., slightly inclined one way or the other, then one wall or side will be more inclined than the other. This is called a flange cut (Figs. 34 and 35).

Fig. 34—Section through an ordinary cut. Fig. 35—Section through a flange cut.

The graver should be held in the following manner : take it in the right hand with the handle in the palm, grasping it firmly with the forefinger and thumb. Hold the article to be engraved in the left hand, leaving the first finger of that hand free to place in front of the thumb of the right hand to prevent the graver from slipping (Fig. 36). The energy for forcing the graver is exerted through the hand and not through the arm. The length of the initial cut is rarely more than one inch.

The importance of the thumb cannot be over-stressed. It is used as the fulcrum or basis of all the cuts ; it controls the graver just as a rudder steers a ship. The thumb is of special importance when

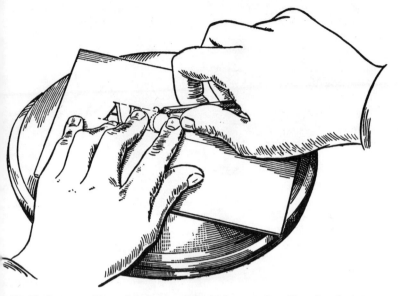

Fig. 36—Correct positions of the hands and fingers for engraving. Note that the index
finger of the left hand presses against the thumb which is the turning fulcrum.

forming curves as it is the fulcrum about which the graver is revolved
thereby ensuring a perfection of form which otherwise would not be
possible.

Assuming that three circles have been pointed-in on the practice
plate, begin to engrave the smallest circle first. Place the graver on
the line marking the circumference of the circle, raise the hand to the
required angle and push the graver until it begins to cut.

Continue the cut but turn the plate at the same time and rate to
the right as the cut turns to the left; in other words, the plate should
be turned into the graver (Fig. 37).

The plate is easily revolved on the sandbags (round or ring), which
have been placed in position on the bench before the actual engraving
has begun. It is optional whether one or two sandbags are used.
The reason for the ring is for the purpose of holding the upper bag
firmly in position when two bags are required, the belly of the round
fitting snugly into the ring.

It will be necessary after cutting the first circle to touch up the point
of the graver because, being the first attempt, the chances are that the
student has skidded, dug too deep and, in fact, done all the things
that should not have been done. The graver has probably suffered
accordingly.

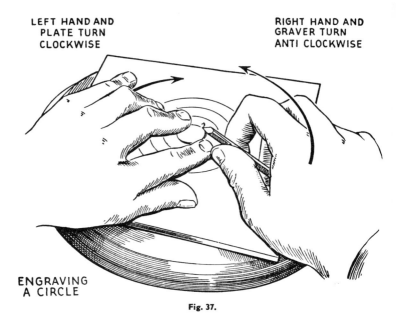

LEFT HAND AND
PLATE TURN
CLOCKWISE

RIGHT HAND AND
GRAVER TURN
ANTI CLOCKWISE

ENGRAVING
A CIRCLE

Fig. 37.

In performing this first operation the learner has now discovered some of the snags, such as holding the graver at the wrong angle and at the wrong inclination. There has been a tendency after each cut to take a deep breath before starting out on the second stage, with the result that the angle and inclination have both altered and a deeper, shallower, thinner or thicker cut has been the result. This will be overcome only by constant practice, with the result that later, when near perfection has been reached, the angles and inclinations will become friends to be used to give that little extra character to a cut which distinguishes the outstanding engraver from the " bread and cheese " man.

THE WRIST IS THE SECRET

The whole secret of engraving is in the wrist which will at the right moment, give a slight inclination or alteration of angle and turn an ordinary cut into a thing of beauty. The belly of the graver is a curved line convex towards the surface of the engraving and if the hand is lowered the point will be raised and the tool will skid over the surface. If, on the other hand, the handle is raised, the tool will dip deeper into the metal or come to a complete stop. It is only practice and still more practice which will give the necessary co-ordination of mind and hand and complete muscle control. After many, many years of

24

practice it will be possible to engrave an inscription without the usual preliminaries of measuring, planning and drawing in, but I think there are very few engravers who can do that to-day. In many cases the planning and the sketching take far longer than the actual engraving. This will be more fully discussed later.

It is necessary when cutting a curved line to observe which is the vertical and which is the inclined side of the cut. The learner now knows, of course, that the handle of the graver, when cutting a circle, must " follow " behind the point. The moment that the body of the graver fails to " follow " the point of the graver then the belly of the tool has the tendency to touch the edge of the cut already made. This will be more readily understood if the graver is imagined to be making a straight cut and the handle of the graver suddenly swings to the right or left. Damage will immediately be done by the belly of the graver to the cut already made and will cause one or the other of the edges to be torn or bruised.

It is only when engraving very small circles or making a deep cut on a small radius that there is likely to be difficulty with the belly of the graver damaging the cut. This is avoided by rolling the tool; that is, turning it slightly by turning the wrist to the outside of the

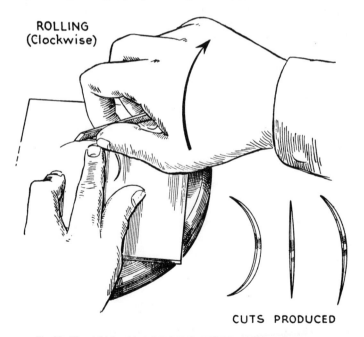

ROLLING
(Clockwise)

CUTS PRODUCED

Fig. 38—The right hand is twisted at the wrist to produce a flange cut.

curve as shown in Fig. 38, to produce a flange cut. The shallower outside edge of the cut will allow the belly of the tool to clear it without damage (Fig. 39).

GRAVER ROLLED TOWARDS
CONVEX EDGE OF CUT

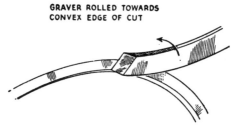

Fig. 39—The graver is twisted about its own axis.

It is not necessary to make a flange cut for circles other than those of small diameter because the set-off of the graver permits it to clear the walls of the cut.

Rolling the graver, when the depth of cut is maintained, broadens the line. Very graceful curves can be cut by the method, but it suffers from the disadvantage that the shallow wall does not give a good wearing edge and, after a time, especially on articles which are in constant use, the engraved lines lose their sharpness.

Script lettering is a good example of rolling the graver to produce wide and narrow cuts. The method is far easier than others for widening letters in the required places. However, the best work is not produced in this way.

Although script lettering, which is not easy to execute well, will be dealt with in detail later in this book, I think it wise to point out here that the best lettering is produced by threading. This is a tedious process compared with rolling, but it produces a beautiful and long-wearing letter.

ROLLING THREADING

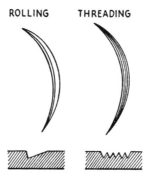

Fig. 40—The best and most expensive type of lettering is done by the threading method.

Threading entails outlining the wide parts of the letter and then "filling in" with a series of fine cuts. The difference between the two methods is shown in Fig. 40.

Most retailers do not appreciate the fact that a simple job of lettering can be done in several different ways—employing exactly the same lettering—according to the quality of work required. I usually quote several prices for a job and explain what the customer is receiving for each price.

Once the difference between threading and rolling is explained and shown (the method employed can easily be seen on an engraved article) to a customer, there is usually no difficulty about the price for extra work involved.

Threading is the method used in a good-class workshop. It takes longer and requires greater care, but it is considered the hall-mark of a good job.

One or two questions have naturally arisen in the reader's mind at this point. The first one may be : why engrave a circle as the first lesson instead of a straight line or a series of straight lines ? The answer is that it is easier to engrave a curve than a straight line. Also, the curve will teach the learner all the movements in one operation : the wrist moving the graver, the left hand moving the plate into the graver, and the thumb controlling the direction and movement of the right hand. With continuous practice on circles or initials like the letter " S " the learner will quickly become fairly proficient in the use of his graver. It is very important that the learner should co-ordinate the movements of the two hands so that they move in the required manner without any signs of awkwardness.

It is essential that the action of moving the plate into the graver should be practised to perfection. It will be found quite simple after plenty of practice, and the reason for it will become obvious when engraving a very large article, as it will clearly be easier to revolve the job on a sandbag into the graver than to turn the graver round the article. In the case of a flat plate it is comparatively easy to control the action of the job into the graver by placing all the fingers on the top of the plate, the forefinger of the left hand and the thumb of the right hand in their proper positions and the remainder of the fingers resting on the plate for control, but some articles are far from easy.

One or two other points arise, such as the length of each cut and the depth and width. These points are immediately answered when the student begins to practise. The length of the cut is as long as it is required or as long as it can be performed efficiently. In the case of the student it will be found to be a matter of half an inch or so, and in the case of an efficient engraver, as long as he is able to control the

27

job. In the case of engraving a circle the extent of the cut is governed by the extent to which the job can be revolved in one movement. The width of the cut is naturally governed by the width of the graver and the depth to which the cut is made. The beginner should make a cut which is not too fine and yet not deep enough to cause much resistance to the graver.

It will often be found that a certain graver will require a rest after constant use, as it may be getting a little tired—this is not an old maid's yarn, but a fact! Like razors, gravers should be given their periodic rests because constant use in some way upsets the cutting edges so that, no matter how often they are stoned up, they will not cut at their best. The reason lies deep in atomic physics and is not necessary for us to bother about.

TRACING AND TRANSFERRING DESIGNS

After competence is achieved in engraving circles, the beginner might like to try his hand at a simple design. This can be drawn direct on the metal—i.e., the copper practice plate. A pencil will not draw directly on the buffed surface of the plate, so the surface has to be prepared before the design to be engraved can be drawn on it.

The usual method is to dull down the surface with a soft wax or plasticine and then to give it a thin coating of powder, such as fine chalk, whiting or French chalk.

The powder can be dabbed on with a wad of cotton-wool or with a pounce bag—a linen or fine muslin bag filled with powder.

The design is drawn on by means of a pointed orange stick which leaves a fine mark but does not scratch the surface. When the design has been completed satisfactorily with the orange stick, it is pointed in by a steel point. The grease and powder are then removed and it will be found that the design is delicately outlined on the highly polished surface. All is now ready for engraving.

It may well be that the engraver prefers to see the design on paper before committing it to metal, in which case the design can be transferred from the paper direct to the metal. This is done by waxing the back of the sketch with modelling or jewellers' wax and placing the sketch in position over the metal to be engraved. Trace over the sketch with the steel point. (Fig. 41.) The result will be a fine outline traced on a background of wax. If the result is satisfactory, then it can be traced over with the steel point and the wax wiped away. This will leave the design in fine outline on the metal ready for engraving.

Another way of transferring an engraved design to another article, is to fill the engraving with a little soap by using the finger and carefully

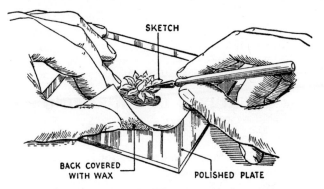

SKETCH

BACK COVERED
WITH WAX

POLISHED PLATE

Fig. 4I—How a sketch is transferred to a plate for engraving.

wipe off any surplus soap from the article with a dampened piece of tissue paper, taking care to leave the soap that fills the cuts. Then place a piece of damp paper over the soap-filled cuts and a drier piece on top and rub these gently with a burnisher. If the dampened paper is now gently removed it will be seen to carry an image of the engraving. If it is now placed gently on the polished surface of the article to be engraved and pressed lightly with the finger the design should be transferred and its outline in soap should be clear against the polished surface. If it is not, the bad impression can be removed with a piece of chamois leather and the process tried again. Some engravers do not even use soap as they find that ordinary damp paper is sufficient to transfer a clear impression of an engraved design to another article.

For metal surfaces on which a particularly intricate design is to be engraved, the surface can be covered with chinese white, and the design drawn with a sharp pencil or stick. Very often, in order to save time, articles are actually drawn in Chinese white on the article for the customer's approval instead of making a special sketch.

EXERCISES IN ENGRAVING

By A. Brittain

IN Chapter 2 I described the best way for a beginner to learn to handle his graver, by making curved cuts and particularly by cutting circles of different diameters. This is excellent practice to give the " feel " of the tool and to become familiar with the action of " feeding the work into the tool," but continually cutting circles is apt to become boring. So a set of exercises is required which gives practice on curves and also on straight lines, which should now come easily.

Engraving lettering is among the hardest of the engraver's operations and is left to a later chapter of this book when the learner is fully competent. To give some variety in exercises, then, I propose to dig —but not very deeply—into heraldry, the devices of which form excellent exercises and at the same time teach something about the subject.

The commercial engraver is often called upon to engrave a crest and must know the basic principles of the subject, that certain shading is used to represent certain colours, for instance. The average shop assistant, even in a high-class shop where one would expect otherwise, is woefully ignorant, and I know for a fact that most people entitled to use crests make a point of going to shops which are conversant with the details of heraldry. Should they think that the assistant who is taking their instructions is ignorant of the subject they would probably —and quite rightly—walk straight out of the shop.

The orders passing through our office show a surprising lack of knowledge on the subject even from people whose livelihood depends to some extent on knowing about it. We are often asked to engrave a crest when a full coat of arms is really required and vice versa, or again we are asked to engrave parts of arms which are obviously incorrect.

I do not propose to go into the history of heraldry ; there are many excellent books on the subject. I merely intend to give details of use to the engraver and parts of a full coat of arms which make good exercises and useful knowledge for the beginner.

The shield, as the most important piece of defensive armour, was essential to the warrior of bygone days and has become the most important heraldic device, being an integral part of all heraldry. Shields which are known in heraldry as *escutcheons*, are used in many shapes, some of which are shown in Fig. 42. The most frequently used shape is that shown at the top left.

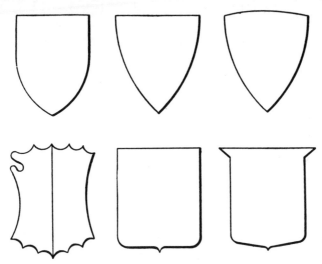

Fig. 42—Some shield (or escutcheon) shapes.

Certain parts or " points " of a shield have names which are used in describing the coat of arms. Incidentally, heraldic descriptions are such exact word pictures that it is possible to make a drawing or engraving with the correct colours indicated, without actually seeing the coat of arms.

The " points " of a shield are shown in Fig. 43. The Fesse point is in the exact centre of the shield, the *chief* is the top part, and the *base* the bottom. The *dexter* is the left-hand side of the shield as reproduced, but actually the right-hand side from the point of view of the warrior, and the *sinister* is the other side. Different points have different ranks, so the dexter is more honourable than the sinister and the chief more honourable than the base.

Only certain metals and colours are allowed in heraldry, the metals, being gold, known as *or*, and silver, known as *argent* or *arg*. There are normally five colours, *gules* (red), *azure* (blue), *sable* (black), *vert* (green), and *purpure* (purple). The shading which must be used to indicate these colours is shown in Fig. 44. This shading of course, is

31

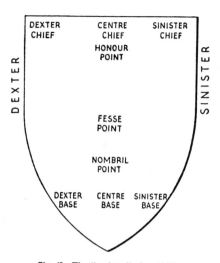

Fig. 43—The " points " of a shield.

what is used in engraving and the shields should be used as exercises. The vert (green) has shading running from top left to bottom right, or, to use the proper language, from dexter chief to sinister base, and purpure shading is at the opposite angle, from sinister chief to dexter base.

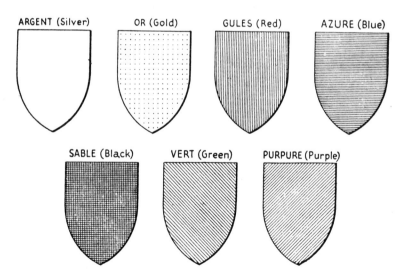

ARGENT (Silver) OR (Gold) GULES (Red) AZURE (Blue)

SABLE (Black) VERT (Green) PURPURE (Purple)

Fig. 44—How colours are indicated by shading.

There are two other colours, *tenné* (orange) and *sanguine* (reddish-purple), sometimes encountered, the latter only in coats of arms of the Royal Family. Tenné is represented by vertical shading crossing the shading used for purpure and sanguine by a combination of the horizontal and purpure shadings.

Besides the metals and colours, there is a variety of furs, which also have their special way of reproduction. They are based on two patterns, *ermine*, which has a motif like an arrow head with three dots above it, and *vair*, the motif of which is like a small shield or a skin stretched for drying.

Ermine itself has the pattern on a white, i.e., argent, field. See Fig. 45. The *field*, by the way, in the background. Ermines is the reverse of ermine, i.e., white pattern on a black ground. The little shield of the vair pattern is normally azure or blue as shown by the horizontal lines in Fig. 45, but other colours may be specified. Potent, shown in Fig. 45, is also understood to be azure (blue—horizontal shading) on a field of argent (silver, unshaded, background) unless otherwise specified. Counter vair and potent counter-potent are pattern variations.

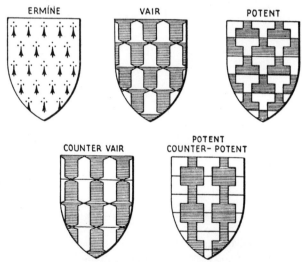

Fig. 45—The heraldic furs and their pattern variations.

So much for the shading that the engraver has to know.

Next, divisions of the shield. A shield can be divided up only in certain ways. The heraldic language for division is " party," so a horizontal division through the fesse point or centre of the shield is " party per fesse," but a vertical one through the centre is known as

" party per pale." Often the word " party " is omitted so that the partition lines are indicated by " per bend," " per bend sinister " and so on, as shown in Fig. 46. When a shield is divided quarterly the quarters are numbered and always in the same order as shown in the diagram. The division of a shield divided quarterly is always through the fesse point.

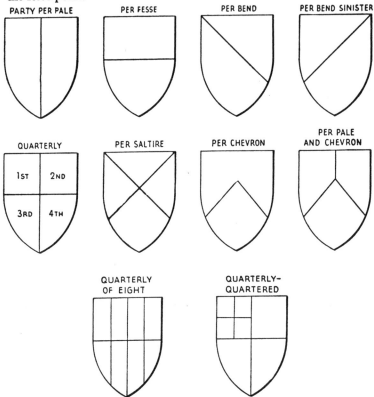

Fig. 46—The divisions of a shield.

Certain decorative lines or divisions are permitted in heraldic design as shown in Fig. 47 and certain patterns are permitted also as in Fig. 48.

The apprentice engraver should have learnt enough to be able to draw a simple shield without offending the traditions of heraldry. Engraving one is a different matter, however, so it is intended to describe this step by step.

To transfer the design to the metal, the shield could be drawn on a sheet of paper, and the back waxed, the design being traced out as

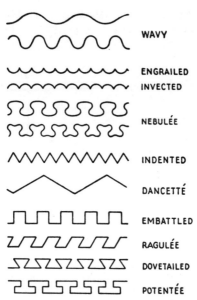

WAVY

ENGRAILED

INVECTED

NEBULÉE

INDENTED

DANCETTÉ

EMBATTLED

RAGULÉE

DOVETAILED

POTENTÉE

Fig. 47—Some of the decorative lines permitted in heraldic design.

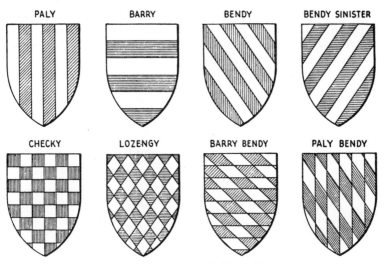

PALY BARRY BENDY BENDY SINISTER

CHECKY LOZENGY BARRY BENDY PALY BENDY

Fig. 48—Examples of patterns permitted in various " colours."

already described. A commercial engraver, however, would probably draw a simple design such as this direct on the metal. For the purpose of the exercise, a shield of slightly more elaborate design than the

plain ones showing heraldic shading will be used, so that the method of cutting S-curves can be practised. The shape is shown in Fig. 49.

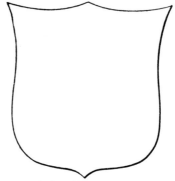

Fig. 49—The shield to be engraved.

Decide where on the metal the shield is to be positioned and cover the area with a thin film of wax by dabbing with a piece of modeller's wax. It is not advisable to use Plasticine as it will stain the metal, particularly if it is used on silver. Dab some French chalk on the waxed area with a piece of cotton wool or a pounce bag and blow off the surplus to leave an even, white surface.

Next draw a centre line with a pencil or steel point. If a polished copper practice plate is being used and the shield is to be parallel to the side of the plate, use a pair of compasses with pencil, or a pair of dividers to draw the line, sliding the point of the compasses along the edge of the plate (Fig. 50). The centre line should be lightly made,

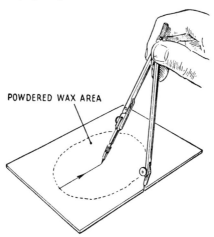

POWDERED WAX AREA

Fig. 50—Marking a centre line.

but hard enough just to show on the metal itself when later the wax is removed. Eventually, of course, the centre line is polished out.

With a pointed orange wood stick—a cocktail stick is suitable but rather too short to handle comfortably—draw in *one side* of the shield, as shown in Fig. 51. When this is satisfactory point it in, i.e., follow round the lines with a scriber to mark the metal. If any mistakes are made when drawing with the orange stick they are easily rectified by rewaxing, powdering the area and redrawing. After pointing-in, rub off the wax and powder. Half of the shield should now be clearly visible scribed on the metal with the centre line shown only faintly.

Fig. 51—Sketching in half the shield.

It is now necessary to transfer the shape of the half shield to the other side of the centre line. Rub a little printers' ink on the plate with a pad so that it enters the scribed lines. Instead of a pad, the edge of a small piece of card used as a scraper answers very well. Wipe off surplus ink. The ink is fairly stiff and will remain in the scribed lines.

Soak a piece of clean paper, preferably good printing paper, in water. Let it drain and dry slightly so that there is no surplus water. Place this carefully over the inked plate and rub over with a rubbing stick, as shown in Fig. 52, until an impression of the half shield and centre

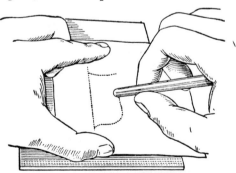

Fig. 52—First impression on damp paper.

line are picked up by the paper. The method should give a clear, bold print. The rounded end of a plastic or bone penholder will serve as a rubbing stick.

Use a strong paper, otherwise when it is damp it will tear at a critical moment. Now remove the damped paper, and by a similar process transfer the image to a piece of tracing paper. This reversed impression on the tracing paper is the one that has to be printed back on to the plate (Fig. 53).

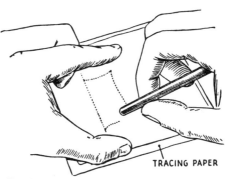

Fig. 53—Transferring the impression to tracing paper.

The centre line should just show on this print of the half shield cut exactly along this with a pair of scissors and mark on the back of the paper where the top and bottom points of the shield come. Now place this on the plate, print side downwards, exactly along the centre line so that it matches with the half of the shield already pointed in, as in Fig. 54. The rubbing stick is again used to transfer the print to the plate. After the impression has been pointed in with the scriber the ink is rubbed off and the shield is ready to engrave.

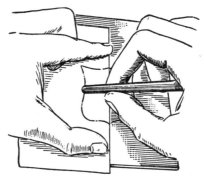

Fig. 54—Returning the reversed impression back to the plate.

Up to now the beginner has been practising chiefly on circles, so the curved sides of the shield should not present any great difficulty. There are two problems, however, that may arise, as they have not been encountered before. The first is to make a cut that is even in width and the same at both the beginning and end; the other is to cut S-curves.

Take the graver you propose to use and make sure that it is sharp by seeing if it " sticks " when touched on the thumb nail. To start a cut, the graver has to be inclined to the metal at an angle that depends on the amount of set-off. The beginning of the cut always tapers slightly where the bottom edge of the graver enters the cut (Fig. 56). A cut can be finished without this taper, however by bringing the graver smartly out of the work—almost flicking it out—which will break off the curl of metal swarf and give a clean end to the cut (Fig. 55). If the graver is brought out of the metal gradually there is danger of its slipping and damaging the work.

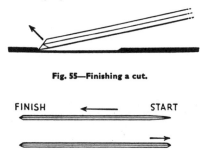

Fig. 55—Finishing a cut.

FINISH ⟵ START

Fig. 56 (top)—A cut showing its tapered start and Fig. 57 (bottom) the same cut finished by returning over the first part of the cut.

When a cut of even width is being made it improves the cut if the beginning is finished off in the same way as the end. This is done by turning the work and going back, or returning over the first part of the cut in the opposite direction, and " flicking out " as described (Fig. 57). Only the first eighth or quarter of an inch of cut need be treated in this way. The technique gives cuts of even width without tapering ends and is used for the shield and for any shading that is done on it.

When finishing a cut the engraver should lift the point of the graver so that it runs out of the metal cleanly. With some metals, however, a little chip will sometimes cling to the point of the graver. This will interfere with the next cut but can easily be removed by jabbing the point of the tool into the end grain of a piece of hard wood. The average engraver's bench looks as if a woodpecker has gone crazy there !

Now for the actual engraving. Place the plate on one or two sand-bags as already described and begin to engrave one of the top curves, holding the plate so that the cut is towards you, and, of course, turning the plate and tool into each other in the proper manner. Then cut the part marked 2 in Fig. 58, and so on in order as shown so that each cut is made towards the engraver. A skilled man can cut a curve away from himself or an S or even a double S-curve, but that is best left for the time being to the expert.

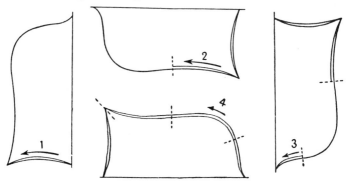

Fig. 58—Stages in cutting the shield.

The other side of the shield is, of course, engraved in the same way. Make sure that each cut merges into the joining ones without disclosing that they are separate cuts. The corners may require cleaning up before the engraved shield is considered satisfactory.

It is customary to give some relief or edge shading to a shield to improve its appearance by threading the right-hand side and bottom right edge. It is done with the graver, cutting lines very close to each

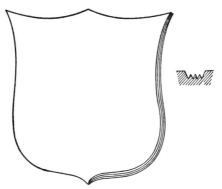

Fig. 59—Shading or heightening with a graver.

40

other so that they overlap. The number of cuts, i.e., the width of edge shading, depends on the size of the shield. For a shield about an inch and a half high three threaded lines will usually be found sufficient (Fig. 59).

The engraver should now try some shading as practice in engraving straight and parallel lines, working to an edge, and returning cuts. Try vert shading, i.e., from dexter chief to sinister base or, in other words, from top left to bottom right.

If a cut is started exactly from the engraved edge of the shield it will be found to overlap the edge as shown by the top line in Fig. 60. Instead, start a little inside the edge, when the beginning of the cut will just extend to the line. Cut straight, across and "flick out" the end of the cut as soon as the opposite edge is reached, then return in the opposite direction for just the first part of the cut to clean up the beginning and square it up to the edge of the shield. The middle and lower lines in Fig. 60 should make this clear.

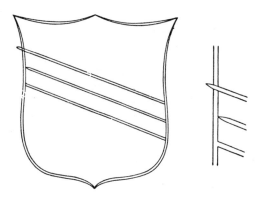

Fig. 60—How shading should be cut. Top line wrong. Centre line is correct. Bottom shows cut finished by returning.

Incidentally, a division of a shield like a chevron can be included in the original drawing and transfer operation (Fig. 61).

A quick method of transferring half a pattern is sometimes used. Instead of a sheet of paper, two sheets of celluloid or acetate sheet are required, thin and transparent, and jewellers' wax takes the place of printers' ink. After half of the design has been pointed in, the wax is not removed but an impression of the design on it is taken on one of the transparent sheets with the help of the rubbing stick. This is then transferred to the other sheet of celluloid by the same method, and from this sheet back to the metal, when it will be reversed left to right. There is no need to cut along the centre line to align the half

41

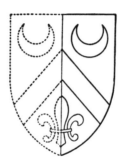

Fig. 61—A shield like this can be reproduced completely by the transfer method.

of the pattern as the centre line can be seen through the transparent sheet. The impressions produced are faint, but normally clear enough to work from if the transparent sheets are clear and clean before the transfers are made.

Do not stop at this one shield. Try other simple shapes which include straight lines and curves.

Practising cutting simple designs may seem a little tedious, and the beginner may want to start lettering right away, but I must stress the point that to become a skilled engraver one must also have some artistic sense. No amount of description will turn a man into an engraver; it is only the combination of artistic ability and hard and continuous practice that will make him one.

Engraving is a very individual art and the hints and advice I have given should only be taken as a basis for tackling a job. No two engravers use exactly the same methods because each has developed the technique which most suited him. One will insist that a scorper is best suited to a particular cut. Another will use a square graver. It is only by experimenting with different tools that the beginner will be able to find one that suits him and the job in hand. If by trial and error he finds that he prefers to carry out a job by some method other than I have described here, he should try to develop it. The final analysis is only by results.

As a change from shields, try some other regular shapes. It frequently happens that monograms are contained in a frame such as a diamond, square, oval and, in fact, any and every sort of frame. It would, therefore, be a good idea for the student to practice the design, drawing and the cutting of sundry shapes. When the shape is regular, proceed in the same way as for a shield, by drawing in half of the shape and then reversing and transferring it. These shapes are also good exercise in heightening or shading.

MONOGRAM PANELS

Many articles which have to be engraved with a monogram are engine-turned and sometimes the manufacturers leave some queer-shaped panels for engraving purposes in order to enhance the appearance of the article. The result is that the engraver has to use his ingenuity in order to design a suitable monogram to fit the shape of the panel. Very often the initials are quite unsuitable for certain shapes and it is often quite difficult to design a monogram to suit the customer's taste. In such circumstances a sketch is always submitted to the customer first for approval before any cut is made in the article, which saves a great deal of trouble in the event of the design being unsuitable.

Again it often happens that a monogram has to be engraved in the corner of a plain case. When this happens there are two shapes which immediately come to mind, a right-angled triangle and an oblong or square shape. The shapes may have been left by the manufacturer of the article or they may be required to be actually engraved, at a customer's request. For example, an oval shape on a brush is very commonly required.

An oval is one of the most difficult shapes to construct, because an oval, especially if it is engraved on an oval article, has to be perfectly true otherwise any imperfection immediately shows up. Many engravers admit frankly that they are defeated every time they have to draw an oval and they go to great lengths to overcome this difficulty. Some go to the trouble of making up shapes in brass in varying sizes so that all they have to do is to put down the shape of the required size and draw round it. This is a very good idea and does save a great deal of time once the shapes have been prepared.

Do not neglect freehand exercises with pencil and paper. The use of mechanical aids must come after one is proficient in freehand sketching. Naturally, when an engraver has a job to carry out he is going to use the method which is the quickest and, rather than waste time in attempting to sketch a perfect circle, he is, of course, going to make use of his compasses. That applies to sketching all shapes. When he has to make a shape with two straight lines and two curved he is going to use a ruler and a paid of compasses. If he wants an oval he will use a template or sketch it, using a circle as a basis drawing half or a quarter of the oval and reversing and transferring it as already described. For some shapes, geometrical constructions are too lengthy and elaborate and mathematical precision is not needed for small shapes. There should be no need to discuss elementary geometry here as it is assumed that the reader has a good working knowledge of this.

Engraving shapes is usually carried out with the ordinary lozenge

graver. Other tools required will be those which are found on the average engraver's bench. That is, a set of sandbags, ruler, pencil, pounce bag, gravers, printing ink, turpentine, and orange stick. Wax the plate to be engraved and dust with powder. Sketch in the shape and point in. Wipe off the wax and powder and engrave the outline of the shape. The turpentine, by the way, is to help remove the printing ink from the engraved lines.

When the engraved outline is completed to your satisfaction, start on the heightening.

Heightening should normally be carried out as if the shape were in slight relief and a shadow was being thrown by light coming from the top left. This rule is not always exactly followed. The appearance of the final job is of more importance. The heightening in engraving is invariably engraved at least on the right and bottom sides (Fig. 62).

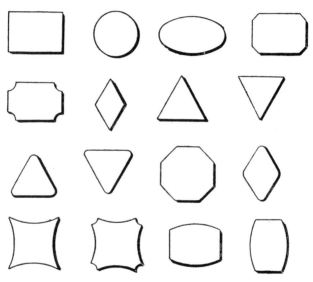

Fig. 62—Some monogram frames which can be used for practice in various sizes. The shape at the bottom left could be improved by heightening the bottom line.

When engraving a monogram in a shape it is not always necessary to engrave the heightening on the shape. It should be quite sufficient to heighten the monogram itself, but there is no harm in practising the engraving of heightening on the shapes for exercise, because it is sometimes necessary to do so on an actual job. To ensure neatness the shading lines should all finish at the same level and should not be allowed to straggle. When a shape such as a right-angled triangle as used in corners is made to face another way, the heightening is altered.

44

In shapes such as the scroll in Fig. 63, roundness is given to the rolled part by shading. This is done with the lozenge graver, making each shading cut towards the upright engraved line where the shading finishes. In a ribbon with a wavy band, the bottom edge is usually heightened all along its length, although, strictly speaking, only certain parts should be heightened.

Fig. 63—Heightening scrolls and ribbons.

It is, of course, important to see that the graver is properly sharpened and spare gravers should always be handy in case the point of the graver in use suddenly goes. It is important to see when engraving anything that the positioning of the hands is correct and that you have full control over the graver, otherwise when the point flies the graver will skid over the engraving surface and spoil the job. Again, until one is proficient in the handling of the tools nasty cuts may be made in the finger of the left hand.

Traces of slight damage on work can sometimes be removed by burnishing and polishing, but on engine-turned work there is often no alternative but to replace the article or part of it. A point breaking from a graver is an accident that can happen to the most skilled of engravers, and however careful he may be, the job is almost invariably damaged. When the job is completed satisfactorily, the engraving should be perfectly smooth with no trace of roughness or burr. Should there be any sign of a burr then it may be safely assumed that the graver was not sharpened properly in the first place. The correct method for removing burr and for general polishing is explained in Chapter 10.

When sketching in any designs that are symmetrical, the same method may be used as described for sketching and laying down shields. When a design has some asymmetrical parts, leave these out until the transfer is made.

The same principle can be applied to sketching with pencil and paper. Complete one side of the drawing and then fold the paper in the centre of the shape and rub the paper. The sketched side will become duplicated on the other side; it then only requires the final sketching in to complete the shape. This can then be transferred direct on to the plate, by the method described on page 28.

It may occur to the reader that it may be possible to use the threading tool for heightening purposes. An experiment with this tool will soon show that it is unsuccessful for this purpose as the true shading effect is not achieved.

A threader is not really suitable for heightening as there is not the same freedom of cutting, and the threaded lines are too " mechanical looking " and do not overlap as they should for effective heightening.

Although it is not satisfactory to carry out shading or heightening by using a threader, the threader is suitable for even shading open letters such as shown on the letter *A* (Fig. 64). The open letter is outlined with a graver and then shaded. When the lines cut by a threader meet another line at an angle, care must be taken not to cut across this line and some of the cuts made by the threader will end short. They are finished off by using a graver. This method is seldom used and does not save any time. It is mentioned only to emphasise the use of the threader.

Fig. 64—This shading can be done with a threading tool.

It would be a change from engraving simple shapes as previously described to go on to a simple crest, such as a tree. This is not difficult to sketch and to engrave. As a crest it denotes or rather is a symbol of strength or knowledge. The tools required will be the ordinary lozenge graver and perhaps a threader, in addition to the usual equipment and stones which should be at hand at all times.

Sketch the tree on a piece of paper first until a satisfactory shape has been achieved. If it is going to be a crest, sketch in a wreath at the bottom of the tree. A crest must have a wreath at the base, otherwise it is merely a device. The wreath is the bar at the base of the object and contains six scrolls, as shown in the engravings. The purpose of the wreath was to enable the crest to be fixed to the knight's

helmet. It was round in shape but for heraldic purposes is usually represented as a straight bar, but may be curved.

Now that the tree is sketched on paper it only requires to be transferred to the practice plate in the manner already described. For a simple exercise such as this it may be as well to sketch it straight on to the plate after the usual waxing and powdering. Later, when efficiency has been achieved, it will be found both unnecessary and a waste of time to sketch on paper first. Point in and remove the powder and wax. The tree will be found faintly outlined on the plate.

The next operation is to engrave the main lines of the outline with the graver. Shading of the trunk is done with the graver. The engravings indicate clearly how the shading should be applied. When it comes to shading the foliage this may be done either with the graver or the threader. I should add that the threader in this case is, in my opinion, a rather cheap and lazy method of shading as it merely roughens up the area of the foliage without giving it that true appearance of depth and life. The threader is passed criss-cross and wriggled over the area until the whole surface has been covered.

When shading by graver the foliage should first of all be outlined lightly and the shading carried out by engraving a number of fine parallel lines as shown. This will give the appearance of life and depth just as can be done with a pencil on paper. The shading should be heavier and thicker in the folds of the foliage and thinning out towards the light. The wreath should be engraved with the graver and the shading done with a number of parallel lines in the alternative sections. The wreath should be heightened along the bottom by a series of short lines at the same angle as the shaded sections. The engravings in Fig. 65 show a series of trees from actual crests which can be used for practice. They have been selected so that they are roughly graded in difficulty.

TAKING PRINTS

It would be good practice at this stage to begin taking prints of an engraving when it is completed because in any efficient workshop every job is recorded by taking prints and recording all information either on the print itself or on the workshop order form which should accompany each job. This is essential because of the number of engraving repeats which are received. Not only is it useful from the customer's point of view, but it saves a great deal of the engraver's time when the actual print is at hand. The method of taking such a print is to rub printing ink into the engraving, place a piece of damp paper over it and rub down with a burnisher or any other smooth and rounded object. The print will not be of any use at a later date for

Fig. 65—Example of crests for free style practice. These are prints (actual size) from real engraved crests. They are in rough order of difficulty.

a direct transfer, but it will give all the necessary information with regard to style, size, etc. It can, of course, be used by tracing through.

In the case of a number of articles of different sizes, such as cutlery, spoons, forks, etc., or a nest of silver bowls, ash trays, inscriptions on silver cups with a possibility of annual repetition, being engraved with the same crest or device, it is essential to take prints of each size for future reference. It is not possible to record too much information about the various jobs which pass through the workshop and it cannot be regarded as a waste of time. Many times I have been very thankful for a print of, say, a regimental badge or some other emblem or device which is not recorded correctly in the usual publications.

It is not essential to use printing ink or any other filling for taking a print; it can be done quite efficiently with damp paper rubbed into the engraving. When the paper dries it will be found that the impression of the engraving is firmly and permanently indented on the paper. This is probably the better method because it saves cleaning

out the engraving after using the ink, with the possibility of damage to the surface of the engraved article, especially if the article happens to be lacquered or to have any other type of prepared surface.

MORE HERALDRY PRACTICE

Here is a little more about heraldry which will give the beginner plenty of practice and at the same time teach him something useful if he becomes a high-class engraver. The various signs and decorations inside the shield are called charges (Fig. 66).

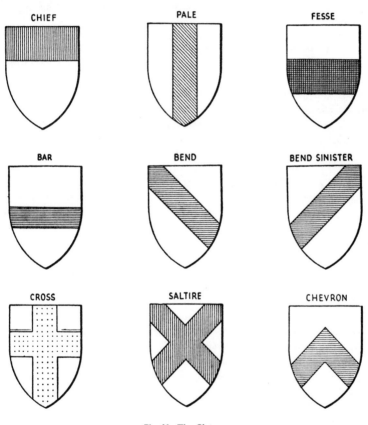

Fig. 66—The Charges.

The Chief : As already stated, this is the most honourable. It takes up one-third of the top of the shield or escutcheon. One-quarter

of its depth is called the Fillet. These may be coloured or blazoned plain.

The Fesse occupies the centre of the shield and takes up one-third of its depth. It has no diminutive and it may be coloured or blazoned plain.

The Bend is formed by two parallel lines drawn from the Dexter Chief to the Sinister Base. It may be one-third or one-fifth the width of the shield, depending on whether it is charged or uncharged. It has three diminutives, the Bendlet, which is half the width of the Bend, the Cost which is again half the Bendlet, and the Riband which is the same width as the Cost but it does not reach the edge of the shield.

The Pale is formed by two parallel lines drawn from the centre top to the bottom of the shield vertically. It is one-third of the width of the shield. It has two diminutives which are called the Pallet and the Endorse. The Pallet is half the width of the Pale and the Endorse is half the width of the Pallet. The Endorse is placed on either side of the Pale and when this is the case the Pale is said to be Endorsed.

The Bend Sinister crosses the Shield in the opposite direction to the Bend, i.e., from the Sinister Chief to the Dexter Base. It has two diminutives the Scarp and the Baton. The Scarp is half the Bend Sinister and the Baton is half the Scarp but it does not reach to the sides of the Shield, in other words it is couped. The Baton is used only to denote bastardy.

The Saltire : The Saltire is formed by two diagonal crosses or the Bend Sinister and the Bend crossing each other in the centre of the shield. It occupies one third and one fifth of the shield, depending on whether it is charged or uncharged.

The Cross is formed by two horizontal lines crossing two vertical lines in the centre of the shield. Some crosses do not reach to the end of the shield and some extend to the edge. There are so many varieties of crosses that for our purpose it is sufficient to say that they vary to a great extent and that for more detailed information recognised books on heraldry should be consulted.

The Chevron is formed by two parallel lines drawn from the Sinister and Dexter Bases and meeting at the fesse point. It occupies one-fifth shield when uncharged and one-third of the shield when charged. The Chevronel is its diminutive and it is borne in pairs.

Minor or subordinate charges : It is impossible to describe the hundreds of minor charges which may be incorporated in the shield. They range from anything to fishes, birds, snakes, animals, and so on, but more important subordinates as shown in Fig. 67 are excellent for the beginner.

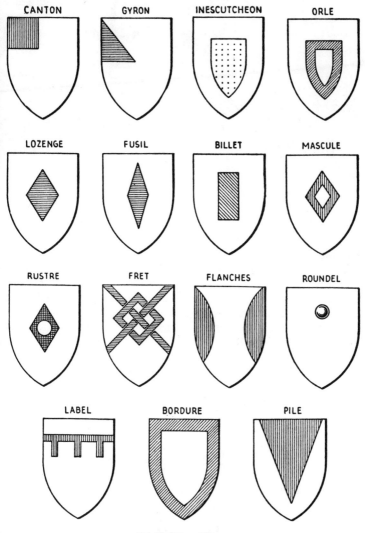

CANTON GYRON INESCUTCHEON ORLE

LOZENGE FUSIL BILLET MASCULE

RUSTRE FRET FLANCHES ROUNDEL

LABEL BORDURE PILE

Fig. 67—Minor Charges.

We now come to the Differences, which are marks placed on the Coat to distinguish between persons bearing the same arms (Fig. 68). This was essential in the days when knights were fully dressed for combat. These marks are usually placed on the Fesse point of the shield.

Fig. 68—The Differences. 1, eldest son ; 2, second son ; 3, third son ; and so on.

Having dealt with the shield and its formation as far as the engraver is concerned, there is now the Helmet to consider. This is placed above the shield to denote the rank of the person concerned.

The Helmet of the King and Princes of the Blood is of gold, having grilles and is facing to the front or affrontee. The Helmet of a Peer is silver with gold grilles and placed in profile, and that of a Baronet is of steel garnished with silver, the visor being open and placed affrontee. An Esquire's helmet is steel with the visor closed and placed in profile (Fig. 69).

Fig. 69—Helmets of : 1, the King and Princes; 2, a Peer; 3, a Baronet; and 4, an Esquire.

52

Now we come to that very important part of heraldry to the engraver —the Crest. This very abused and often distorted part of the build-up is placed on top of the helmet resting on the wreath of the Liveries, or as I have so often heard it called " a bit of rope." The wreath of the Liveries is the chief colour or metal of the coat. The Crest may issue from a type of crown, or it may rest on a chapeau or coronet. It may take various forms such as birds, animals, snakes, humans, and so on and was intended originally to identify a knight in full battle kit as there was no other way of deciding who occupied that particular suit of armour. Crests may not be worn by ladies or dignitaries of the church. Fig. 70 shows a crest in place. It is also used separately as a badge ; King Richard II's badge is also shown in Fig. 70.

Fig. 70—On the left is a crest on top of a helmet. The crest rests on a wreath and is also used separately, and usually with the wreath, as a badge. The badge on the right belonged to King Richard II.

Having now assembled the shield, its charges, helmet and crest, there is the mantling. This is the decorative part outside the shield and may take any form. It represents the mantle which has been badly torn in battle and it is fastened to the helmet so that it falls to the shoulders. Finally there remain the Supporters which are figures which are placed on either side of the shield as if on guard. They may be in any form such as birds and animals, mermaids, griffiths, and so on. They are often borne in pairs but this is not essential as may be seen in the Royal Arms with its Unicorn and Lion. Complete coats of arms are shown in Fig. 71.

Fig. 71—Two coats of arms. That on the left has Supporters and that on the right has mantling.

The motto is not an essential part of the Arms in English heraldry and in fact is not included in the grant. In Scotland a motto is included in the patent. The Scots always have their motto placed in a compartment or ribbon above the Crest and not below it like the English.

ENGRAVING THE SCRIPT ALPHABET

By S. Wolpert

THE alphabet was invented by many men. Slowly and gradually the forms were changed by craftsmen who learned from other craftsmen who preceded them. The development of the alphabet has been recognised as one of the great achievements of the human mind.

There are many forms of the alphabet in all languages. The Roman capitals are the source of the letters which we use at the present day. Lower-case letters came along after the capitals were used, perhaps centuries later. Their forms are a simpler and speedier rendering of the capital letter. The sloping of the letter came about naturally, from the tendency to write faster.

The slope of the letters of the round hand alphabet is about 50 to 60 degrees. The round hand letters are commonly known as script, which is an imitation of handwriting.

In practising the drawing of script letters, guide lines (Fig. 72) should be used so that all the letters will be drawn at the same angle of 60 degrees. Draw lightly, using very little pressure, so that you can make corrections if necessary. Use a hard lead pencil (4H) and you will encounter no trouble in drawing over it with a softer pencil.

Fig. 72—Guide lines at 60 degrees.

The basic forms of script lettering should be known to all students learning to engrave. The likenesses of the basic strokes and their dependence upon each other should be readily understood by a study of the step-by-step rules (Fig. 73).

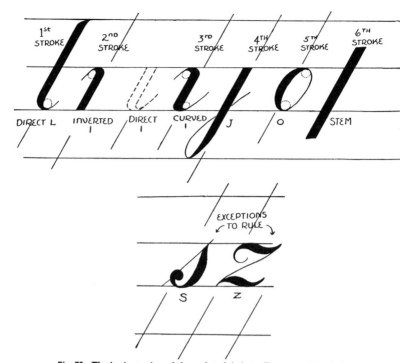

Fig. 73—The basic strokes of the script alphabet. Two exceptions below.

We shall begin our lessons in drawing lower-case script letters by taking first the letter *l*, using guide lines drawn at an angle of 60 degrees. Take particular notice of the turn at the bottom of the *l*. When a knowledge of the stroke at the bottom of this letter has been acquired one has learned the turn of all the other lower-case letters in the alphabet.

Take notice that three of the principal strokes form perfect letters, such as *l*, *j*. and *o*. These three letters by themselves and differently joined, make up fourteen letters.

The first lesson is the direct *l*. The *d* is formed by adding the *o*. The *t* has the same shape as the *l* but is not as long. The *l* is drawn on the right side of the *o* to form the *d* (Fig. 74).

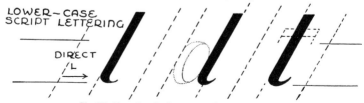

Fig. 74—Forming the lower case *l* and derivations.

56

The second stroke is the inverted *i* or the direct *i* drawn bottom upward. Both the inverted *i* and the curved *i* should be studied and drawn as carefully as the direct *i*. The beginner, by doing so, will understand more easily their dependence on each other (Fig. 75).

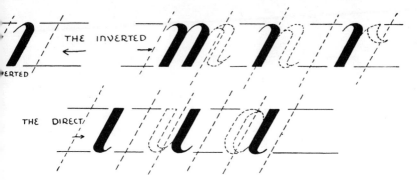

Fig. 75—The inverted *i* is the basis of a number of lower-case letters.

Take particular care to understand the meaning of the word " inverted." You will then acquire the meaning of this stroke more quickly.

The inverted *i* is the first and second stroke of the *m*, the first of the letter *n* and the first of the letter *r*.

The direct *i* is the second stroke of the *u*, the curved *i* is the first stroke. The direct *i* drawn on the right side of the *o* forms the *a*.

The third stroke is the curved *i*. This stroke includes both the direct and inverted *i*. The curved *i* is the last stroke in the *m*, *n*, *h*, *p*, and the first in the *y*, *v* and *u*. (Fig. 76).

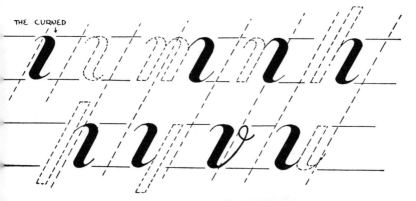

Fig. 76—Shows the curved *i* and letters derived from it.

The fourth stroke is the *j*. The *j* drawn on the right side of the *o* forms the *g*, and drawn on the right side of the curved *i* forms the *y*. The *j* surmounted with the inverted *j* forms the running *f*. The *j* inverted and protracted a little forms the straight *f* (Fig. 77).

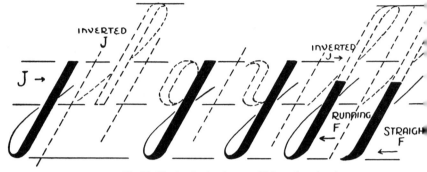

Fig. 77—The *j* and other letters which are based on it.

The fifth stroke is the *o*, which is the root form of the *a*, *c*, *d*, *e*, *g*, *q* and *x*. The *c* is made of the left side of the *o*. The *e* is also made of the left side of the *o*, with a curved hair line from the centre of the space to the top. The *x* is a combination of the two *c*'s one being direct and the other inverted, joined together (Fig. 78).

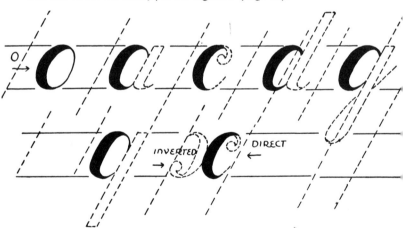

Fig. 78—The letter *o* is used in a number of other letters.

The sixth stroke is the stem. This stroke is contained in the *l*. The stem is the first stroke of the *h*, *p* and *k*. It is the second in the *q*. The *k* is made by adding the inverted *c* to the stem. The exceptions are the *s* and the *z* (Fig. 79).

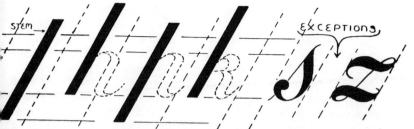

STEM EXCEPTIONS

Fig. 79—The stem, a single stroke forming the upright of a number of letters. The two exceptions to lettering rules are shown on the right.

In Fig. 80 is shown the first letter of the alphabet (capital) which represents the method of sketching. Sketching or marking out is one of the points of engraving that is overlooked or ignored by many engravers, as they consider it necessary to design a letter accurately in detail. This is an erroneous idea. The letters should be simply sketched, as shown at Fig. 71, it only being necessary to convey to the engraver's eye, by such a sketch, the general form of the letter. The exact detail of the letter can be carried out with the graver, with much more accuracy than the pencil.

Fig. 80—Sketching a capital letter before engraving.

To prove further this common error among engravers, if the occasion ever arises, examine a plate which a card engraver is about to cut and you will observe that he simply uses the guide lines and scratches lines representing the main bars of his letters on the plate at the correct angle. To one who is not familiar with this class of engraving, the sketch is so incomplete as to the exact form of the letter that it would not be intelligible to one not familiar with engraving sketches. To illustrate this point, the word " and " being easy to sketch, we show it in Fig. 81 sketched as it should be engraved. A student in engraving with any experience will readily agree that from this sketch he can more accurately make the letters than he could if he endeavoured to sketch the hair lines and all the details of the letter.

Fig. 81—Only parts of the letters need be sketched.

59

Accuracy and rapidity are required. Rapidity is gained by minimising the amount of sketching. Accuracy is gained by making lines straight down on an angle of a correct degree for the letters to be engraved. It will be seen from what we have mentioned that the sketches for all the engravings should be made by broken lines and free-hand drawing. The pencil or stylus (scriber) is held in the hand as one would hold a pen or pencil in regular writing, and the weight of the hand rests on the fourth finger or fourth and third fingers, as the artist prefers. It is the same in designing for engraving as in writing. It is not necessary that when learning to do the work the artist should hold his pencil or stylus in any particular way, it being natural for one person to hold it in an entirely different way from another. The method mentioned above is the common way, and one which should be followed if habit is not formed in other ways.

The script alphabet is the most popular style of letter engraving known, either to card engravers or jewellery engravers. We must consider each and every letter of the alphabet as to its correct formation and method of cutting.

Previous chapters have given instructions on the correct method of making a flange cut—or, as it is sometimes called, a scroll cut. The value of this will readily be seen and appreciated in the instructions to follow.

The flange cut previously referred to is the so-called capital stem or line of beauty of the script letters. This scroll-shaped stem or line of beauty is used in making many of the capital letters of the script alphabet, some of which are shaded and others not. The first thing to be considered in reference to the script alphabet is the exact proportion. As the script alphabet is an imitation of handwriting, one would naturally suppose that in engraving the scroll letters the engravers would proceed as they would write, only perfecting the letters. This is true, yet the style of the letter is somewhat different from that in which one would write. Even though a person is a good penman he must not think for a moment that his style of lettering would suffice for the engraver.

The style of script letters I personally prefer is known as the bank-note script, and which is the shade style used among card engravers (Fig. 82). We must first learn the correct angle and correct proportions of one bar or line of a letter to another. It is necessary that the student should know above all other things the correct formation of the script alphabet. It is the style that he will generally be called on to engrave and with rapidity.

The angle of the script alphabet is usually about 60°, and the relative proportion of the lower case, or small letters, to the capitals is

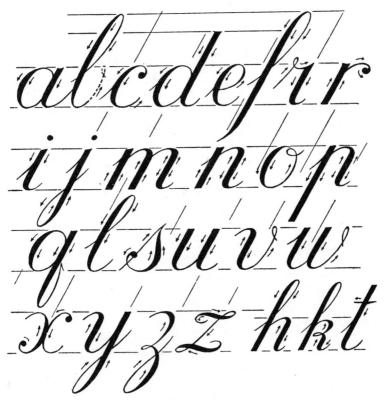

Fig. 82—An example of script lettering.

Fig. 83—The lower-case script alphabet with directions of engraving. These should be practised over and over again.

ordinarily about one-third the height of the capitals. We will use this scale as a nucleus. Variations from the style here outlined can be made at will to please the artistic eye of the advanced student, but the beginner must remember that he must strictly follow the general form of the letters to reach any degree of satisfaction.

There are three styles of script that can be used by the engraver to advantage. One style is where only such loops as are necessary are used. Another is where loops are made at all available ends or beginnings, and the other the back-hand script. It is generally conceded that a script with a forward slope is the best, therefore we shall use the slanted script as the medium for learning rather than the straight or back-hand type.

OVALS AND LOOPS

The unskilled or careless engraver will manifest his inability more in his formation of ovals and loops than in any other way. In Fig. 84 is a loop or oval, which is the general form of a loop used in script letters, showing a line drawn through the centre of the loop. The curves on the right and left, using the outside as a guide line, are exactly the same, the swell forming the shade, being all on the inside of the line at the left. This is the foundation of the error made by most students, their theory being that the point of the graver, where a shade is made, should traverse the same arc in an oval or a loop as the opposite side, which is a hair line. This is obviously wrong, as is shown in Fig. 84. In this case the loop looks flat on the right side, yet the curve on the right side is exactly the same as on the left, using the inside of the left as a guide, showing that the loop is out of true, just as much as the width of the shade, and this will be true, when applied to loops or ovals of whatever character.

Fig. 84—Wrong. Shading on both sides of left hand curve.

Fig. 85—Right. Shading on inside of line.

The student should make it a point to engrave the letters so that the loops will be concentrically formed, and he should never end a loop, other than at the end of the line opening on an arc, concentrically

62

with the outer portion of the loop. Fig. 85 illustrates the oval, cut and formed correctly. Here it will be seen that the shade is on the inside of the arc, which arc is the same on the left side as on the right side. The appearance of this is correct, which proves the theory that the shade forming the oval should be on the inside of the arc. A student of engraving should practise diligently on loops and other preliminary practice work mentioned. An engraver who is capable of engraving perfectly-formed ovals and loops will be able to engrave very accurate script.

Fig. 86 shows the left side of the oval partially shaded; it is obvious that the lower half is exactly the same curvature at the right and the left, and that the shade comes on the inside of the arc at the left, which will make a perfectly-formed loop.

Fig. 86—The part which should be shaded.

CUTTING LOWER-CASE LETTERS

We will now take up the engraving of the lower-case script letters and leave the cutting of the capitals until afterwards. Lower-case letters are easier to master. In Fig. 87 the first letter of the alphabet is shown, each stroke being cut with a graver in the direction of the arrows. Letters are started and ended at each cross line. With the previous instruction on letters, scrolls, lines of beauty, and ovals, it will not be necessary to consider each letter in the alphabet, but only the principal bars or limbs of such letters, which will enable the student to engrave the letters with an assurance of accuracy.

Fig. 87—Directions of cutting.

Fig. 88 shows the point of the graver in position to cut the left shade stroke of letter *a*. As the graver is pushed forward it is gradually turned over (i.e., rolled) to effect the proper width of shade until the graver point is nearly two-thirds of the way down from the top of the lower-case letter to the bottom.* The lower-case letters are engraved by cutting all the shade strokes that should be cut down first. Then the article being engraved is reversed, and all the strokes cut up as will be shown later.

* This is the flange cut described on page 25.

63

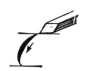

Fig. 88—First stroke of *a*.

The second stroke of the lower-case *a* is the same stroke used in many other letters in the script alphabet and is shown in Fig. 89 with the graver in position for cutting. At this point the graver is inserted by turning it over in the hand to the right to such an extent that when it is inserted in the metal it will cut a stroke the width desired. Great care should be exercised when the graver is thus inserted to hold it at the same angle and the same distance to the right from the body to make a shade the same depth and same width from the extreme beginning nearly to the end. When nearing the base guide line, the graver is gradually turned up in position to cut a V-shaped incision, and at the same time it is turned up, it is also turned around to the right to effect the proper curve at the bottom.

Fig. 89—The second stroke of *a*.

In Fig. 90 is shown the principal shade stroke of a *c* and *e*, also of an *o*, which is the same as the first down stroke of an *a*, and is cut in a like manner.

Fig. 90—Principal shade stroke of c and e

Fig. 91 illustrates the first shade stroke of an *m* or *n*. This stroke should be cut up instead of down. It is, however, often cut down by engravers who are thoroughly skilled in the art. It will be plain to anyone who tries both methods that the method of cutting up is better. The reason for this is that the stroke should be squared at the bottom and should end up at the top the same as the first down stroke of the *a* ends at the bottom, which is the gradual decrease of the shade stroke as it approaches the guide line until it reaches a fine hair line, at which

64

point the graver is thrown out. It would be impossible to cut this stroke down and produce the same effect. Therefore, the first half of the lower-case *n* and the first two strokes of the *m* are cut upwards.

Fig. 91—First shade stroke of *m* or *n*.

At B, in Fig. 92 is shown the second or last stroke (shade) of an *m* or *n*. This stroke is what is called a double cut, it being necessary to curve it to the left at the top and to the right at the bottom. It will be seen that a graver could not be wielded in such a manner as to cut the letter with any degree of accuracy with one stroke. A stroke of this form could be cut with a flat-faced graver, using it in the way that Old English lettering is cut, by rolling, but it would not be practicable to do so in this case for many reasons.

Fig. 92—The last stroke of *m* or *n*.

The lower half of the bar is cut down and the upper half cut up. At B the graver is shown ready to insert in the metal to cut the lower half, and at C in like position to cut the upper half. It will be seen here that when the graver is cutting the upper half it is inserted at the extreme left of the top of the first cut made. It is quite impossible to cut a bar of a letter with a square graver so that it will begin exactly even with the guide line. It is an easy matter to start the point of the graver so that it will be on the point of the guide line, but it is quite difficult to cut the opposite side of the shade stroke so that it will coincide exactly with the point of the beginning.

A very skilful engraver can cut a letter like the top of an *o*, *i*, *u*, or *w*, which begins parallel to the top of the guide line, so that it will appear to be parallel with the line, but it must be conceded that a bar cut in this manner would not be so sharp and deep at the point of the beginning as it ought to be, as the beginning would necessarily be from the surface of the metal down to the bottom of the incision on very much of an angle, and the slightest buffing or wearing would reduce the length of the letter to make the defect very noticeable.

65

There are many skilled engravers who never square up the top of a letter. In fact, they do not think it necessary, and say that a good engraver ought to make the cut in such a way that it would not be necessary to make an extra cut to square it up on the line. While this may be true, we must admit that if an extra cut is made to square up the top of these letters, that portion of the bar will be deeper than it otherwise would, and it will be sharper and clearer and would produce the appearance that is required in correctly-engraved script. In view of the various opinions on the subject, I would advise the student to square up the letters if they need to be squared, and if in his estimation it is not necessary to square them, not to do so. It will be found that the work will have a better appearance if it is squared up and the original appearance will last longer when subjected to wear.

Fig. 93 illustrates the top of a script letter that should end parallel to the top guide line. When cut with a square graver a little space is left at the left of the beginning of the incision, between the top of the bar and the guide line. To square up the top, insert the point of the graver where it was originally inserted and cut a little cut by pushing the graver forward in the direction as indicated at B. The point of the graver in cutting this little cut is inserted at the point of the bar marked A, and is pushed forward until the right cutting edge of the graver arrives at the point C. Thus, by making this little extra cut, the bar of the letter will be sharp and clean-cut at the top, and as deep as the remaining portion of the bar.

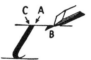

Fig. 93—Cutting the top square. The cut is shown separately at B for clarity. It is actually made from A to C.

The top of the *a*, *d*, *i*, *j*, *p*, *q*, *t*, and *u* is thus squared up, also the bottom of the *k*, *h*, *f*, and *p*. Another very important point for the student to learn in cutting script letters is the curving of the letters forming loops below the base guide lines. If the rules herein set down are strictly followed for cutting these loops a perfect loop will be made each time. In Fig. 94 the lower-case *g* is shown. This is cut the same as the *a*, except the same second stroke is continued below the base guide line forming a loop instead of turning when the guide line is reached as the *a* does. This letter is squared up in the manner previously mentioned for squaring such letters. If a dot on the base guide line is made at the point where the hair line forming the left of the loop crosses the main stroke of the letter, it will be seen

that the base guide line and the two strokes forming the loop cross at exactly the same point, as all letters should that are formed with a loop below the base guide line. The lower-case *r* and *s* are two letters that students have trouble in cutting, which is due to the fact that they do not cut the top of the hair line correctly.

Fig. 94—The lower case *g*.

Figs. 95 and 96 show an *r* and an *s*. The hair line which terminates in the shade line at the top of the guide line of the lower-case letters is cut up in the direction of the arrow. The right stroke of the letter is cut down in the manner described for cutting such strokes. The difficult part, however, in cutting this letter is the hair line, which would seem to the student to be very easy, but the average student finds it very difficult to insert the graver as it crosses the top guide line in such a way as to make this cut as it should be made. It must be borne in mind in making this cut that it imitates a loop, and if it imitates a loop it should be oval in shape ; hence the necessity of holding the graver in the hand so as to cut a V-shaped incision when making the cut. When the graver point arrives at the top guide line, the graver being held in the position necessary to cut the hair line as above mentioned, the graver is simply made to cut deeper without turning over to the right or to the left. This swells the line, as much to the left as to the right, and then, instead of breaking off the cut by lifting the graver directly up when the proper length has been reached, it is thrown out more to the front, thus ending the stroke oval-shaped instead of the shape shown at B.

Fig. 95—Similarities of *r* and *s*.

At C, Fig. 96, the *s* is shown with the graver in position to cut the shade stroke at the right. This is cut upwards as the graver indicates, but it will be seen that the stroke is not a curved stroke all the way to the top. When arriving at the point marked A the shade, or flange, stroke is converted into a hair line, and from that point to the top guide line the stroke should be made a perfect hair line, and from

that point of the letter indicated by the point of the graver around to the beginning of the letter it should also be a hair line. Here it may be well to mention that almost invariably when a beginner cuts script letters for the first time he does not sufficiently discriminate between the hair lines and the shade strokes.

Fig. 96—Cutting an s.

The natural tendency of the beginner is to turn the hand over in holding the graver so that it will make a shade stroke, and this tendency follows the beginner through his preliminary work if he is not extremely cautious. It will give him trouble when he arrives at the stage of cutting the most beautiful letters, the script alphabet. A hair line should be a hair line from beginning to end. Hair lines in script letters never vary in their width. The shade strokes should increase and decrease in their widths uniformly and a shade stroke should never be continued past a point where a hair line begins.

Another letter that gives the student some trouble is the lower-case *e*, the trouble being that he does not start to cut the loop at the top correctly. Some will begin too far down and some will begin too high. All these things should be governed by set rules. The rule in this case is to begin to cut the loop at the top at a point mid-way between the top and the base guide line, as shown in Fig. 97.

Fig. 97—The lower case e.

In Fig. 98 the down stroke of an *h*, *k*, or *f* is illustrated, with the graver in position at the bottom to make the little extra cut that is necessary to square it up. The stroke is cut downwards and it is impossible to cut it so that it will end square on the bottom guide line.

Fig. 98—Down stroke of h, k or f.

68

When engraving lower-case script letters, all the down strokes are cut first; then the plate or article being engraved is reversed and all the shade strokes cut up; then all the hair lines are cut, which finishes the letters.

FINISHED SCRIPT LETTERING

To finish a piece of lettering, particular attention must be paid to the distance from one letter to another. A separate section of this book is devoted to layout, including letter spacing. The component parts and whole letters must be correctly proportioned. The letters should flow together, each conveying its character to the eye. Measure only with your eye. Figs. 99 and 100 show the proper and uniform distance of the letters from each other and also the place at which one letter should join the other.

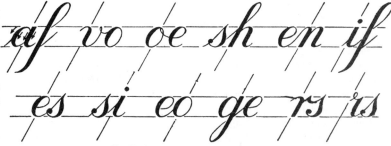

Fig. 99—Pairs of letters correctly spaced.

Fig. 100—Correct letter spacing.

LAYOUT OF SCRIPT LETTERS

In joining script letters, pay particular attention to the distance between them. They must be uniform. Train your eye to measure properly. No space should be apparent between the letters. The letters should flow together, each conveying its character to the eye to form the words. Only by diligent practice can one master the technique of the art of script letter engraving.

There is no substitute for practice in lettering. The amount of time spent in practising will depend on the individual's ability to

69

master the technique of drawing the letters. A sincere desire to learn will help greatly in reducing the practising time to a minimum. Do not let slight irregularities of line in your lettering discourage you while practising. The most important thing is the basic construction of the letters. You can master them by concentrated effort. Until one is well trained in lettering, the guide lines should be used; with practice it is possible to make good free-hand lettering by using only a base line as a guide.

CONSTRUCTION OF NUMERALS AND CAPITALS

The numbers from 1 to 10 are illustrated in Fig. 101. Observe that the six strokes used to compose the numerals are similar to the ones used in the capital script letter alphabet.

$$1 \quad 2 \quad 3 \quad 4 \quad 5 \quad 6 \quad 7 \quad 8 \quad 9 \quad 10$$

Fig. 101—The script numerals are based on the same strokes as the letters.

We will now consider the correct method of cutting the capital script letters, and in doing this we will give the correct formation of each letter and figure of the script alphabet that requires special attention. The letters, as shown, while not models of perfection, are in general information mechanically correct.

The proper method of cutting a capital stem or the line of beauty, which is shown in Figs. 102 and 103, brings forth the fact that many good engravers differ as to their construction. The line of beauty shown here is not shaded. In some cases these lines are shaded and in some they are not, the shading depending on the letter. I generally find it best to cut a hair line capital stem down instead of up, and all that are to be shaded cut up instead of down. The reason is that in letters where the line of beauty is a hair line, the top should be pointed, and it is more natural to begin a line pointed than it is to end it pointed.

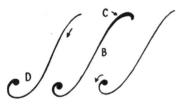

Fig. 102—An unshaded line of beauty.

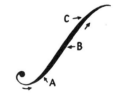

Fig. 103—A shaded line of beauty.

Fig. 102 shows at B a hair line of beauty cut upwards, illustrating the common error of shading it at the top. When the graver arrives

at the point marked C the natural tendency of the hand, as it curves around to the left at the point, would be to turn over to the right thereby forming the shade. The line of beauty that is shaded should end up pointed the same as the one that is not shaded. As it is more natural to shade the letter to the right than to the left of the capital stem, it is preferable to cut it upwards. When arriving at the point C, Fig. 103, great care should be exercised to hold the graver in such a position as to cut a perfect V-shaped incision.

At D, Fig. 102, is the capital stem or line of beauty, showing the method of finishing the end. It will be noticed that the line is severed in the middle; this is only done to illustrate the point where the two cuts should connect. The line, if a hair line, would be cut down in the direction of the arrow, which would make a hair line, care being taken not to cut too deeply.

CORRECT ROLLING

Fig. 103 illustrates the line of beauty as a capital stem. The student should remember that, in general formation, it is the exact form of a scroll. The shading of the line is one of the very important things to remember. Some engravers do not finish the line very fine at the top, as they should. The shaded line of beauty is a hair line from the beginning around to A, at which point it begins gradually to increase in width and continues to increase until the graver arrives at B, which is midway between the top and the bottom guide line. From B to C the line is gradually decreased, and at C it is brought to a perfect hair line or V-shaped incision. The beginner will find, by observing work of unskilled engravers, that a great many of them begin by shading the capital letters down too low.

Another error is to follow the exact centre line of the stroke with the graver. This is not correct as it will give uneven curves each side. The curve on the left side of the line should be exactly the same as on the right.

Referring to Fig. 103, it should be plain to the beginner that the graver point, when arriving at the point A, instead of traversing the exact form of the line of beauty, should be turned so as to curve to the left of it. Rolling the graver to the right causes the extreme edge of the right side of the incision to curve to the right, and, as the incision is decreased by rolling the graver to the upright position again, the point of the graver from B to C is gradually turned to the right, in order to arrive on the line of beauty at C.

In Figs. 104 and 105 are all the strokes of the capital script letters. Engravers use different terminology for these strokes, calling them beauty lines, shade strokes, capital stems, etc.

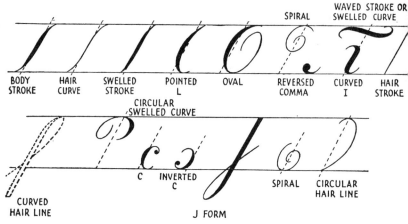

Fig. 104—The strokes of the capital letters.

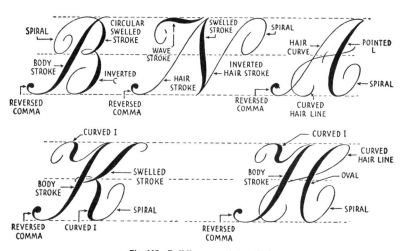

Fig. 105—Building up script capitals.

THE FORMATION OF THE SCRIPT CAPITALS

We shall now proceed with the cutting of the letters of the capital script alphabet (Fig. 105).

The capital *A* is formed by a hair-width beauty line for the first stroke on the left side of the letter. The cutting of this line has been previously described. The right side of the letter *A* meets the top of the beauty line at the top guide line. Its shape is a pointed *L* enhanced with a spiral resting on the lower guide line. This line may

be shaded or tapered width to add interest to this letter. The completion of the letter *A* consists of the third stroke or cross line over the right and left sides of the *A*. This line should be a hair line, cut downward, from right to left ending in a graceful curve not going below the lower guide line.

The main stem of the *B* differs from the *A* in that it is a shaded stroke instead of a hair line. None of these letters go above or below the guide lines. The right side of the *B* is divided into two sections, the division being slightly above the centre of the area between the guide lines. The upper section is started on the right side of the beauty stem, shaded, and crossing over the beauty stem at the top guide line and ends in a spiral opposite the beginning of this stroke. The lower section is started with the spiral which apparently ends the letter. It is a repetition of the upper section except that it ends where the upper and lower sections meet. A small hair line cut completes the middle loop at the centre of the right side of the letter *B*. The lower section of the letter *B* on the right side is extended further outward to the right from the main stem than the upper section. It gives a better feeling of balance.

The first stroke of the letter *C* is the same pointed *L* as on the right side of the letter *A*. This stroke should be shaded. The upper portion of the *C* is a large hair line loop crossing the centre of the shade stroke. This line is started at the top of the guide line on the left of the first stroke, crosses that stroke and ends upon meeting the main stem (Fig. 106).

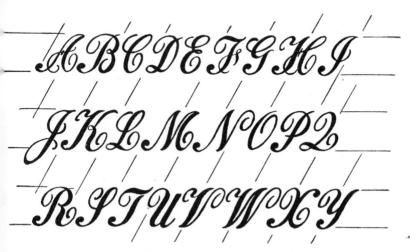

Fig. 106—The script capitals.

73

The main stem of the D is formed by a line of beauty in the same manner as the letter B. The second stroke forms the loop at the lower left side of the beauty line, starting at the main stem and curving to meet the end of the first stroke. This stroke starts out heavy and ends in a hair line. The third stroke begins where the second stroke starts but going in the opposite direction, touching the lower guide line travelling upward, with a shaded stroke, and crossing the beauty line ending in a spiral similar to the left side of the letter B.

The loops on the right side of the letter B are the same in reverse for the capital E. These loops are cut upward. The swelled curves on the right side of these loops are cut upwards the lower swelled curve beginning with a curved hair line, and the upper swelled curve terminating with a curved hair line.

The capital F is formed by a line of beauty and the waved stroke. The waved stroke is cut exactly the same as the beauty stem except that it is a hair line, terminating on the left in a spiral. In other words, the waved stroke is a curved hair line. The letter is topped by a shaded pointed L stroke parallel to the top guide line.

The capital G is a combination of two formations of letters—the top of the C for the upper part and the beauty stem of the F for the lower part. The line of beauty is cut and formed exactly the same as any line of beauty, except that it is shorter, coming slightly above the centre guide line.

MANY STYLES OF 'H'

The capital H is engraved in many styles. The portion changing the styles is the top of the line of beauty, being cut in two strokes. This loop will come down nearly to the centre guide line. It will be seen that the shade stroke at the right of the line of beauty is nearly parallel to the line, and if a letter is made in this way it is more likely to be correct. Most beginners form the line of beauty in too much of a scroll shape, making it impossible to cut the stroke on the right parallel to it. A point may be given here to the beginner that will be of benefit to him in cutting the letter. That is, to make the line of beauty of an H straighter than any other line of beauty in the script capitals. Great care should be exercised not to make the line too straight. The loop at the right at the top is formed by the hair line crossing the two main strokes of the H midway between the bottom and the top of the letter. The loop at the right, the same as all other small loops in the script capitals, is cut up nearly to the lower-case guide line.

The capital I is formed simply by the line of beauty on the correct angle of $60°$ with the stroke at the left, which is cut down and crosses the line of beauty on the centre guide line.

The capital \mathcal{J} is, in general formation, the same as the I, except that a loop is formed at the base of the letter and that this loop protrudes below the line one and a half times the height of the lower-case letters. The loop at the left of the line of beauty forming the top stroke should come down to the top of the lower-case guide line.

The first half of the capital K is formed in the same way as the capital H. The upper half of the right portion of the letter is a hair line only. The lower half of the right portion of the letter is a double cut which was thoroughly described in a previous chapter as applied to the lower-case n and m. The little loop at the right centre of the capital stem is formed midway between the top and the bottom of the letter. The loop at the lower right of the letter is not made quite as high as the loops in other letters. The reason for this will be plainly seen if the student will try cutting both ways. Some engravers cut the loop nearly to the centre guide line the same as a like loop in the capital H, but, generally speaking, it is made smaller than such loops in other letters.

BASE LINES

The capital L is formed by a line of beauty, the stroke at the left being cut down and crossing the capital stem at the centre, and the base line is cut by cutting from the line of beauty to the left and the end of the loop beginning again at the line of beauty and cutting to the right. If this method is used to make a cut midway between where the line crosses the line of beauty and the end of the loop it will not matter. This base line of the capital L is rather difficult to cut without making the line appear to curve downward too much. This is avoided by carrying the point of the graver upward to counterbalance the curving downward of the stroke, the graver being turned over to the right to make the shaded stroke.

Engravers do not agree as to the method of cutting the capital M, but I believe that the best way to cut the letter is to cut all the strokes except the right stroke of the loop downwards. The object of cutting them down is that the top of the letter should be pointed, and, as previously stated, it is easier to make an artistic point of such a letter by cutting down instead of up. The perfect capital M would be so outlined as to make the first hair line and the first shade stroke, and the second hair line and the second shade stroke nearly an equal distance apart, although, of course, there will be a variation in cutting these lines.

In cutting the letter N it will be seen that the two hair lines, which are nearly of the form of the line of beauty, are made almost parallel to each other, and the main shade stroke is nearly perpendicular.

In forming the capital *O* I have shortened the length of the loop forming the middle or right portion of the letter, and have thrown the highest point of the letter over to the right to counterbalance the diminishing of the loop.

TYPES OF LOOP

The capital *P* is formed the same as like portions of a capital *B*, except that the loop at the right of the line of beauty crosses the main stem. Even this is not true in some cases. Some prefer to have the loop curved slightly upward at the right of the line of beauty. This is a matter that the artist should decide for himself. The point of meeting of such loop and the line of beauty should be nearly midway between the top and the bottom of the letter.

Forming the capital *Q*, the loop at the top comes down to the middle guide line. The stroke at the base of the letter is cut over where it crosses the main stroke of the letter to the end of the loop at the left, and from the beginning of such cut to the right at the end of the loop at the right, which terminates a hair line. This loop in other words, is cut the same as the base of the capital *L*, except that the loop at the left of the main line is fuller than the loop of the *L*. It matters not if this loop is begun where the shade begins to appear on the right, making it all one stroke, and then finishing it up from such beginning to the end of the loop by cutting in the opposite direction.

I have mentioned with reference to forming loops with the square graver that it is preferable to cut all curves to the left and if the student will bear in mind this valuable point all through his engraving he will find that he will never be troubled to know how or in which direction to cut a loop.

The first half of the *R* is formed the same as the *B*, and the lower half of the letter is formed the same as the *K*.

The capital *S* is a difficult letter to cut, yet a very simple letter in its formation. The loop at the top, protruding over to the right without any loop at the base to counterbalance it, confuses the student in designing or even cutting it. A good practice to ensure getting this line of beauty on the correct angle is to design the loop on an angle of about 10° higher than any other line of beauty, which will be sufficient to counterbalance the optical illusion.

The capital *T* is formed the same as the capital *F*, except that it is not crossed.

The first main stroke of the capital *U* is a double cut, the upper half being cut upward and the lower half downward. The loop at the left of this stroke is cut the same as the like loop in the capitals *R*, *P*, or *B*. The second stroke of the capital *U* is cut downward, and is the same width from beginning to end, and is squared up at the top when necessary.

CAPITALS V AND W

The capital *V* is formed by cutting a small shaded line with a hair line to the right, increasing in its distance from the main stroke gradually as it is engraved upward. The upper left portion of the letter is cut the same as a like portion of the capital *K*.

The *W* is formed the same as the two *V's* placed together, with the absence of the upper left portion of the letter in the case of the second *V*. Great care should be taken to make the hair lines of the *W* parallel to one another, the same as the main shade strokes.

The capital *X* is simply a series of loops, all of which are cut by curving to the left, remembering to throw the graver out at the bottom and top of all loops.

The capital *Y* is made by cutting the stroke to the left down to the centre guide line. The first main stroke of the letter is a double cut. The top of this stroke should come either to the top guide line or slightly below it.

Capital *Z* is made by forming the main stroke of the letter a hair line of beauty, the top and bottom shade strokes being cut and formed the same as the like stroke in the capital *L*.

The correct *&* and all figures belonging to the script alphabet are made two-thirds of the height of the capitals.

The top loop of the *2* can be brought downward to the centre of the line midway between the top and the bottom.

The loop in the middle of the *3* can be formed directly above the centre line.

The loop at the lower left of the figure *4* should be brought down nearly to the lower-case guide line. The line crossing the main stroke of the *4* crosses it one-fourth of the distance from the base to the top guide line.

The meeting of the first loop of the *5* and the hair line running from same to the top is made half-way between the top and the bottom of the line.

The lower loop of the *6* comes half-way to the top of the figure. The widest part of the shade stroke should be midway between top and bottom of the figure.

The top of the 9 should come down to the centre guide line. Both to the right and left of the figure *0* should be shaded equally.

These suggestions as to the correct formation of the perfectly plain script alphabet should be followed accurately until the student has become familiar with the forms of the letters, and with a little practice he will be able to cut the letters on these strict mechanical lines without any particular reference to the rules here laid down.

ENGRAVING LOOPED SCRIPT
AND MONOGRAMS

By S. Wolpert

THERE are a great many styles of script letters and a great many
different methods of cutting them, but the style here given is a
perfectly plain one, and is used largely in the art of engraving.
It forms the basis for more elaborate letters. After having mastered
the simpler form of capital script lettering the student will find the
others comparatively easy to draw and engrave.

The general construction of the script letters is the same in all
different styles of forming and engraving them. Looped script has
the characteristic of having the scrolled beginning and ending of each
letter. The angle of the looped script can be on the regular angle of
60° or perpendicular or back hand. As the looped script style is the
kind that forms the basis for ciphers or script monograms, it is necessary
that the student thoroughly masters the plain looped script letters.

I advise a plain, accurate foundation of the letters. Discretion must
be used in the matter of using the loops. There are a great many
little cuts, scrolls and curves that might be used which will add to the
beauty of the letter, yet it is my opinion that the alphabet shown in Fig.
107 contains the most simple and artistic formations of the looped script.

It will be noticed in the letter A the first loop of the letter is at
more of an angle than the second loop, which is due to the fact that
the first stroke of the letter is at a greater angle than the second stroke,
or shade stroke. This is made necessary as the letter is pointed at
the top.

In the capital B the loop at the top should be shorter than in the
regular alphabet to allow for the loop at the end of the line of beauty.
The loop at the top of the line of beauty should be very delicate and
very accurately made. The remaining portion of the letter in its
general formation is the same as in the plain script alphabet.

It will be seen in the capital C that the general formation is the same
as the regular formation of the C, except for the smaller loop within
the loop at the top, and that the loop at the base of the line curves a
little more.

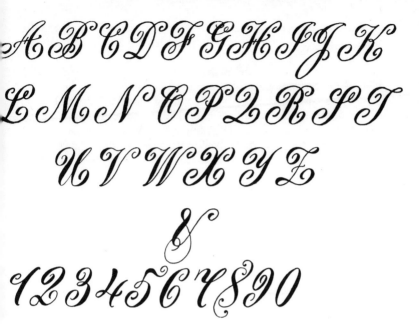

Fig. 107—The looped script alphabet and numerals.

In the capital *D* the loop at the bottom can be, but not necessarily, fuller than in the plain alphabet, and the loop at the top can be curved around a little further, and also the line of beauty can curve around at the top the same in the *B*.

The looped capital *E* is the same as the plain *E*, with the exception of an inner loop at the top, and also a little extra line that curves around the top loop, and the lower loop curves upward further than in the plain script.

In the capital *F* it will be noticed that at the top the line of beauty connects with the stroke crossing the top and forms the loop. The line of beauty curves around and forms a loop at the bottom and another loop within it, then continuing across the line of beauty exactly in the centre to form still another loop.

The capital *G* differs in formation from the plain letter only in the loop within the top loop, and in the line at the upper left portion of the letter curving over the main shade line at the top ; also in the loop at the bottom of the line of beauty.

Capital *H* can be made in a great many different ways. The style here shown is probably the most common. The first half of the letter varies only from the plain script letter in the loop being at the end of

the line of beauty, the second half of the letter forming the loop terminating within itself at the top, and having an extra line to cross the two bars.

There can be no change in the capital *I* with the exception of the loop at the bottom, and a slight continuation of the loop forming the top of the latter. It must be remembered that the lines of beauty in this alphabet can be curved more than in the plain script. This is also true of the capital *J*. The capital *J*, however, in back hand and perpendicular script, is made exactly the same as the *I* shown here.

The looped style of the *K* varies from the regular style of the script only in the loop at the end of the line of beauty and an extra loop at the top, and a slight continuation of the loop at the bottom.

The *L* changes very little, simply having a loop within the loop at the top, and the line in the upper left portion of the letter continuing over the line of beauty instead of stopping slightly at the left of it.

The capital *M* is the same in general construction as the plain M with the exception of the loop, which in this case should come up to the line drawn half-way between the top and the bottom guide lines. It will also be noticed that the top of this letter curves a little more than in the plain style of letters.

The looped *N* has a loop at the top and at the bottom, otherwise it is generally constructed the same with possibly the exception of a slight shade near the top and near the bottom of the two hair lines to enhance the beauty of the letter and fill in or balance the loops.

The general character of the capital *O* is such that it is difficult to make any change in it. The only change that can be made consistently is a continuation of the beginning and the ending of the line forming it.

The capital *P* line of beauty continues around to the right and forms a very delicate loop; also the regular style of a loop at the end of the line of beauty at the bottom and a slight continuation of the loop at the top.

There is no change in the style of the *Q* except a slight increase in the loop.

The capital *R* loop at the top is slightly shorter than in the plain style and, with the addition of the loop at the bottom and the top of the line of beauty, and a slight continuation of the loop in the lower right portions of the letter, it is the same style as the plain letter.

The capital *S* is made the same as the plain style, with the exception of the inner loop at the top and the main loop at the bottom, and a slight curve in around to the right in the line of beauty and in the left portion of the letter.

The *T* differs in its construction the same as the *F*, with the exception of the crossing of the *F*.

The capital *U* can be changed by making a loop at the top of the second main stroke of the letter, instead of beginning it square on top as the top of a *D* or *T*.

The capital *V* simply has the additional loop at the top at the right portion of the letter and a slight increase in the loop in the left portion of the letter.

The *W*, being practically the same in general construction as the *V*, has only the same changes. These letters, however, can be curved more than in the regular style of script.

There is no radical change that can be made in the *X*, with the exception of elaborating the loops if possible and advisable.

The looped *Y* is made the same as in the plain script alphabet, except for the loop at the end of the line of beauty.

There is no change that can be made in the *Z*, except in elaborating the loops.

The correct *&* is made the same in general construction, with the exception of a slight continuation of the loops.

THE NUMERALS

It will be seen in the numerals that the curves run to the right at the bottom, and that the hair line forming the top has a slight loop at the end.

In the case of the *2* the loop is increased a little at the top and at the bottom. There is also an extra loop at the lower left portion of the figure at the bottom.

In the *3* there is a loop in the centre and a full loop at the bottom and at the top.

The *4* is practically the same with the exception of the down stroke curving around to the right as in the figure *1*.

The figure *5* has a loop in the centre and at the top. The remaining portion of the figure is the same as the plain figures.

The *6* is practically the same as the plain *6*, except that there is more of a loop at the top.

The *7* differs only in its main stroke, the same as figures *1* and *4*, with a loop at the top.

It is equally difficult to make any change in the *8*, unless the lines are broken or severed at the top and at the bottom, as here shown, in which case they can curve around as the case may require.

The *9* simply has an extra loop at the bottom.

The *0* cannot be changed as the letter, by virtue of its shape, gives no opportunity for making loops.

In Fig 108 we show the looped script style of letters forming the initials *B*, *G*, *H*, made backhand. It is impractical to make the plain

script letters backhand artistically. In Fig. 109 the name " Rose "
is shown engraved perpendicularly, using the looped capital *R* made
back-hand, it being necessary in this case to change the loop at the
lower right portion of the letter, allowing it to drop below the guide
line. It will be noticed that there is no change in the lower-case
letters, with possibly the exception that the letters are more the style
of the round-hand script.

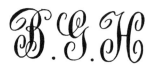

Fig. 108

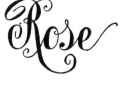

Fig. 109

Fig. 110 illustrates the name " Roseline," the capital of which is
formed from the looped style of the script. Many pieces of silver
that come to the engraver to be engraved are best laid out by making
the word run up at an angle. Fig. 111 illustrates the name " Florence,"
running down at an angle, with a few scrolls above and below and at
the end of the word. The scrolls are not necessary, but they can
sometimes fill in the space advantageously. This style of script
is known as the round-hand style. The method of cutting the letter
running down on an angle, as here illustrated, is exactly the same
for cutting the regular script, with the exception of squaring up the
top of the *i*, *t*, *u*, *d*, etc., and the bottom of the *m*, *n*, *h*, *k*, in which case
the squaring up is done from the opposite direction. In the case of
the bottom of the *n* in the word " Florence," the graver should be
inserted at the lower right portion of the base of the first down
stroke of *n*, in order to square it up ; whereas, in the case of the
regular script, it would be placed at the lower left corner.

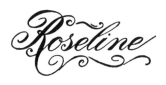

Fig. 110

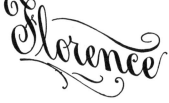

Fig. 111

In Fig. 112 is shown the vertical script of the looped style, and in
Fig. 113 the backhand script of the same style, showing the student

82

that the looped style of the script is appropriate for either vertical or back-hand style.

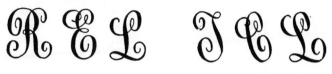

Fig. 112 Fig. 113

TRANSFER PAD

It is necessary to digress a moment to explain the use of the transfer pad for taking impressions of engraving in order to duplicate them. Rub powdered whiting into the cuts of the engraving to be copied, and wipe off the surplus. Press the engraving down on the transfer pad, remove it, and you will have the form of the engraving where the whiting was deposited. Daub a film of tallow on the piece that is to be engraved, and press it down on the transfer pad, over the whiting design. This will imprint the design on the piece. Several impressions can be made from each whiting transfer.

This method of transferring a design on to another piece of metal is more practical for lettering than an ornamental design.

Transfer pads can usually be bought ready-made from the material supply houses. If, however, your dealer does not have any in stock, you may make one by following this method. Get some printers' roller gelatine from a local jobbing printer or from a supply house. Heat water in a kettle to boiling point. Set a can containing the gelatine in the kettle and leave it there until it melts. Pour the melted gelatine into a tin box, forming a cake of about 3 by 6 in., $\frac{1}{2}$ in. thick. The transfer pad is the cake of gelatine. When cool, it may be taken from the box and is ready for use.

DESIGNING AND ENGRAVING MONOGRAMS

Monograms can be engraved either bright cut or fine line, the style depending on the article to be engraved. If a monogram is to be engraved on a polished area, teaspoon, or any sterling silver article highly polished, it is advisable either to cut fine lines with an unpolished graver or a line graver, or to cut it in the style of bright cut with an unpolished graver. Some skilled engravers have been criticised for engraving with an unpolished graver on polished metals, the criticism being that the cuts are ragged, and the critic believing that the skill of the engraver is manifested in his ability to cut a bright cut. Of course, that is an erroneous idea. The reason an unpolished

83

graver is used on a polished surface is to produce a contrast between the surface of the metal and the lines cut.

It has been mentioned that the stone used for sharpening a graver should not be a coarse one. The graver should be finished on a very hard Arkansas stone, as a coarse stone would leave it in too rough a condition to cut smoothly. I do not mean when I say an incision should be cut with an unpolished graver that the cuts should be necessarily ragged and rough, but that a deadened appearance should be produced—clean, but not bright or polished. Fine-line engraving or threading, such as that employed in fine-line Old English, is the most beautiful of all styles of engraving and perhaps requires as much skill to execute as any other. In cutting fine lines the graver should always be unpolished ; it matters not where or on what the lines are cut.

Some engravers use a polished graver for cutting fine-line monograms on a deadened surface. This, generally speaking, is unwise, as a satin surface or French grey finished article could be engraved with a bright-cut monogram, and if a bright-cut monogram was not wanted there are other styles of outlined monograms, described later, that could be used.

In cutting monograms, the all-important feature to be borne in mind is that the loops of the letters should not be made so close together that they appear crowded. Whenever a loop is made so that it comes near to another loop, it is advisable to stretch it a little more and make it hook into the loop. A monogram should be so formed that the space occupied by it is nearly uniformly filled in with the bars or loops of the letters. (Fig. 114.) One often sees a beautifully cut monogram crowded in some spaces and too open in others.

One point of advice to be followed by the student is to cross all vertical lines with loops as nearly as possible at right angles, always endeavouring to avoid crowding and never forming one loop to run exactly parallel to another. This does not mean that all capital stems and lines of beauty of letters should *not* be parallel to one another or perpendicular. It is necessary in some cases to have bars of letters running parallel to each other, even though they are close together. This would be the case if there were a *V* for the first letter and an *A* for the second, when it is impossible to avoid lines running parallel to one another. It is also advisable to avoid curling one loop inside another, although in exceptional cases (such as in Fig. 120) it may be entirely successful.

Beginners are sometimes confused by the apparent complexity of monograms. They get lost in their design, and fail to see the individual letter. It is a difficult matter for a beginner to see the letter separately

84

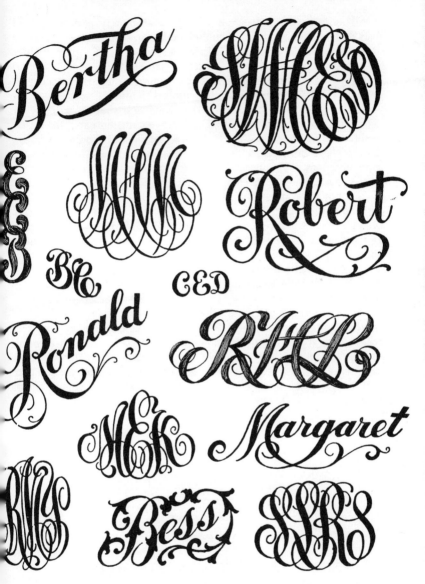

Fig. 114

and then see the entire monogram at the same time. While studying and working on a single letter, one must consider and observe its relation to the monogram as a whole.

All loops in the monogram should be absolutely perfect, and all bars and limbs of the letter should be perfect in their angle or whatever form they may be made in. It is just as easy to make a perfect letter in a monogram as it is to perfect letters separately.

It is possible for a skilled engraver to visualise the letters in monogram form from the moment they are mentioned to him.

In designing a monogram the engraver should work very deliberately and carefully. Designing monograms on paper for a trial before placing them on the article is advisable and should always be done by beginners. Sketching should be done free-hand in broken and very fine lines. This leaves an opportunity for one to make changes as the combination nears completion.

It is not more difficult to design a round monogram than it is one in a square, or any other shape. In Fig. 115 is illustrated a circle with a vertical and three horizontal lines. To engrave a plain monogram in a circular disc, take the dividers and allow one point to rest against the edge of the plate and the other to protrude over the plate to such a distance as it is desired to engrave the monogram from the edge. Make a circle by drawing the dividers around the disc. The vertical line is drawn across the centre of the disc. Then the horizontal line is drawn across the centre, and other lines are drawn above and below the horizontal line as shown in Fig. 115. Now, assuming that the reader has at this point learned how to design a straightforward monogram, flat on the top and bottom and nearly square, it will be an easy matter to place it in the circle as here shown, between the top and bottom horizontal lines. The first and the last letters should be as near the form of the circle as possible.

Fig. 115

To make the monogram as nearly round as possible, all that it is necessary to do is to change the design above the top horizontal line and below the lowest one—that is, to change and drop the centre letter, or such portions of it as can be changed down below the bottom line, and to raise it, or such portions of it as can be raised, above the top line.

To explain this point more thoroughly, illustrated in Fig. 116 is a monogram of the initials " T.R.S." designed with a flat top and a flat base. The dotted line indicates how, after making a design in this way, the loops are simply dropped down to make the monogram nearly round.

Fig. 116

It is often necessary to engrave a monogram oblong. In such case the engraver must make the letters long and slim, and his loops oblong instead of rounded. By doing so he will find it no more difficult to make the oblong monogram than the square or rounded one, except that it is necessary to make the letters closer together, inasmuch as the proximity of the letters requires the highest degree of accuracy, there being no room for any irregularities or variations of the letters.

It is often necessary to engrave monograms in the bottom of oblong trays. An example of a style used is shown in Fig. 117. First draw an oval on the bottom of the tray ; then make the monogram in what might be called rounding script, with the letters drawn out to fill the space within the oval as nearly as possible.

Fig. 117

There are many forms of monograms engraved in the same general style, and the general rules in reference to their construction are the same.

A monogram with the top tipped in is very desirable for some spaces. However, it is not necessary that a student in engraving should make these different forms of monograms. The monograms illustrated are the principal styles used and will suffice in all ordinary cases, bearing in mind that the flourishes employed only enhance the simple form of the letter. They should at no time be employed unless they definitely add value to the letter.

No two engravers design letters in the same manner. A personal element of charm enters into their construction of a monogram. When a perfect idea of the capital script letter is well fixed in one's mind, the beginner may use as many ornamental strokes as he likes as long as he never allows a letter to depend upon a flourish. Accent the main stems at all times.

All examples illustrated here should be studied for their basic conceptions and should not be copied with too much devotion. The beginner should consider the principles of form, balance, and construction which underlie them, then develop an individual style rather than copy and imitate that of others.

To impress the fact that script monograms should be drawn and engraved so that the layman will have no difficulty in reading them, I must again emphasise that the *main stems* (body lines) of monogram lettering *must always be drawn simply*, so that the completed monogram will be easy to read. The main stems must be accented to give them prominence, and never be outclassed by flourishes. The eye must see the body lines of the letter first, and not the extra added lines. Study Figs. 118 to 124 closely for a better understanding of these basic facts.

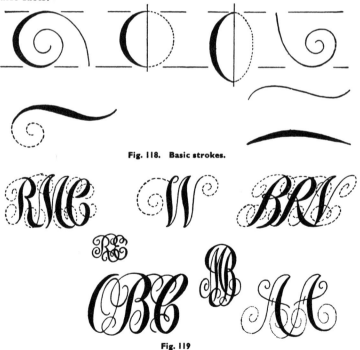

Fig. 118. Basic strokes.

Fig. 119

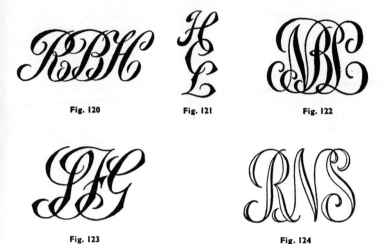

Fig. 120 Fig. 121 Fig. 122

Fig. 123 Fig. 124

In Figs. 125 and 126 are shown two hearts, showing different ways in which initials may be engraved. A few little scrolls above and below the letters are sometimes added for those who like more florid effects. In Figs. 127 to 129 are three monograms suitable for circular spaces, such as, for example, round lockets.

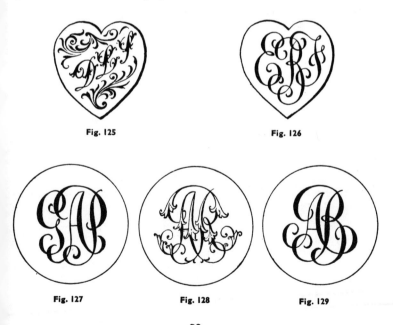

Fig. 125 Fig. 126

Fig. 127 Fig. 128 Fig. 129

The exact diameter of an inscription is a matter that has attracted the attention of a great many beginners in engraving. Some labour under the impression that in engraving a monogram on a circular plate, for example, the monogram should be made as large as can be placed on the plate. ·A customer might prefer to have a very small monogram or inscription right in the middle of the plate, which is his right, being the owner of the plate.

Several styles of engraving for spoon and fork handles are shown in Figs. 130 to 133. The most difficult feature in designing a word on a spoon handle is to sketch it so that the word appears to be in the centre of the space allotted to it. This is accomplished when engraving a spoon handle by first drawing a centre line along the length of the spoon handle. Now, whether or not this line should be exactly at the top of the lower-case letters or slightly below depends altogether upon the number of letters coming above the lower-case guide line.

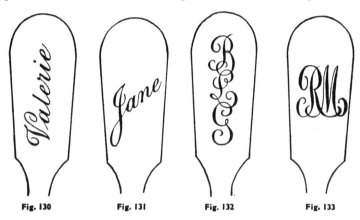

Fig. 130 Fig. 131 Fig. 132 Fig. 133

In the case of the name in Fig. 130, " Valerie," there are two letters coming above the lower-case guide line. It is therefore necessary that this centre guide line should be the top guide line of the lower-case letters. On the other hand, if there were some letters coming above the line and others below it, these conditions would be changed to such an extent that it would be necessary for the centre line to pass through the top of the letters about one-fourth the distance from the top of the lower-case guide line. A beautifully engraved letter or word not properly placed on a spoon handle or fork handle is more irritating to an artistic eye than one properly located of the right size if not so well engraved. Therefore, the beginner is especially cautioned in regard to this, and advised to practise this particular point diligently.

In Figs. 132 and 133 are handles of spoons or forks with the initials

90

" B.L.G." and " R.M." engraved on them, showing how the letters should be designed for such a space. The student should endeavour to educate his eye to arrange the style of letters and shape to correspond as far as possible with the style of the article to be engraved.

In Fig. 134 is the name " Florence " suitably laid out for a small article such as a pin tray. In such a case the engraver must first find the centre of the dish and then decide on the correct size for the letters. If they are engraved too large and are not appropriately graded for the size, or are too small and perhaps too heavily shaded, they will look wrong. Careful study of a design after it has been sketched on an article will determine whether it is the right size or not. Very often beginners sketch the design on the article and then study only the accuracy of the letters. As previously stated, while the accuracy of the letters is the principal point, yet we must give due consideration to the size and proportion of the letters and their relation to the space allotted to the word.

Florence

Fig. 134—A simple script name.

ENGRAVING SCRIPT INSCRIPTIONS

Scrolls such as those in Fig. 135 can sometimes be used to advantage with script words and initials in engraving ornamental script. I am not, however, in favour of engraving words and initials very fancifully. Simplicity and accuracy should be the aim of all engravers. Great care should be taken to avoid elaborating the space around the letters to detract attention from the words or initials, bearing in mind at all times that the initial or word should stand out boldly and that whatever ornamental work is done should be executed so delicately that it will appear to be in the background.

Fig. 135—Ornamental scrolls.

Of all the different classes of work with which the engraver has to deal, that of engraving an inscription on a circular plate is the most difficult. This is because words must be given different prominence according to the significance of each word.

When an inscription is written out by the customer it should be rewritten by the engraver, putting certain words on the lines as they best fit to balance in a circle, and at the same time be grammatically correct. One may be very skilled with the graver, and yet be unable to cut an inscription with the necessary accuracy. After the inscription has been rewritten and arranged in lines, as it is proposed to engrave it, allowing for the principal name or names to be engraved in slightly larger letters, the next step is to find the centre of the inscription. If, for example, there are eight lines, the second line being larger than any of the others, being the principal name of the party or parties mentioned in the inscription, the first four lines would occupy more space than the four lines to follow, and such allowance for space must be given in spacing the inscription on a piece of paper. Draw a circle and then a horizontal and a vertical line through it. Write the inscription in this space, enlarging the name or names to the extent called for. When such words as " of the," " by the," " is," " and," " of," " for," or any prepositions, conjunctions or connecting words occur, they may be engraved in smaller letters. In spacing, a much smaller line should be allowed for such words than for the principal words or names.

After the inscription has been written in the circle, the engraver can form an idea of how it will appear when finished. He can also find the centre of the inscription and lay it out on the plate accordingly.

The circular plate should be cemented to a piece of brass or wood. The cement is heated on the block and the plate is warmed slightly and pressed on to the cement. If it is desired to rush the work, the block and plate can be plunged into cold water, which will cool it very quickly. It is dried thoroughly and covered with transfer wax. The wax is not rubbed on to the plate, but applied by patting with the finger, which has been pressed on the wax. Sufficient wax will stick to the finger to cover the plate. The patting gives it a deadened appearance.

Horizontal and vertical lines are drawn with a pointed orange stick to find the centre of the circular plate, and having previously found the centre of the inscription by the method described, next dot little marks on the vertical line above the centre of the horizontal line, each dot indicating the space allotted to each line. Then draw guide lines parallel to the horizontal line across the circular plate.

Having found the location of the principal name of the inscription, the all-important point now is to decide on the size of the letters. The

size is decided in the mind of the engraver at the moment when he places the rule to draw the second guide for the lower-case letters. This is the time when all his skill and judgment should be brought into account, as if the line is made too large or too small the inscription is spoiled.

Some engravers space by letters, some by words. If the words are short it is safe to space by words. Spacing by words means making small dots to indicate the gaps between successive words. If the beginner finds it necessary, it is not objectionable to space by letters—allowing, of course, more space for the capital letters and then allowing space for the letters according to the size of each, the letter *i* requiring less space than *m*, and so on.

Having spaced the lines, hold the plate at a distance of 14 to 15 in. in front of the eyes and study the appearance of it before it is cut. Letters which are too large or small are obliterated by patting the index finger over the words and doing them over again, and if any change is necessary great care should be taken to avoid crowding the letters or allowing more than the proper space for the letters or words. The distance between the letters—that is, lower-case letters—at the beginning of the line should be maintained throughout the line. A common fault with beginners is to begin the words by drawing the letters out, and to finish by crowding the letters.

AVOID RUBBING OUT

If the words appear to the engraver to be accurate, he then begins to engrave from the left, taking care to avoid rubbing out. There is no more danger of erasing a sketch in cutting from the left to the right than from right to left, and it is more natural to work forwards.

Begin at the left of the line and cut the first capital complete. Then cut all the down strokes in the first word. Reverse the article and cut all the shade strokes that should be cut up. Cutting the shade strokes up, going backwards, is done by beginning at the right and cutting back to the left. Arriving at the capital letter again, go over the word the third and last time, and cut up all the hair lines and all the cross lines, such as the top of an *r*. The second word and the third and so on are engraved similarly throughout the line. A great many engravers prefer, in work of this kind, to cut all the down strokes first throughout the line, then all the up strokes and then the hair lines, but it is perhaps more advisable to cut one word only at a time when such words begin with capitals. Where a line begins with a lower-case letter and is composed of lower-case letters throughout, the spacing being very accurate, all the shade strokes throughout the line should be cut first.

After the principal name has been engraved, then the words " presented to " or " awarded to," or any forms preceding the principal name, should be engraved in a size smaller, but otherwise harmonising with the first name engraved. Then the second line should be engraved, and if there is a preposition or conjunction or other connecting word between the third and second lines, it should be engraved after the third line has been cut. The space between the second and third lines should be a very little more than is necessary, as it can be filled in by the preposition or conjunction, such words being engraved so small that they can often fit in well over the lower-case letters. Lines following are engraved in order. The engraver should be very particular to engrave the last line, which is usually the date, in exactly the same size letters as the words " presented to," or whatever the first words of the inscription may be.

If an inscription is of the style where the article is presented to a person in honour of any event or for heroic performance of duty, the sentence in reference to such incident should be engraved in exactly the same size and style of letter.

BLOCK, ROMAN AND OLD ENGLISH LETTERS

By S. Wolpert

B LOCK letters are used considerably by jewellery engravers, and the public has accepted them. They are easily read, which accounts for their popularity, and are not hard to cut (Fig. 136).

A B C D E F G H I J K L M N O P Q R

S T U V W X Y Z

a b c d e f g h i j k l m n o p q r s t u v w x y z

Fig. 136—A sans serif alphabet, commonly called block letters.

Next in importance to the accurate formation of letters is the correct spacing of the letters in words. By correct spacing is meant the placing of letters at such distances apart as to give the appearance of equal spacing between all letters, without unduly large white areas.

More space is required between two letters both of which have straight sides than between two letters one of which has a straight side and one a round side. Less space is required between two letters with rounded sides, as OO or DO, than is required in either of the preceding cases. The space at the bottom between the two capital letters AL should be small so that the space between them at the top will be reduced to the minimum. The capital letters AW have parallel sides, consequently considerable space is required between them. The letters that cause the most trouble in spacing are A, W, V, X and Y, as, unless good judgment is used, their slanting sides produce unequal white spaces. Letters with projecting strokes as F, J, L, and T, are difficult at times to combine with other letters. The letters that are most easily spaced are those with straight sides as H, B, N, D, etc.

There is no way to space letters by mathematical measurement. Therefore they must be strictly measured by the eye. As an example, try spacing the letters of the word WILT, Fig. 137, using a fixed measured distance between the extremities of each and then spacing them by eye.

WILT
WILT

Fig. 137—The word " WILT " evenly spaced above and visibly spaced below.

When drawing Gothic, Roman, or Block letters, take care to make the vertical lines perfectly upright. To do this freehand is very difficult. Therefore, draw guide lines, very lightly. Bear in mind that the guide lines are only for guiding your vertical strokes and are not to be part of the letter.

PROPORTIONS OF THE BLOCK LETTERS

Block letters and figures should be made five times higher than the width of one bar, except A, I, L, M, and W, and the numerals 1 and 4. The bar of a letter is one complete stroke of the letter. It may be horizontal or vertical. The letter E is composed of four bars. The letter I is composed of one.

The width of the bar is determined by the engraver. When using a scorper or line tool for cutting, the width of the bar corresponds to the width of the graver. See Fig. 138 for a clearer understanding.

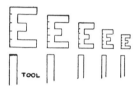

Fig. 138—Width of the graver determines the width of the block letter. A good proportion for the height is five times the width.

BASIC EXERCISES FOR CUTTING BLOCK LETTERS

The sides of flat gravers are, when purchased, usually rough, which causes additional friction when being forced through the metal. It is, therefore, advisable for the engraver to whet the sides down flat and smooth, thereby reducing the friction to a minimum. Having the graver in perfect condition, proceed with some of the exercises necessary to properly begin cutting block letters. In Fig. 139 are shown the perpendicular, horizontal and angular bars from which block letters are made. In cutting these bars, the graver should be pushed downward on an angle of about 45° and then lowered to the proper angle at which it will move forward. This angle will be about 20°. The object of inserting the graver at about 45° and then dropping it down to about 20° is to make the end of the cut as steep as possible.

96

For the same reason the graver should be " thrown out " when completing the cut. See Fig. 140, representing a cross-section of the plate being engraved. *A* shows the incision properly begun and properly ended, and *B* is the beginning of a line made by inserting the graver at an angle of less than 45°. A line cut in this way would produce a very undesirable appearance if the work were to be enamelled ; in engraving for reproduction, the ink would rub out.

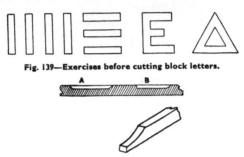

Fig. 139—Exercises before cutting block letters.

Fig. 140—Proper incision in section is shown in A. At B the beginning and end incision are uneven. Below is shown one type of flat graver or square scorper that can be used for block lettering.

Therefore bars should, for general appearance in bright cut work, begin and end as nearly as possible on the same incline. Of course, it is impossible to end a cut on an incline. As the graver is thrown out, it is naturally raised upward to break off the chip, and this leaves the cut about as perpendicular as is practicable. So the beginning can be improved by cutting back in the opposite direction.

After sufficient practice in cutting vertical lines, they should then be cut horizontally, changing the length gradually. Start at the top of a short line and gradually increase the length until it is more than double. The depth of these incisions is a hard matter for an instructor to tell a student. Articles engraved with block letters are usually engraved just deep enough to look well. The engraver can tell very easily when he is cutting too deeply, as his work will be very rough. It is well to advise the beginner to cut as shallow an incision as he can, and to keep both points of the graver* in the metal.

In Fig. 141 is the first letter of the block alphabet. It shows the two bars forming the angles of the first letter. The angles of these bars should be about 65°. The cross bar should cross midway between the extreme point of a letter and the base. The letter is shown with the bars lapping and crossing one another as they would be cut with the flat graver. This illustration shows that they are not in line with

* In engraving shops in the U.S.A., a square scorper is often used. In the U.K., a modified lozenge graver is more common. See Fig. 8.

the base guide line and that the top is neither properly pointed or flat. This is a difficult letter to cut properly. It matters little whether the bars are cut up or down. The condition of the bars on the base line can easily be remedied by making an extra cut with the right corner of the flat graver, which is shown also in Fig. 141. In correcting the right bar of this letter, the cut in question is made into the bar of the letter. And when correcting the left bar it is made similarly, in the direction shown by the point of the cut. If it is desired to make the top of the letter flat, another triangular shaped incision is made with a flat-faced graver by cutting in the direction of the " arrow " shown at the top of the letter ; the right corner of the graver being the one inserted.

There are methods of avoiding this cut in the top of the letter, as shown in Fig. 142. If the letter is small a top point can be obtained by cutting directly downward with a square graver, which would make a different shaped incision, the general outlines of which would represent a pyramid. If the letter is large, either the right or the left bar of the letter can be pointed by rolling or turning the graver to the right or the left, the direction depending upon which bar is being cut (Fig. 142). For the sake of explicitness, assume that the last bar to be cut is that on the right. Gradually roll the graver over on to the right point, which will gradually lift the left point out of the metal, and bring the top of the letter square. It diminishes the width of the incision as well as making it deeper on the right than on the left, but unless the letter is very large this will scarcely be noticeable.

Fig. 141—Cutting the block letter A. On the left the letter is as left by the graver. On the right it has been squared off by extra cuts.

Fig. 142—Pointed and squared tops. The squared top on the right is obtained by rolling the graver when cutting the right hand bar.

Fig. 143—Cutting the crossbar.

98

In cutting the crossbar shown in Fig. 143 it matters not in which direction the graver is pushed, as the obstacles are equal on each side. If the graver is carelessly inserted the letter will be badly marred, the cross bar cutting into the uprights as indicated by the dotted lines. This is avoided by starting the graver tilted up at one corner, and as it is pushed forward it is gradually turned over, which will increase the width of the incision. This increase must be such that the angle of the start of the cut will be equal to the angle of the right bar of the letter, so that the line of the beginning of this bar will be apparently parallel to the inner line of the letter. When arriving at that point where the bar should be the maximum width, the graver should be flat and is held in this position until the original point of the graver arrives at the left bar of the letter. It is then gradually raised up. The operation, thus explained, may appear difficult; but it is an easy matter to cut a letter in this way very accurately. Other bars of the block alphabet and other cuts which can be handled in this manner and will not need further mention.

In drawing block letters, it is advisable to divide the height of the letters into five equal parts (see Fig. 138) and make the width as follows; all the letters and figures except I, M, and W, and the figure 1 should be four such parts in width; M being five parts, W seven parts, I and 1 one part. These parts referred to are the little squares indicated in the background of the alphabet shown in Fig. 144. The thickness of all the line should be one part. The distance between any two lines should be one space, except when A follows P or F; when V, W, or Y follow L; when J follows F, P, T, V, W, or Y; when T and A or A and V, W, or Y, are side by side. In these cases the bottom of the A, J, or L and the top of the other letter should be on the same vertical line.

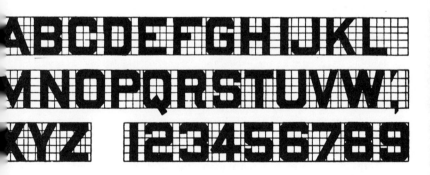

Fig. 144—Block letters drawn on a grid, a simple method for those whose lettering is not good.

99

METHODS OF CUTTING BLOCK LETTERS

There are many different methods of cutting block letters. One is to make a bright cut, as already described the parts of the graver in contact with the job having been well polished ; another is to cut the letters in the same manner but with the graver as it comes from the Arkansas stone. A graver in this condition will make a dull cut and produce a contrast between a bright surface and the engraved lines. Another method is to wriggle the letters, and still another is to use a line graver.

Fig. 145 shows the block letter B which, with the exception of the letter S, has more octagonal corners than any other letter in the alphabet.

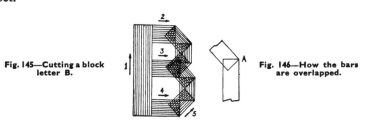

Fig. 145—Cutting a block letter B.

Fig. 146—How the bars are overlapped.

First cut the bar marked 1 in the direction of the arrow ; next cut the bar 2 in the direction of the arrow. Great care should be exercised in seeing that all the metal is cut out and that the bar 2 begins exactly on the left side of the bar 1. Next cut the bar 3 in the direction of the arrow and then the bar 4. We now have a perfect E, and to convert the letter into a B it is necessary to cut the remaining portion of the letter as shown in the figure. Begin at the bar indicated by the figure 5 and cut up to the turn, where the graver is thrown out ; cut the next bar up to the next turn in the same way, then the third one joining the centre bar 3. The top of the letter is cut the same way as the bottom. It will be noticed here that each bar overlaps the bar of the letter formerly cut. Great care should be exercised in over-lapping such bars as otherwise the corners would be open instead of being pointed.

The over-lapping is illustrated more clearly in Fig. 146. When cutting the upper bar the right hand point of the graver should be placed in the corner marked *A*. If the right point starts exactly on the right hand corner of last stroke, the corners are sharp and accurately made.

Another great difficulty in this work is to cut various bars the same depth, and also to avoid damaging the work by " backing up " the graver when inserting it. It is difficult to over-lap cuts and not cut one angle a little deeper, or apparently a little deeper, than the other ;

but great care will enable one to cut the letters with such accuracy that there will appear to be the same depth.

The method of squaring up the top of the W or of a V, the bottom of an R, of a 7, a top and bottom of an X or a Y, are the same as described for such work on the first letter of the alphabet.

Referring to Fig. 144, it will be seen that the letters are drawn strictly on mechanical lines, and the rules governing the general formation of these letters are given so that the student may thoroughly familirize himself with their formation. In actual work it would not be practical for the engraver to use horizontal and perpendicular guide lines to form the little squares mentioned, but a knowledge of them in his practice work and some actual practice in drawing accurate mechanical forms on paper is conducive to a high degree of accuracy. After he has educated his eye, it will only be necessary to use the top and base guide lines. In die cutting, where extreme accuracy in spacing and forming the letters is required, artists use the perpendicular guide lines, not for spacing but to get the perpendiculars of the letters accurate.

Wriggling block letters is done with a flat graver previously described, as shown in Fig. 147. The graver is rocked from one corner to another and gently pushed forward in the process of wriggling. The angle at which the graver is held and the amount of pressure forward determines the degree of fineness of the wriggling. The use of the block letters, wriggled, is very common in cheap work. Sometimes letters are wriggled by making the horizontal bars fine and the perpendicular bars coarse (Fig. 148).

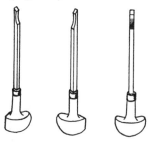

Fig. 147—The positions of the graver when wriggling.

METHOD OF SHADING BLOCK LETTERS

Many errors are made in shading letters with a flat graver. When a letter is to be shaded, the incline of the incision should be against the letter. The point is illustrated in Fig. 149, where B represents the plate; C, the wriggled bar of the letter; D, the incision; and A, the graver. Here the graver is cutting the incision so that it inclines

101

toward the letter. This point should be remembered in all cases of shading letters of whatsoever size or style. Fine monograms, well cut, are not infrequently spoiled by being shaded away from the letter instead of towards it as described and the heightening effect from an artistic standpoint is lost. Fig. 150 shows a letter F bright cut, i.e., with a polished graver so that the cut is bright or polished. The letter H in Fig. 151 is as it would be cut by a flat graver as it comes from the oil stone, thus making a ragged incision. The shading on the letter F is done by single cuts with a square graver. In other words, the shading is made by running a fine hair line along the right hand sides and undersides of the bars of the letter.

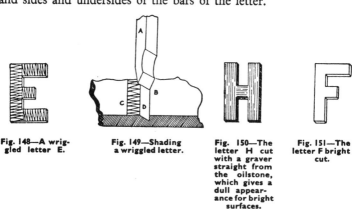

Fig. 148—A wriggled letter E.

Fig. 149—Shading a wriggled letter.

Fig. 150—The letter H cut with a graver straight from the oilstone, which gives a dull appearance for bright surfaces.

Fig. 151—The letter F bright cut.

Lined letters can be cut with a line graver which when purchased has a series of grooves on the underside. After one of these has been sharpened in the same way as a flat graver, it can be used for cutting block letters in the same way. The liner cuts a number of parallel fine lines. Each line could be cut with a square graver separately, which makes it a more expensive piece of work. The line graver should be ground on an angle on the front somewhat less than the regular angle of the graver, as the extreme points of the grooves on the inside of the graver, which produce the incision lines, are so delicate that a more obtuse angle is needed on the front of the graver in order to ensure the points do not break off. The fine line shaded on the right and underside of the letter H in Fig. 151 were done by cutting in towards the letter with the liner.

GOTHIC LETTERS

Another form of block letter, sometimes called Gothic, is shown in Fig. 152 and is commonly cut with a round-faced graver. It will be noticed that the circular portions of the letters, as in C or in O or in D,

the corners are not octagonal shaped, and for this reason they can be cut with a round-faced graver with one steady cut from the beginning of the letter to the end or from the beginning to the end of an arc of a letter. These letters are useful where the block formed letters previously mentioned are not. The letters can be made very attractive by polishing the round-faced graver and cutting the letters bright. Another method practised by some engravers is to wriggle a very small portion of the letter in the centre on all the perpendicular bars, leaving the remaining portion of the letters bright-cut, an effect that is appreciated in certain classes of work.

ABCDEFGHIJKL&
MNOPQRSTUVW
XYZ abcdefghij!
mnopqrstuvwx
yz

Fig. 152—The Gothic alphabet, another form of block letter.

THICK AND THIN

Thick and thin letters differ from block letters in form and construction. Whereas the block letters are of one thickness throughout, these letters use strokes of two different widths. They are adapted well to the use of the engravers' tools, but are not beautiful to everybody. They can be used especially when fast service is required, as they can be cut very quickly. Fig. 153 gives some examples. The form of the remaining letters is easy to arrive at.

Fig. 153—Thick and thin lettering.

103

RAISED BLOCK LETTERS

" Raised " block letters have their uses in inscriptions and monograms. They are shaded block letters and the formation of the letters is difficult and must be executed slowly and carefully. When engraving raised block letters, one must outline them first with a point tool, and then cut the shaded line with a flat, bright cutting graver. Fig. 154 gives some examples.

Fig. 154—" Raised " block lettering.

HOW TO ENGRAVE ROMAN LETTERS

Roman letters are a little difficult to engrave. Because of this fact and as a credit to himself, it is therefore the duty of the skilled engraver to be a master of this style of lettering. It is a class of lettering that can be used in connection with general jewellery and silverware and many other types of engraving to the advantage of the engraver, and to the satisfaction of the owner of the article engraved.

The most useful place for the Roman lettering is in engraved inscriptions. Words connecting lines, such as prepositions and conjunctions, should normally be cut in this style of letter, because if cut in script they would occupy too much space vertically, and if cut in block letters they would be too prominent for the space occupied. The Roman letter occupies a small space and has a delicate and neat appearance. It can be bright or dull cut. Both types of cut have their uses.

In Fig. 155 we have the upper portion of the letters R or P and a complete B, the perpendicular bars or all bars of the letters, where they are the same from the beginning to the end, being cut with the corner of a flat-faced graver. That portion of the bar shown in Fig. 155 and indicated by the letter *A*, is cut either with a flat-faced graver that cuts the perpendicular strokes or it can be cut with a square graver (see Fig. 8). Cutting a swelled line, such as that at *C*, with the corner of a flat-faced graver or a square graver, the student should know, from what has been mentioned previously that the lines should all be cut by rolling the graver. In starting a hair line, the left corner of the graver is used, and as the tool is pushed forward it is gradually twisted

104

to increase the width of the incision as it is required, the diminishing line being produced by rolling the graver back, in the opposite direction. When the graver is thrown out at the point indicated by the letter *E*, the flat-faced graver can be exchanged for the square graver, and the line continued to the end with a square graver, or the cut may be continued with the flat-faced graver if the engraver prefers it.

Fig. 155—Cutting Roman serifs.

Fig. 156—Serifs are cut the same way at the base of letters.

Referring to Fig. 156 the same stroke is shown but with the bar swelled at the bottom to give the Roman type of serif. The little strokes indicated by the letters *C* are cut with the square graver in the direction of the arrows. The graver should be skilfully wielded so that the underside of the graver will not chip the top line. There is a great danger of doing this and thereby widening the stroke in that particular place, producing a very ugly appearance. It will be seen that these little cuts, one only on each side, should curve very slightly. Letters can be cut without curving the strips if so desired, but the curved serifs are the true Roman style.

Good work of any sort cannot be executed in a hurry. Good lettering and layout are no exception to this rule, but this does not imply that the beginner should not try to develop speed in conjunction with proficiency, because some commercial work may have to be done within a time limit, according to the value of the work to be done.

The quality of the work produced depends on many things but primarily on the skill of the craftsman. Originality of layout and fine engraving are important elements. And it is needless to say that good tools, perfectly sharpened, are essential to producing good work.

OLD ENGLISH LETTERS

Old English letters are formed of strokes and fine lines at various angles. A number of styles have evolved through the years. Flat or line gravers may be used (or square gravers modified to scorpers), the width of the tools depending upon the height of the letters ; the higher the letter, the wider the graver.

When engraving Old English letters, it is imperative to do the bars first and the squares and curves last. To begin, use guide lines as

shown in Fig. 157. It is wise for the student to hold the work to be engraved firmly in front of him, to avoid any slanting of the letters. Any stroke that should be engraved vertically is more difficult to make exactly right than one at an angle owing to the fact that a slight variation from vertical is more noticeable.

Fig. 157—Guide lines for old English letters.

Achieving the correct spacing between Old English letters is found quite difficult by some engravers owing to the fact that they do not begin the letter to the right of one just finished accurately. If the hair line protruding downward or upward from the main bar of a lower-case letter is drawn first, setting it as close to the preceding similar line as is advisable, and making the particular bar according to the location of this hair line, the work is easy to do. The most valuable advice that can be given the beginner in reference to sketching Old English, apart from keeping the work directly in front of him, is to remember to make the perpendicular main bars of the letter first, the angular bars next, and then add the connecting hair lines.

Remember that flat-faced gravers (square scorpers) should not be inclined to one side or the other when making a smooth, straight cut ; they must be absolutely flat on their bellies. Different widths must be used for different sized letters, as in block lettering.

METHOD OF CUTTING OLD ENGLISH LETTERING

Fig. 158 illustrates the proportion of Old English lower-case letters to the capitals ; the capital has twice the space of the lower-case letter, a proportion that can be used in a great many places, but if space is limited it is preferable to make the lower-case letter two-thirds the height of the capital, as shown in Fig. 159.

Fig. 158—Capital twice the height of lower case letters.

Fig. 159—Capital a third higher than lower case letters.

106

It will not be necessary to show by illustration, or to give instructions how to cut all the different bars of the Old English alphabet, as there are only a limited number of bars in the entire alphabet, many of them being exactly the same, as shown in Fig. 160. Therefore mention of a few of the principal bars will suffice for the beginner to cut the entire alphabet. The main bar of a great many capitals is cut by placing a flat-bottom graver so that it cuts with the left point (see Fig. 161). As the graver is pushed forward to cut at the angle indicated, it is gradually turned over to the right. The vertical stroke is continued with both

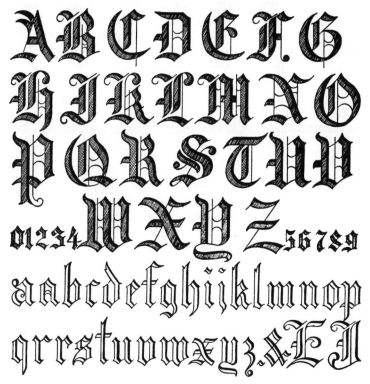

Fig. 160—An old English alphabet.

Fig. 161—A common bar of many old English letters.

107

corners of the graver in the metal and an equal distance from the surface until the graver arrives at the top of the bar where it is rolled over on its right corner and the handle swung to the left, which throws the graver out, leaving the bar pointed at the top and slightly curving to the right in a direction opposite to that at the start.

Fig. 162 shows the graver in position to cut the little bar protruding from the main bar of a number of the letters. It would be easier to make this cut by beginning at the pointed end and cutting in, but that is not done in this case because when the graver arrives at the main bar of the letter, the tendency would be for it to slide into the incision and damage it. For this reason the graver is placed in position as shown and pushed forward in the direction of the arrow. As it is pushed forward, it is gradually turned up on the left corner and the handle away from the operator.

Fig. 162—Cutting a small bar.

Fig. 164—Lapping angular and vertical bars.

Fig. 163 Cutting a tapered curve bar.

In Fig. 163 a similar bar of a letter is shown. It is used in most of the capital letters either at the top or at the bottom. The flat-faced graver is used as indicated being pushed forward in the direction of the arrow. When the graver arrives at the end of the line the left point of the graver should come even with the surface of the metal, thereby making the ending of the bar exactly the same width as the graver.

Fig. 164 illustrates the principal of lapping angular and vertical bars of the lower-case Old English letters. Angular bars are wider than vertical ones by about one-third, a proportion that gives an artistic letter. The lower point of the angular bar comes directly in the centre of the vertical bar and the cutting edge of the graver just crossing the upper left corner of the vertical bar. This bar of the letter should be cut on an angle of 45°, and when cutting the angular bar the left corner of the graver should be placed directly in the centre of the vertical one and with the cutting edge of the graver covering the upper right corner of the vertical bar.

The length of the vertical portion of lower-case letters should be about twice the length of the angular portion. In Fig. 165 the angular bars are the same width as the vertical ones in one letter and wider in

the other, which shows that the slight increase of width of the angular bars looks better. In Fig. 166 the vertical portions of the letter have been reduced in length until it is about the same as the angular portion.

Fig. 165—Angular bars wider than vertical (left), and angular bars the same size as vertical (right.)

Fig. 166—Short vertical stroke.

Fig. 167 illustrates a cut used extensively in capital Old English letters, which is known as the roll cut or flange cut*. The term roll cut is applied to it because the bar is made by beginning on the right corner of the flat-faced graver, as shown in Fig. 167, the graver being pushed forward and gradually turned so as to increase the width of the incision until it arrives at the point indicated by B, where the graver should be flat with both corners held into the metal. At A it is gradually turned to the right and tipped up on the opposite corner. The old style of making this stroke was to make a straight bar with a flat-faced graver and then a pointed cut at each end. This method necessitated three strokes, while in this case it can be done complete with one, and much more rapidly.

Fig. 167—A roll or flange cut.

In cutting a letter of the kind shown in Fig. 168, the graver is inserted at the extreme point of the main bar of the letter indicated by the letter A. As it is pushed forward and curved around sufficiently to make the proper curve, it is gradually rolled as explained to swell the stroke and diminish it again. The main centre bar of the letter is as shown in Fig. 161, with the exception that the beginning and

* In high class work the threaded cut is still used. See page 113.

ending of the letter is not as pointed. The top of the C, it will be observed, is an inverted stroke, as shown in Fig. 163, and the method of cutting it is the same. These cuts are the principal ones embodied in bright-cut Old English letters, and anyone familiar with block letters and such cuts as we have mentioned will find little trouble in cutting any letter of the alphabet. One reason for beginners being discouraged when they start Old English is that the letters are so complicated in appearance that they fear they will not be able to cut them properly. Actually the letters are simple, being composed of vertical and angular bars connected with straight lines, which make them easy letters to master.

Fig. 168—Details of cutting an old English capital C

Old English letters, bright-cut, are usually used on Roman gold finish, aluminum or Britannia metal goods, satin finish, and even sterling silver satin finished. The higher class of Old English is known in card engraving as solid old English. In cutting this class of letter, the method is exactly the same as described, except that the graver is left in the condition that it comes from the oilstone—not polished— thereby making the cut dull, and suitable for polished surfaces.

Fig. 169 illustrates a bar of several of the old English capital letters, which is cut in the direction of the arrows. It is specially illustrated because many beginners cut it in the opposite direction.

Fig. 169—Detail of a bar occurring in capitals.

110

Fig. 170—One way of proportioning capitals and lower case letters.

The word " Roe " in Fig. 170 is arranged to show the proportions of the letters which are divided into eight equal spaces, the capital occupying eight and the lower-case letters four ; the angular bars of the lower-case letters one space and the perpendicular bars two. If it is desired to increase the height of the lower-case letters, five spaces should be used, and if still higher, six. It is better, however, to make the lower-case letters either one-half or five-eights the height of the capitals.

One of the styles of cutting old English letters used extensively on plated ware, is that of wriggled Old English. The method of wriggling has been previously described (see page 101). The flat-faced graver is rocked from side to side and rolled slightly at the same time which causes it to advance along the cut. Fig. 171 illustrates one of the principal bars of the lower-case letters, showing how the vertical bars are coarse wriggled with one width of graver and the angular bars wriggled finer with another, graver about one-third wider. The width of the wriggling is increased and diminished by the angle at which the graver is held. The higher up the graver is held and the less rocking to the right and the left, the finer the wriggling.

Fig. 171 also shows, from the top of the bar down to the point indicated by the letter B, shading with a flat-faced graver. The method of shading, allowing the angle of the incision to incline toward the bar of the letter, has been previously described (page 102).

Fig. 171—A wriggled old English letter.

Fig. 172—Wriggling of a point.

111

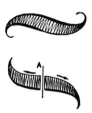

Fig. 173 Wriggling a swelled line from one end to the other (top), and from the centre in each direction (bottom).

One of the bars of Old English letters is shown wriggled in Fig. 172. The method of wriggling such a bar is difficult to describe yet it is an easy thing to do. Place the graver in position for regular wriggling and as the graver is pushed forward and rocked, swing the handle round. Just how much to pull the graver toward the operator and just how much to push it forward is the secret of doing this work with accuracy. The graver must not be turned or its position changed; it should be facing the same direction when it is thrown out at the bottom of the line as when it was first inserted in the metal. A line with a double point as in Fig. 173 can be wriggled in one operation, but when it is the centre of a letter S it is normally better to make two cuts in opposite directions starting from the middle as shown.

CHAPTER 7

CHOICE OF LETTERING
AND LAYOUT STYLES

By A. Brittain

IN the previous chapters, the design of various styles of lettering was dealt with at some length. The engraving methods described apply to all styles of lettering. In this it is proposed to describe the difference between British and American styles without going into engraving techniques again. Before referring to design, however, it should be noted that all the cuts described were made by the square or flat-faced graver (square scorper) by "rolling" or making a flange cut, as illustrated in Fig. 38, page 25 and Fig. 40. It must not be forgotten, however, that the best lettering is not done in this way but by threading, as shown also in Fig. 40. Samples of the two styles are given below (Fig. 174). Although threading takes longer to do, it is definitely superior in appearance, because the swelled part of the strokes are better controlled, and in wearing qualities. Threaded letters will still look cleanly cut after a considerable amount of metal has been worn from the surface and long after flange cut letters would have become ragged or disappeared altogether.

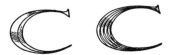

Fig. 174—Appearance of a flange cut (left) and a threaded cut (right).

For threaded lettering, the square or lozenge shaped graver (see Fig. 18) should be used. The method is as described for heightening on page 40.

British and American styles differ especially with regard to the formation of monograms and other styles of entwined letters. The monogram is the one form of lettering which is subject to the designer's own particular taste and, provided that the letters are formed in a well-balanced and symetrical manner, the results may properly be termed a monogram.

113

The American style of monogram is inclined to be rather Victorian in treatment. This, from the point of view of practice, is a good thing, but I should say that the British student would treat it as such because such styles are now out of favour in this country.

Lettering in general is the most difficult part of engraving because of the almost mathematically correct formation of letters required. It is easy to imagine the horror of, say, block lettering with the letter spacing very irregular and the strokes leaning all over the place. To do lettering correctly and with a reasonable speed, because we still have to earn a living, calls for constant practice until one is able to draw in the required lettering without the aid of the guide lines indicating the angles of the strokes and the spacing between the letters. These guide lines are a very good idea for the beginner but they must be treated with caution as they are inclined to become a bad habit and the student may find it very difficult to execute the lettering at a later date without the assistance of the lines.

Apprentices in London engraving shops do not touch a graver for at least six months and only then are they permitted to handle one for the sake of relieving the boredom of perpetual sketching. An apprentice is taught to dismember each letter so that he could readily assemble or even design a letter without reference to a copybook. Some of the old engravers never started their apprentices on engraving from the beginning, but first taught them three alphabets—Roman, Script and Old English—by making them draw the letters in copybooks in pencil.

The eye is the best guide to perfect lettering because some letters are formed in such a manner as to cause an optical illusion. For example, the letters " O " and " S " should always be mathematically larger in order that they may appear to be the correct size. Also, letters with points such as capital " A " should extend slightly above the lines (see Fig. 175).

Fig. 175—Letters made slightly larger in order to appear the correct size to the eye.

ART AND ILLUSION

All pictorial art depends on illusion and lettering is no exception. The spacing between letters in a word and between words in a sentence must be uneven in order to appear even to the eye. Some letters must

114

be engraved larger or smaller than others to appear to be the same size. The engraver who works *only* mathematically to rule is a mechanic, not an artist.

Many styles of lettering are used in engraving, the principal ones being Roman, italic, block, script, Old English, Gothic, antique script. These styles have already been fully described so there is no need for me to go over the ground again. My personal preference on almost any article is for a mixed style. I consider that any one set style, unless it is a facsimile of a person's handwriting, becomes monotonous, but a mixture of, say, old style or antique script and Roman lettering looks good and breaks the monotony. At the same time it is useful for emphasising any particular line of engraving, such as the name of the donor or recipient. An example is shown in Fig. 176.

To

ANDREW THOMPSON

in appreciation of an outstanding record of
Loyal and Efficient Service
throughout 54 years with the

Fig. 176—A print taken from an actual engraving on silver.

The main part of the inscription may be carried out in antique script and the main lines in Roman lettering. The antique script looks especially good when an inscription is engraved underneath a Coat of Arms ; it blends very well.

I do not propose to talk about any forms of fancy lettering or so-called ultra-modern styles because in point of fact there are none. The so-called fancy lettering or ultra-modern styles are merely distortions of the beautiful lettering designed many years ago, which, in my opinion, cannot be improved in any way. We often get a new fashion in lettering, which is nothing more than a distortion of the true lettering but fortunately this does not last long enough to be given a name, except perhaps by the engraver who is called upon to carry out the work !

In the planning of a lengthy inscription, care should be taken to space the words and lines so that the letters do not appear to run into each other and so that the lines are not too close together. In

fact, good balance is the key to a good inscription. The whole should be a little above centre on the plate or article in order that it may look central, again defeating our enemy the optical illusion.

HARMONY AND SPEED

When engraving an inscription one should aim at neatness, compactness and harmony of type. Please remember that the inscription is there for purpose other than an engraver's amusement or reward. It is there to be read, so all fancy lines and curls should be avoided at all costs. I am always suspicious of any fancy work on an inscription because it makes me feel that it is put there to hide some defect in the general work, perhaps a slip with the graver, a misspelt word which has been partly erased and covered with a fancy line and then balanced up on the other side or maybe just to camouflage plain bad engraving. Anyhow, it is bad form.

The style of lettering to be used is nearly always governed by the article to be engraved, the engraving matter and the customer's particular taste. For example, a memorial plate should always be engraved in Trajan Roman lettering as described in the next chapter ; this, in my opinion, is the most beautiful lettering of all. An antique mug looks good when engraved in antique script. A plain silver cup calls for a mixture of blocks and lower case if it is for sports, Trajan Roman for horse-racing, and a mixture of Trajan Roman and antique script if for a flower show. These are merely my taste for such articles and events ; you may have other ideas, but please do not mix plain blocks with Roman lettering, as they clash.

Look again at Fig. 176 for good example of mixed styles Roman and antique script. Other styles favoured by British customers and engravers are shown in Fig. 177, and at the end of the book is a special section containing many more examples.

It is not usually an advantage for a beginner to sketch a word to be centred in a certain space by starting at the first letter. Almost invariably, the word ends without enough space so that the letters are cramped, or with too much so that there is too much white space. The simplest method to centre a word is to mark a centre line in the space to be filled, find the centre of the word, and work from the middle letter in each direction. It may seem an unnatural way of going about this task but it is practical and sure until the engraver's skill is such that he can judge the centring of a word so well that he can start from the first letter (Fig. 177). Some final adjustment in spacing may be necessary, of course, because of the varying widths of the letters. Commercial engravers almost invariably start from the beginning of a word or sentence and can judge its placing exactly.

116

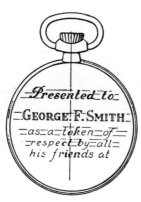

Fig. 177—Laying out letter by starting from the line.

For a cigarette-case, the most suitable and personal inscription is certainly a facsimile of the donor's own handwriting. After all, lettering was invented for the purpose of conveying a message in writing from one person or persons to another or others, and it was intended that a pen or other instrument should be used for that purpose. It was also intended that the message should be of a personal nature, and what could be more personal than a message engraved in the person's own handwriting? No matter how awful we think our handwriting, when it is engraved in metal it seems to turn into a work of art in the hands of an engraver, while still maintaining the character of the handwriting.

Engravers in our workshops copy any handwriting direct, although sometimes, as for instance when a number of different signatures are required on one salver, some scaling has to be done. But copying another person's handwriting, is difficult enough with a pen, let alone a graver.

An array of signatures on, say, a silver tray, makes a handsome and very personal subject for presentation. (See Fig. 178 and further comments on page 121).

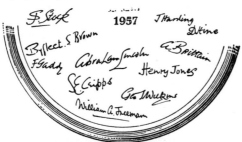

Fig. 178—Facsimile signatures on a tray laid out in an apparently haphazard way. More space can be left round important signatures.

117

COPYING HANDWRITING

I have been told that forgers copy handwriting by turning the original signature or writing upside down and copying it that way. The idea is that as the letters are strange when written backward upside down, there is no tendency to fall into one's own habits of writing. However, here is the idea for what it is worth; some engravers may find facsimile writing much easier to engrave upside down.

If it is to be reproduced the same size, tracing the signature or writing on to the metal is, of course, the obvious way to set about the job if freehand copying is too difficult.

MONOGRAMS

Designing and engraving monograms are an important part of the engraver's work. It might be as well first of all to describe what a monogram is, in view of some of the ambiguous orders that are received in our workshop. A monogram is not two or three separate letters, but a character composed of the principal letters of a name interwoven. Monograms are engraved on such articles as signet rings, watches, cutlery, and any other article of a personal nature. It is quite a common practice for a person to have his or her monogram specially designed and to keep that particular style for life so that it is used as a device. Great care should be taken with the original design to see that it would be suitable for articles of any shape, such as an oval signet ring or a square compact.

It takes a great deal of practice to be able to design a good-looking monogram, and it may be as well to obtain a book of monograms and practise drawing by copying rather than to start off by designing one's own. In designing or drawing a monogram, balance is the main consideration. A lopsided monogram, or one that is too top- or bottom-heavy, looks very ugly. When a good one has been achieved, then shading is the next consideration, to give it life. The shading will either be in the letters themselves or, if the letters are to remain open, then great care must be taken to give the monogram the right amount of heightening or side-shading, as already described in shading the side of a shield. (*See* page 40).

For the purpose of exercise only, and definitely not for future designing, it is not a bad idea to obtain a book of the old Victorian monograms with their very elaborate ribbon and floral effect. It would indeed be excellent practice to copy and engrave some of these. There is almost as much work in an old-fashioned " mono " as there is in a moderate Coat of Arms. Engravers in the old days would spend hours and hours designing and engraving those monstrosities,

Richard Sutton.

R

MARGARET T. WILKINSON.

R.S.D.

H.A.K

S·C·D

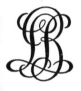

D.H.L.

FFS

RAC
1946

C·E·N

Fig. 179—Some styles popular in the U.K.

119

but although the effect on the back of a gold hunter watch was in my opinion unpleasant, the engraving was superb.

Assuming that the student has designed on paper a suitable monogram, to be engraved on, say, the usual copper practice plate, the monogram should be transferred to the plate one of the ways already described. The tools necessary to carry out the operation are : tracing point, set of cushions or sandbags, steel ruler with a straight line engraved down the centre, three or four assorted gravers, pencils, oilstone, printing ink and spring dividers.

The gravers for monogram work must be properly sharpened in order to produce a narrow and clean cut without burr or rough edge. A type of lozenge graver is very suitable for this type of work. When carrying out fine work it is advisable to use an eyeglass or an engraver's glass mounted on a stand. When the monogram is on the plate it should be pointed in as already described and the engraving begun in the usual way. When pointing in, corrections may be made to the original pencil design if necessary, but care should be taken to see that no marks are made on the plate other than those which have to be engraved. In the case of an involved monogram the pointing should be very clear and precise, otherwise confusion of lines is bound to occur.

Outline the monogram with the graver first, preserving the same depths of cut throughout. The result will be a rather dead and open monogram. The next thing is to cut the unders and overs, i.e., the letters which should appear to be placed over the other letters must be made to look so. This is done by fine shading lines on the part of the letter which passes under the others. This can be seen in the monogram HTS in Fig. 179.

" COLOURING " LETTERS

If the centre letter is to be made prominent, this may be done by " colouring " the letter, which means engraving with fine parallel lines. It is usual to engrave diagonal lines or, to use the correct term, to " purple colour " the letter. (*See* page 32). Take care to see that the heightening is all on the same side in order to give it the proper shadow effect. If the initial is in your opinion too thin, there is no harm in going over the whole monogram again before putting in the heightening.

Finally, square in where necessary, which means that all the top and bottom corners of the letters should be finished off by coming back along the engraved line and flicking out a sliver of metal at the top or bottom of the letter to give it a clean finish, as described in shading the heraldic shield (See page 39). One square graver is really all that is necessary to carry out this job, although it is as well to have three or

four sharpened ready for use in case the one in use becomes tired or
" plays up," as they sometimes do.

Should it be necessary to copy a design and reduce it at the same time
first of all draw a grid of vertical and horizontal lines over the design
to a definite scale. Then take the dimensions to which it is required
to reduce the drawing and divide them by the same number of lines
each way. It will then be found fairly simple to draw in the outline
of the design to the reduced scale. The design may be enlarged by
reversing the process. I must add here that an experienced engraver
does not use these aids but draws the design by eye, whether it has to
be reduced or enlarged.

POSITIONING ENGRAVING

The position for engraving certain articles is as follows unless
otherwise stated by the customer :—

Cigarette cases with the hinge to the left ; powder compacts and
cigarette boxes with the hinge to the top ; pens and pencils with the
points to the left, or if the initials are to read one above the other then
the cap should be to the top.

Tankards may be engraved on the near side, off side, or on the
opposite side to the handle. Should a crest and inscription be engraved
on a mug or tankard, then the crest may either be engraved above the
inscription or crest on the off side and the inscription on the near side.
There are no set rules with regard to the positions of engraving ; it is
a matter of balance and taste. Many people prefer to have the
engraving underneath the article, especially if the article, such as a
christening mug, is to become a family heirloom. The engraving will
then not only be preserved better but it can be arranged in such a
manner that additions may be made from time to time.

When engraving facsimile signatures, on a salver for example, they
should be arranged in such a manner as to look as if they had been
written direct on the salver by the people themselves in " orderly
disorder " (Fig. 178). They should not in any case be arranged in
perfect Naval formation. Should there be any matter of precedence
with regard to the signatures, then the senior names may be engraved at
the top above the inscription if any, arranging a little more space between
the names than with the more junior ones.

Cutlery and flatware should be engraved as common sense would
dictate, that is with the bowls, blades, and prongs facing up. They
used to be engraved in the opposite direction but this began to go out
of fashion about fifty years ago. I am given to understand that they
were engraved upside down because of the manner in which they
were placed on the table, but today they should be engraved as stated.

121

Care should be taken when engraving silver pieces of a certain period to ensure that the engraving is done in the correct contemporary manner. This also applies to engraving on antique pieces, such as a snuff box, when care must be taken to see that the style of engraving is contempory.

Signet rings, of course, can only be engraved on the obvious place—that is the head—but there are different ways of treating the engraving. It can be surface engraved in the ordinary way, or it can be sunk and reversed left to right for sealing purposes, and again it can be sunk the right way round in order to give it the necessary depth. We are frequently asked to engrave a signet ring so deeply that it will last. The only way to treat this is to sink it in the head, that is to carve it out as it would be done for sealing, but facing the correct way round. It is impossible to engrave a crest deeply on a signet without causing an appearance of roughness and coarse shading because the deeper one engraves with a graver the wider will be the cut and delicacy of shading becomes an impossibility. A monogram or entwined cypher is a different matter; a considerable depth can be obtained while still maintaining an attractive appearance.

Cups should be engraved on the opposite side to the Hallmark. This is only because the Hallmark, which is usually on the top left side of the cup, throws the engraving out of balance.

The backs of wrist watches should be engraved with the winding button upwards, as should pocket watches. If a pocket watch is engraved on the inside of the back of the case, the work should be done with the hinge to the left.

Scales of pocket knives should be engraved with the blades opening upwards or to the left, according to some engravers, although again there is no obligation to engrave them in this way.

Problems of where to engrave are cropping up in the workshops all day long. No two jobs are the same and all the time it is a question of finding a suitable position to engrave with a view to balance, easy reading, appearance and so on. There are really no set rules with regard to engraving positions; it is all a matter of common sense, except probably with cutlery and watch backs, but even then the best position is the obvious one.

STUDIES IN LETTERING AND LAYOUT DESIGN

By P. Morton

THE study of lettering is easy to approach, for there is no initial barrier : the student is not faced with esoteric hieroglyphics but with familiar forms. The main object of the study is to guide the student to a knowledge of good lettering, which means not only the study of the shape and proportions of letters but also of their juxtaposition. The placing of a letter with reference to its immediate neighbours is as important as its shape.

ABCDEFG
HIJKLMN
OPQRST
UVWXYZ

Fig. 180—A beautifully proportioned alphabet based on the original Roman alphabet.

Letters—written, printed or inscribed—over a great portion of the world have their roots in the Roman alphabet: in fact, the Roman alphabet is not only the root but the very stuff of which the tree is made. During the centuries changes of outlook and dictates of fashion have thrown out abortive branches, but there still remains the Roman alphabet.

The tablet in the Forum of Trajan bears the eternal alphabet, the exemplar for all time. To begin with, there are two prohibitions : first, do not copy it ; secondly, do not attempt to improve it, or try to " bring it up to date."

There is but one thing to do : make the Roman alphabet fertile, have living descendants instead of effigies, get behind the outward seeming of it and find the basis of its existence. The alphabet shown in Fig. 180 was derived from a study of the proportions and ratios of the Trajan letters.

The passage of years has brought about developments, and doubtless it differs in a multitude of details from that first attempt which was the founder of its dynasty. But many of the main features have survived : the ratios of width to height are, for the most part, unaltered.

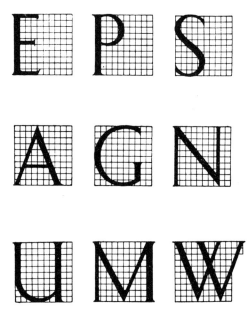

Fig. 181—The letters are all based on a certain ratio.

Fig. 181 shows nine letters each imposed on a frame of a hundred squares. It will be seen that the persistent ratio is something in ten. An inscription produced from them will have an unbroken rhythm.

Now that a basis has been arrived at, the way lies open for count-less experiments. Set out an alphabet with a constant ratio of some-thing in nine, another of something in eleven. Here is the way to "go modern"—along a well-constructed road, not a haphazard track leading nowhere in particular.

Here is a word, the letters of which have a ratio of something in nine (Fig. 182) :

GAIETY

Fig. 182

Here is another, the ratio being something in twelve (Fig. 183) :

FLUSH

Fig. 183

Each word preserves the rhythm of its alphabet and in each case development has a measure of promise. But carry the experiment further : take a letter from each word alternately—and this is approxi-mately the result (Fig. 184) :

GHASTLY

Fig. 184

Fig. 185 shows a practical example of layout. It was arrived at after visualising the tablet bearing the inscription using the alphabet shown in Fig. 185, with " SAMUEL PICKWICK " as the line in chief. The layout of the line in chief was calculated in units for each letter, the unit being one-tenth the height of the letter. The line in chief calculations settle the size and scale of the letters of the inscription.

Fig. 185—An example of calculated layout.

" SAMUEL PICKWICK " is set out so :—

Letter	Width of letter in units	Space between letters in units
S	5	
		3
A	8	
		3
M	10	
		4
U	8	
		4
E	4	
		4
L	4	
Totals :	39	18

Space between words in units .. 9

Letter	Width of letter in units	Space between letters in units
P	5	
		3
I	1	
		3
C	8	
		3½
K	7	
		2
W	12	
		3
I	1	
		3
C	8	
		3½
K	7	
Totals :	49	21

Sum total : 136 units

In Fig. 181 there appear in frames of 100 squares most of the letters here set down. This should be referred to for a proper understanding.

The 136 units of the line have to be related to the space available to determine the value in inches of the unit, i.e., the actual size of the letters. The unit figures against each letter and each space need not be adhered to without discretion ; some of the spaces will require

127

adjustment and also some of the letters, but these adjustments should balance one another.

The other lines of the inscription are arrived at in the same way, adjusting the length of the line to control the size of the letters. The spaces between lines, and at top and bottom of the inscription, control the length of the panel. This kind of calculation can obviously be made only with larger lettering, but knowledge of it helps the apprentice engraver to gauge the proportions of smaller letters by eye.

So far we have only considered capital letters, of similar height and with the thickness of the main stroke constant at one-tenth the height of the letter. Lower-case, as the " small " letters are called, possess no such uniformity. Not only does the constancy of stroke break down, but the constancy of scale comes to grief also—" a " and " g," for instance, are " crowded " letters ; they have too many twists and turns. Look at the word " bad." Observe the congestion of the " a " against the openness of the " b " and the " d." Regard the word " grudging," and the same sort of contrast is apparent.

It is significant that of all the characters in lower-case (perhaps with the exception of " r "), " a " and " g " are most unlike their ancestors in the Roman alphabet.

That the engraver should have recourse to an alphabet of small letters there is no gain-saying (although not for the reason rooted deep in the mind of the laity that " small letters take up less room "— actually they take up more room), but he will find that an alphabet of italics will serve him better. The difference in width of strokes is more easily hidden amid the slopes and curves that italics demand than in the austerities of lower-case. The " *a* " may be the open " *a* " of script, the " *g* " may also follow script. And while the congested letters assume simplicity, those whose lower-case aspect is stark, don the decorative attire of loops and curves. Thus, all at their assembly make a uniform array.

The point to remember is that to the printer the small letter makes up the greater part of the population of his world, and claims the privilege of a majority to rule ; while in the engraver's kingdom the capital letter is sometimes in the ruling majority, and the small letter has to accommodate itself to the views of the greater number.

A well-designed letter, so useful and ornamental within its accepted sphere, can carry these qualities to a different sphere and add to them. For instance, in Fig. 186, the letters do not form part of the design, they *are* the design, a cluster of decorative units becomes a decorative composition. The device illustrated is but a sign-post to a field teeming with possibilities and pitfalls, the biggest pitfall being the spacing. The way to proceed with such a work is this :—

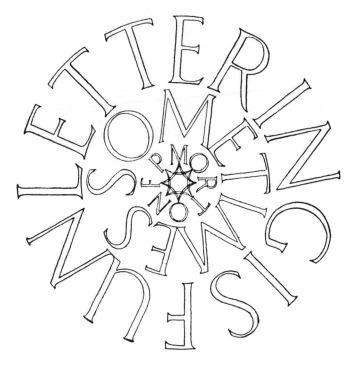

Fig. 186—In this example the lettering is also the design.

After having envisaged the design mentally, ascertain the lettering and spacing values in similar manner to that used for the Pickwick inscription. Having arrived at the height of the various letters, draw the concentric circles needed to provide the top, bottom and centre lines of the various sizes of letters, and all the other lines, which in the ordinary way would be horizontal. Use the centre line as a basis for measurements. The preliminary work having been accomplished, outline the letters. Begin with the L of LETTERING. The width of this letter is four-tenths the height. From the starting point measure off two-tenths the height of the letter, and thus determine the centre point width-wise. Draw a radiating line from the centre of the circle passing through this point, until it meets the concentric line that represents the top of the letter. Then, to the extent of the height of the letter, add a parallel line on each side of the radiating line, and two-tenths from it. These parallel lines give the framework of the letter. All lines that would be upright in ordinary circumstances must be parallel to the radiating centre line in such a case as this.

129

Proceed to treat the E in like manner—every letter has to be treated so. The drawing of the parallel lines presents no difficulty if executed with the aid of two set-squares—the one kept rigid as a base on which the other slides up and down.

In the matter of spacing, the principles of the Pickwick memorial will avail only in a measure. The T's in LETTERING, it will be found, will require to be nearer their neighbours, and nearer each other, than in the Pickwick memorial. Again the F in FUN has to be placed nearer the U than in " straight " lettering. Even from this piece of amusement much can be learned. By persevering with similar problems a basis of spacing can ultimately be established.

In the innermost band of lettering the spacing has to be relatively wide, else there would be a jumble of over-lapping at the base. In this case the wide letters M and N have parted with a little of their width for the general good. One further point. The centre arms of E and F have to be straightened out for proper appearance, and, for the same reason, the long bottom lines of the E's and the L are slightly—ever so slightly—inclined towards the straight.

It might be suggested : " Why draw the ' horizontal' strokes in the curve ? Why not make them straight and rectangular to the ' upright ' strokes " ? The advice is : " Try it. Set it out on paper." The advice is always to test the practical quality of ideas. There are two methods. One : to draw the " horizontals " from the centre lines of each letter, and at a tangent to the circles. In setting-out this, the experimenter will be hopeful when he sees that LETTE looks quite comfortable, but the R will give him trouble, and the N will jump right out of the circle. And in the inner ring the M's of SOMETIMES will defeat him.

The second method is to join in a straight line the ends of the horizontals, and thus have every part of the letter contained within its appropriate circular frame. This improves the R and the N, but it is fatal to the T's—especially to the T of SOMETIMES, for it reduces the height of the letter appreciably.

Fig. 187 shows three T's : No. 1, as shown in Fig. 186 ; No. 2, as the result of the first experiment ; No. 3, as the result of the second experiment.

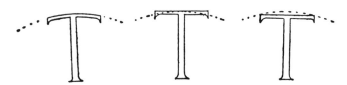

Fig. 187—Practical and impractical ways of forming the letter T for a circular pattern.

130

Another example of patterning is shown at Fig. 188. It is a setting-out symbolic of elementary education. Each line of letters is shown four-fifths, the height of the letters in the line above it. The spaces between the lines diminish in like proportion.

A B C
D E F G H
I J K L M N O
P Q R S T U V W X
Y Z ° 1 2 3 4 5 6 7 8 9 0

Fig. 188—A definite scale for each line gives an even graduation.

Again the student should experiment. For four-fifths substitute nine-tenths, then eleven-twelfths, then five-sixths, then three-fourths —and as many more as he likes. He will find he has fathered a family of alphabets, each with a similarity of form and expression, but each with unmistakable individuality. The fraction is a cellular element, and the structure that proceeds from it is something alive—natural and unchangeable as all life is.

Notice how evenly the letters are spaced in Fig. 188. Spacing is difficult to achieve by rules—it is best done by eye. In the middle word GALLOWAY in Fig. 189, for example, the uneven spacing makes GALL too compressed and OWAY too open. The compressed style at the top (where certain letters overlap) and the open style at the bottom both look even.

A monogram is very easy to do badly, and exceedingly difficult to do well. When distortions and mutilations are indulged in, the monogram will quickly take shape—or mis-shape. Of course, the letters must be coaxed to part with a characteristic here and there ; but, withal the Roman alphabet remains too little plastic to bring about success.

131

GALLOWAY OWAY

GALLOWAY

GALLOWAY

Fig. 189—Examples of spacing. In the first, the word *Galloway* is compressed to a minimum. In the second, the spacing is uneven and in the third it is well-balanced.

Yet, it is not altogether forbidding; it permits ligatures and conjunctions; and seemliness can be reached by an orderly arrangement, rather than by the straining of interlacing lines. An arrangement developed from the reverse of a King Alfred penny, which links together the letters used in the word LONDON, as shown at Fig. 190. It is along such lines that the Roman alphabet can best serve the designer of monograms.

Fig. 190—A monogram of London and a large monogram for a cup.

Script is, however, his best servant, but here again, it is much easier to do badly than to do well. One can lay down no rule, save the greatest rule of all: practise and experiment over and over again.

Fig. 190 contains a monogram of the letters P and N.

It is necessary to examine letters very carefully to understand fully their pecularities, particularly in relation to the eye. For example, lower-case letters are sometimes assumed always to take up less depth

than capitals of the same proportion. Yet they often take up more, as shown in Fig. 191, because of the descenders, or lower strokes of the lower-case letters.

APRIL JULY
APPLE JELLY
April July

Apple Jelly

APRIL JULY

APPLE JELLY

Fig. 191—Lower-case letters may actually take up more space, in depth, than capitals. In that above, the space taken up by the descenders of p and y has pushed the lines of lettering apart. The lines of capitals at the top are spaced the same distance apart as the lower case but take up much less vertical distance. Even the bottom lines of capitals take up much less vertical space than the lower case lines.

Italic letters should be treated with considerable care as the letters *A*, *V* and *W* may appear to have too exaggerated a slope. It is best to keep these letters closer to the Roman than to the italic form when used in a line of italic type (Fig. 192). Italics look better in lines of upper and lower case letters than in capitals alone.

WEALD

WEALD

Fig. 192—Engravers use italic capitals at times, but the letters A, V and W require great care if their slope is not to appear exaggerated. It is best to keep these letters close in form to the Roman in an italic line.

133

In the matter of layout the engraver extends his field enormously. He becomes the architect of a structure of which his letters are in the nature of finishings. Layout is not a chequer-board in which, willy-nilly, letters are moved and mated, but a planned arena in which letters are directed to their appointed place. Any idea then that layout means a process of trial and error, shifting words and phrases this way and that in an aimless search for what " looks nice " must be abandoned.

To illustrate how a basis can be arrived at, Fig. 193 shows a figured parallelogram. Its length and depth are in the proportion of 36 to 25—a proportion not devoid of beauty. Within the enclosing lines three panels of different sizes have been drawn. A feature of their placing is that the centre-line lengthwise of the top panel coincides with the left-hand boundary of the middle panel. Similarly, the centre-line of the middle panel coincides with the left-hand boundary of the bottom panel. Another feature is the relationship of the dimensions ; the figures 2, 5, 7 and 9 (and their multiples) appear frequently, and are the parts of which the whole is built. Indeed, it is a setting-out in which nothing has been left to chance or to expediency.

Fig. 193—A parallelogram laid out so that the spaces occupied by lettering are in definite proportions. The layout here is exact, but the engraver can work on the same principles by eye.

Now fill the panels with lettering and in Fig. 194 observe the result.*

* Some letterers would object to the way " LONDON, W." is centred under " TOM THOM." The centre is mathematically accurate, but looks wrong.

BRUSSELS
SPROUTS

PRODUCED BY
THE BELGIANS
SOLE LICENSEE

TOM THOM
LONDON W

Fig. 194—Shows lettering based on the layout of Fig. 193. An engraver specializing in precious metals, is not often asked to engrave such a message as this,—but the principles of layout remain the same.

Having shown a basis derived from figures, let us consider a basis derived from angles. Fig. 195 is an illustration showing both skeleton and flesh. Apart from the four rectangles contained in the parallelogram, all the angles shown are 30, 60 or 120 degrees—in other words, the patterning is the outcome of interlacing equilateral triangles. Again, this is set down solely to illustrate method and to indicate possibilities.

Fig. 195—A pleasing layout based on diagonals and diamonds.

135

Now introduce circles into the build-up. Observe how it is done in Fig. 196. A semi-circle and two equilateral triangles comprise the skeleton. An arc, a sixth of the circumference, is divided into fifty parts; four of such parts define the height of each line of letters by extending from them lines parallel to the diameter, two parts define the space between each phrase, one part defines the space that subdivides each phrase into two lines, and four parts top and bottom of the sheet define the plain margins. The height of each line of letters, and the width of each space, perforce diminish at an increasing ratio from top to bottom of the message.

Fig. 196—Shows what can be done with semicircle and triangles.

Obviously there is no end to the changes that can be rung by logically planned working. In Fig. 196 the proportion of the frame, which is in the ratio of height to width, is at 125 to 144, and is not of the best. It would be more happy if the figures were reversed—the height 144 to a width of 125. As an exercise, divide the bottom arc of the illustration and deal similarly with it. Turn the paper half-round and set out the lettering. The tallest lines, in this case, will be those nearest the centre.

THE THIRD DIMENSION

So far, letters have been considered in two dimensions; but, except in the case of written letters, there is a third—and one that can exert an influence to affect the other two. And here a new factor makes its presence felt—the material that receives the message. A letter can be placed in three positions in relation to the plane of the material in which it is recorded. It can be level with the ground-face as in the case of a penned or a brushed letter; it can be below the ground-face as in the case of an engraved letter; it can be above the ground-face as a raised letter.

A letter penned or brushed is, of course, two-dimensional. Even if it be embossed it is to all intents and purposes two-dimensional. In the area of what he can do the delineator finds a limitless expanse—and it sometimes obscures what he may do. His tools enable him to execute the most delicate embellishment—and facility can blindfold judgment.

A letter that is formed by sinking it or engraving it into the material gives in the Roman alphabet the happiest result. The letters of the Trajan Column were so formed. They may be V-cut as in the Trajan Column, or square-sunk. The standard for the angle of the V is commonly put at 60°; thus the arms of the V measure the width of the letter. When the inscription is being cut in stone or marble blocks, or in wood of large section, this angle should be preserved; but if the material be slabs or boards or metal, it may be necessary, especially if large letters be present, to reduce the angle, and thus make a more shallow cut. But the angle should never be less than 45°. Viewed with a light from the side, the V-cut letter gives perfect legibility, and at the same time, shows a gentleness of character. The qualities combine and give us good lettering—something that is both arresting and restful. But in a great many instances other than with precious metals, colour, usually painted colour, is required to help in legibility and to define the subtleties. Like the effect of side light, the colour used must be arresting and restful. It must be in contrast to the hue of the material on which the inscription is cut, and yet the two must compose, and strike a chord in harmony. Advice on broad principles only can be given, for each case sets its own problem. One thing to note; on stone, marble or wood, beware of black or of dark anything. In the V-cut letter, colours take a duskier hue. Besides the colour achieved by paint there is the supreme substance for colour and decoration—gold. In a memorial what is more fitting than a record glorified by this most precious metal ?

Gold reflects gloriously when there is light to reflect. But one side of a V-cut letter—an arm of the V, one might call it—has no outlook but in the other arm of the V, and only shade is mirrored there. For gilding, the square-sunk letter is essential. Then the words are transfigured. One thing is unfortunate: square-sinking does not accomplish the refinements that are possible with V-cutting. An examination of Fig. 197 will show this. In the V-cut letter the serifs are pointed; in the square-cut letter these points are blunt.

Now the raised letter : Here there is more to say. In the first place, and contrary to inexpert opinion, it does not define so efficiently or so truly as the sunk letter. The shadow caused by sinking is contained within the letter; the shadow caused by raising is outside the letter.

Fig. 197—Raised, sunk and V-cut letters and their appropriate serifs.

Then, the discussion on the raised letter has to go hand in hand with a discussion on materials. As has been said, a sunk letter gives in the Roman alphabet the happiest result.

Another method is to adopt a Sans-Serif alphabet. If such an alphabet be designed with care something beautiful will result, but it must not be open to the reproach of kinship with the hideous block letters which we see so often, and are encouraged to use by the Ministries of This and That.

In Sans-Serif, the treatment of capitals and of small letters differs. In the capitals all strokes may be equal. In the R for example, the width of the strokes forming the letter is everywhere the same—a tenth of the height of the letter. But in small letters it will be found necessary to thin the curves where they butt into the uprights, as in h, n, r or else there is an effect of smudge. The " n " illustrated in Fig. 198 shows this done. There is much to do to form satisfactory capitals. It is well to blunt the points of the pointed letters, to make a round-bottomed U, and to incline the uprights of the M inwards [A U M]. A thickness of stroke, if an eleventh of the height, will help to clear congestion at angles.

Fig. 198—Sans serif letters. The lower-case n at the end has been thinned where the curve butts into the upright.

CAST BRONZE

There is one material on which the raised letter is to be seen with frequency, and that is cast bronze. Many a memorial tablet is in this metal, cast from a reverse mould—usually a mould of Mansfield sand—which, in its turn is cast from a model. Positive—negative—positive.

The material of the model, the parent of the cast is frequently wood, sometimes plaster. If the wood be of the lime-tree order a good raised letter can be cut, although a little of the refinement will be lost in the processes of moulding and casting. It is not possible in casting from a sand-mould to have any under-cutting on the edge of the letter—indeed, the angle formed by the ground of the tablet and the edge of the letter must incline towards the obtuse to assist in the separation of positive from negative.

As a material for a model plaster is preferred by some bronze-founders, but by others it is not deemed safe. The size, projection and detail of the letter are factors to be considered. In order to convert a mass of loose sand into a compact slab capable of maintaining itself ramming is resorted to; the sand is poured over the mould, and beaten into it with a ram. Plaster breaks under rough treatment, and ramming, unless it be skilful is liable to damage fine points. Small projections and compact serifs are best adapted for a model in plaster.

But raised letters are not always cut as raised letters; frequently they are incised " in the reverse " on a plaster slab, and a plaster positive cast from it. It is a faster method to cut into the surface to form a sunk letter than to cut away the superfluous matter from the surface, and leave a raised letter. " Cutting in the reverse " intimi-dates a novice, and it is a highly skilled piece of work—especially so as the cut to be formed is not a V cut, but the more difficult square-sunk cut—or as square-sunk as it is practical to make it; for a cast has to be obtained, and sinkings have to be " eased " (i.e. all angles must be towards the obtuse) so that positive and negative will come apart. The craftsman tests the quality of his cutting by squeezing clay or plasticine into his sunk letters, and so has an advance view of the ultimate plaster positive. It is unfortunate that one cannot use this plaster reverse in place of a sand-mould, and cast direct from it, and so avoid erosion; for each process takes its toll from the virility of the original. But it cannot be done, either in plaster or in anything else capable of being cut.

Besides the accommodation required on all the strokes to separate positive from negative, there is a difficulty with the pointed letters such as A and V. Often in scanning letters in bronze can it be detected that the points of the A's do not reach the top of the line, and those of the V's the bottom. The " ease " required for separation is here in an aggravated form; there is more loss at points than elsewhere. Of course, the expert cutter is aware of this, and does what he can to minimise it. Sometimes he re-designs these pointed letters—makes them as in Fig. 199. The thick stroke is carried up to the top in its entirety, as in A and N. The point is blunted at the bottom as in N

and V. This difference of treatment between top and bottom is due
to the fact that the top of a letter is regarded more sensitively than is
the bottom.

199—Pointed letters squared off.

Another way : Let the letters be cut in the reverse, but with a
round sinking instead of a square one. The difficulty of ·the points
is not then so great. But, on the other hand, there is a loss of virility,
and—more important—a confusion of line, due to the fact that, for
the most part, the strokes, be they thick or thin, have to arrive at the
same projection. Sans-serif letters, similar to the R in Fig. 200 make
a better impression here.

R R R R

Fig. 200—Sans serif letters such as that on the right are more satisfactory when cutting
in reverse.

SHEET METALS

Besides cast metals there are sheet metals—we have all heard of a
brass plate ! Here, we return to V-cutting. Work of notable refine-
ment can be engraved on brass or bronze sheet. The V-sinkings
require colour for legibility, and, unlike stone or wood—because we
are here dealing with a polished, reflective surface—the colours should
incline towards the darker shades—it may even be black.

Another way—a modern way—of dealing with the bronze plate is
to sink the lettering and have it filled with vitreous cream enamel, and
fired ; and to tone the bronze to a dark brown colour. We all know
it makes a striking business plate, for we have seen it often and often—
especially in Birmingham. But its fitness for a memorial is doubtful ;
it smacks of commerce rather than of devotion and sacrifice. It needs
a revised alphabet, too, for the striking contrast of dark brown and
cream shows lettering in a different light, and it may be found that
certain curves—so right in V-cutting in stone—look somewhat obese
in vitreous enamel.

I have touched on the hardness of material on the colour of material,
and there is a third division—the grain of material. This is not always
present. Brass, for instance, is expressionless ; only the lettering

140

speaks here—and "lettering" means letters and spaces. With no texture of material to soften the contrast, letters and space are both assertive—and liable to sing out of tune. As there are no barriers of grain to break up the surface especial care has to be taken that the spacing between words in one line does not connect with similar spacing in the lines above and below, and form rivers of flowing space on the face of the tablet. The substance that most emphatically asserts that its grain is a voice to be heard in the choir is wood—especially oak—most especially English oak.

Such is a brief outline of the idiosyncracies of materials. Only experience will give the letterer and engraver the requisite knowledge. He will learn from every job he undertakes.

MORE ADVANCED AND AWKWARD JOBS

By A. Brittain

MANY jobs which come into the workshop may be classified as awkward. This is readily understood when one considers the variety of articles suitable for engraving and the positions where the engraving may be executed ; for example, inside signet and wedding rings, inside serviette rings, and underneath and inside the deep recess on the bottom of a bowl. Engraving a maker's name on a fine and delicate piece of jewellery, engraving names and dates close to the handle of a silver cup, engraving the bands on walking sticks and umbrellas and trying to avoid hitting the man next to you on the bench at the same time are all commonplace problems in an engraver's workshop.

The word awkward is probably used more in the engraver's workshop than in any other. The article itself is often awkward, the position where the engraving is required is often awkward, the position where the man is sitting is often awkward and the man himself may be a little awkward ! The only job which may be considered a straightforward one is a nice handy-sized silver plate mounted on a piece of wood. Sometimes a cigarette case may open wide enough not to come under the category of awkward but this is very rare ; the manufacturers seem to take a delight in making the case open just wide enough for a cigarette to be removed but just not wide enough for the case to be engraved inside. The only solution when this happens is to take the case apart before engraving and then respring and repin it afterwards. This may sound a long-winded method but in the event of a long inscription to be engraved it is the only way.

RETAILERS AND PRICES

The retailer naturally objects to the extra charge involved and always seems to expect the engraving to be charged up in the normal fashion as for a straightforward job. He seems to have a natural suspicion about these awkward jobs but he only has to put himself in the place

of the engraver and to think how the man can best approach the job to realise that there will certainly be some difficulty and that some allowance should be made in the charge to the customer.

In the case of a wedding ring, the awkward part is how to hold it when engraving. Most engravers scorn the use of gadgets for holding the ring and merely hold it in their fingers, resting ring and fingers on the cushion (Fig. 201). When the ring has to be engraved on the outside, the best method is to place it on a smooth stick of wood shaped like a ring sizing stick, but again many practical engravers seem to prefer holding it in their fingers as there is always the danger of the ring sliding round the stick at the wrong moment.

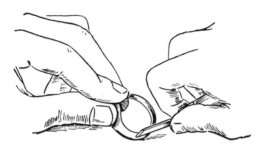

Fig. 201—Engraving inside a ring.

A specially bent graver can be obtained or made for cutting inside rings. The curved stem of this is not as likely to strike the side of a ring as is the straight graver. Many skilled men, however, prefer to use a straight tool. When holding the ring on a hard pad or sandbag, the harder this is the more easily is the ring engraved. Ring holders are available as shown in Fig. 12 (page 8), but beginners find these of great inconvenience and they are usually abandoned as skill improves. When a straight graver is used for engraving rings it has to be backed-off to prevent the point from digging in. The amount of backing-off necessary can be gauged by experience, and some engravers prefer to give the tool a slight bias so that a cut parallel to the side of the ring can be made, although others stone the graver at equal angles.

The gadget which is frequently used is the simple home-made clamp (see Fig. 202). This can be rigged up to take almost any small job but is of no use for engraving inside a ring. There are one or two methods for holding say, a watch back. One is to sink the back into warm cement or wax on a block of wood. When the wax or cement cools it holds the job firmly enough to engrave. Another idea is to use one of the commercial clamps on the market. See Fig. 13.

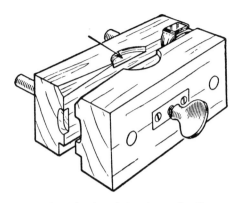

When engraving inside a ring the question naturally arises as to whether the horizontal cuts can be made parallel to the edge of the ring. The answer is : Yes, unless the diameter of the ring is so small and the ring so wide that the graver cannot make the cut parallel without damaging the edge of the ring. In any case the length of the horizontal cut is so small that any deviation from the parallel would not be noticeable. Another point is that to engrave inside the ring is so awkward that a perfect job in every sense of the word cannot be made, therefore any imperfection with regard to the direction of cut would not be obvious. The situation does become very awkward when one has to engrave inside and in the centre of a wide serviette ring in plain block letters ; in fact, it becomes impossible. The only solution is to engrave nearer the edge where it is possible to operate the graver.

Some engravers bend the graver slightly in order to make a parallel cut but this is strictly limited to a small angle otherwise control of the tool is lost. It is essential to have full control of the tool when engraving, say, a 9 ct. gold ring because this metal is comparatively hard and brittle and a direct wrist thrust is important. The tool used for this work is the ordinary lozenge graver.

The average engraver does not bother to wax, whiten and draw in when preparing to engrave a wedding or signet ring ; he usually points in straight away with the scriber and goes straight ahead with the engraving. This also applies to all small work where the area to be engraved is so small that no appreciable errors can occur by pointing in straight away. This saves a considerable amount of time and in commercial engraving time means so much money to-day. In any case, the wooden point cannot be made fine enough for effective sketching in such a small area.

Frequently one has to engrave a trade name on a fine piece of jewellery, probably on the pin or on some other rounded place. This is probably the most awkward job of the lot especially if the metal is white gold or platinum. The answer to this is just plain skill and a very powerful wrist. The job has to be held in the fingers as it is not desirable to run the risk of sinking it into wax or cement. It does not take much imagination to visualise the difficulties. Strong pressure has to be exerted in order to cut into the metal but because it is on the round the job has to be turned into the cut and at the same time great care must be exercised to see that the delicate piece of jewellery is not in any way strained. The usual result, even with the most experienced men, is a cut finger and a few skids in the engraving. The tool used is again our friend the lozenge graver.

ENGRAVING ON CYLINDRICAL SURFACES

Engraving on a round pencil is not by any means a simple, straight-forward job. The most suitable holding device is the ordinary home-made clamp and the best tool is the true scorper (Fig. 18), or lozenge graver sharpened as a scorper (Fig. 8). The scorper is most suitable although an ordinary lozenge graver can be used instead. The scorper is naturally the safer tool because it takes out the metal to the required depth in one operation there being no need for any threading, thereby reducing the risk of a skid.

Assuming that the lettering is to be carried out in plain blocks horizontal line are drawn in faintly (Fig. 203), the lettering is drawn, in the usual manner and pointed in with the scriber. All the vertical strokes should then be engraved first, followed by the horizontal strokes. When this operation is complete the rounded parts of the letters should then be engraved and the whole lot squared in. The reason for putting in the rounded parts last is because the scorper should not be used for taking a curve in one continuous stroke as in the case of the graver. The curve does, in fact, consist of a series of straight lines with the scorper altering course after every stroke (Fig. 204). The effect is rather like that of a piece of corrugated paper bent to form a circle ; the inside part is a series of close-knit corrugation and the outside circumference much more open.

The scorper must only be used to follow a straight line and should not be turned either way while all the edge is in the metal. It can be used for other purposes such as carving ivory or wood in which case the above rules do not apply. It is then used for the express purpose of removing as much material from a given area in as short a time as possible, much as a spade is used for making a trench.

145

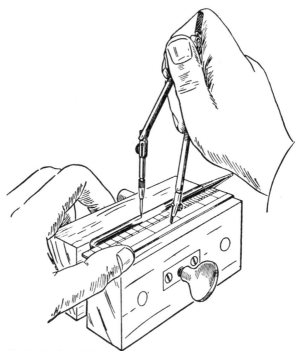

Fig. 203—Marking horizontal lines on a pencil. An orange stick is used in the compasses.

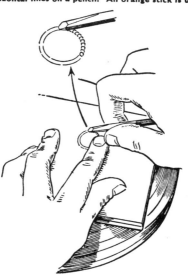

Fig. 204—Engraving a curve with a scorper.

146

To return to the pencil. It will be seen how, by going round curves in the manner described, there is far less chance of skidding, especially on a round surface, than if a lozenge graver were used. A number of engravers use a lozenge graver for such a job, but only because they are not used to handling a scorper. It takes a great deal of practice to use a scorper effectively, but it is well worth while to practice scorper work until perfection is reached because it is far quicker to work with it than tediously threading out with the graver. When used properly it is far more effective for certain classes of work. A scorper is always used for engraving names and dates on cups, for example, and is frequently used for engraving plain and stone block inscriptions on salvers, but only when in the hands of a craftsman.

ENGRAVING ON CONCAVE SURFACES

We now come to that bugbear, the inscription inside a bowl or any concave article. The usual procedure is carried out and the usual tools are at hand. It is always assumed that the student is sitting at a fully-equipped bench. We will assume, too, that the customer has first of all been persuaded to have the inscription engraved in the most suitable style for the job.

To my way of thinking this would most certainly be antique script or old style writing, as some people prefer to call it. This particular style does not call for particular accuracy in the formation of the letters and therefore any imperfection which is bound to occur while engraving in this extremely awkward position will not be apparent. It is permissible to make the letters slightly different in size and sometimes in shape, but the effect when the job is completed is very good.

After seeing that the job is at the correct height on the sandbags or cushions, whiten and sketch in the inscription, which when completed satisfactorily is then pointed in in the usual manner, the powder blown away and the wax wiped off. The tool to use for the job is the lozenge graver, that tool which has been kept specially for just such a job, bent at the correct angle for getting into the bowl without damaging the sides of the article. Should such a tool not be at hand then it will be necessary to make one as described on pages 18-19.

The vertical strokes are engraved first with a graver or a scorper as the case may be. As the position is very awkward it is desirable to cut down the threading out to a minimum, therefore the scorper is the more useful tool for the main or thick strokes and the graver for the fine ones. The article should be held firmly in the left hand and the graver in the right hand but the secret lies in the balance of the article and the control of the wrist, not, as in the case of the easy flat plate, control by the left hand and thumb. I have known a very large

147

cup to be so unwieldy as to make it necessary to suspend it from the ceiling over the bench by means of a rope so that it could be easily revolved by the engraver. During the process of engraving the engraver takes up some extraordinary positions and in the case of this large cup he was at times almost standing on his head.

A bent graver as shown in Fig. 24 (page 13) is often used for the inside of a bowl and some engravers prefer to use bent gravers even for working on flat articles because these give plenty of clearance for the hand and there is a certain amount of backing-off.

HIGHLY POLISHED ARTICLES

Small highly polished articles for engraving such as watch cases and lockets will become scratched if constantly turned on a leather sandbag during the course of engraving. This can be avoided by gumming a piece of paper to the bottom of the article and when the work is finished the paper can easily be removed by soaping off. Great care should, of course, be taken if the watch case contains a movement.

It is sometimes necessary to engrave a highly polished plate which is very dazzling to the eyes and, of course, a great strain on the engraver. A little white tissue paper over the window will help to kill the dazzling effect but the plate itself should be dulled by dabbing modelling wax over the surface.

An expert engraver will ask himself when presented with a new job whether the article concerned is likely to be submitted to wear. This fact will affect his treatment of the engraving particularly regarding the depth of cut. An engraving, for instance, on the inside of the lid of a cigarette box would not need to be so deep as that on the handles of a set of spoons, or an inscription on a watch back need not be so deep as that on a tray which is intended for use. It is, usual though to engrave any article of value with a certain strength of cut with the feeling that one day it may become a valuable antique and the engraving will be studied and criticised by craftsmen of the future as we to-day study the craftsmen of the past.

Any other questions which may arise in the reader's mind are best answered by practice and still more practice during the course of which and after using all the tools of the trade, the answer will soon become clear. Trial and error, in my opinion, are certainly the best teachers in almost every walk of life, at least during the training period. It is always advisable to find out for yourself why such-and-such a thing happens in certain circumstances. In the case of engraving it is certainly a very good idea to use tools which you consider the right ones for a particular job and not to wait for somebody to tell you.

I believe that in other countries engravers are inclined to be a little more mechanically-minded and use special gadgets such as mechanical sharpeners and special holding apparatus for engraving small jobs. In Britain they are looked upon with disfavour, but all engravers have their own special little clamps which they make up themselves to suit their own requirements. Some engravers prefer to stick a small job on to a block of wood by means of cement or hard wax (Fig. 205) and some with strong fingers will hold the job throughout until the operation is completed. We are probably using the same methods for engraving to-day as were used hundreds of years ago but there is no shame in that because it is not mechanical devices that we wish to encourage but the art itself.

Fig. 205—Watch case cemented to a block for engraving.

THE WORK AND THE PRICE

Most time-savers and short cuts are a menace to the skill and artistic ability of the engraver, but where time and money are short, certain short cuts have, unfortunately, to be resorted to, so that in the trade it is essential to know all the short cuts and time-savers because we have to take the rough with the smooth. It would be ideal to be able to treat every job as a work of art, but in this chrome and imitation precious metal age much of the work has to be cut to the minimum to make it pay.

The ignorance of the average retail jeweller does not help the craftsman. In my opinion every retailer should take a course in all relevant branches of the manufacturing trade before being allowed to handle anything in a shop. It is often heartbreaking to submit a really first-class piece of work to the retailer only to find that, after the thought and hard work that has gone into the job, his first reaction is: How

much are you charging? Very often I have been asked to reduce a charge from, say, 55s. to 50s. because the retailer considered that was all the job was worth. I defy anyone to say whether a work of art has a definite value to the nearest ten shillings. Often I have had to adjust a price because three years ago we had done what looked exactly the same kind of job but charged, say, five shillings less on that occasion. This happens because each job is priced on its merit and maybe three years ago there was a technical point that, perhaps, I decided detracted from the value of the work, so the price was reduced.

POLISHING, ERASING, AND RESTORING SURFACES

By A. Brittain

A N engraver is called upon to do a host of other jobs besides engraving; in fact, he must be a first-rate handy man. He should, in my opinion, be entirely " self-contained " in that he should be able to engrave, prepare his own tools, be able to carry out simple heat treatment of metals, be able to outline a good looking monogram and do his own piercing, be able to polish by machine, carve metals, ivory, wood, etc., engrave on engine turning, which many engravers cannot or will not attempt, be able to machine engrave and to understand the mechanics of the machine so that he is able to sharpen the cutters to suit his own requirements. In other words, he should be able to tackle any job which comes into the average modern workshop.

In our workshop we can no more do without the engraving machines than we can do without our hand engravers, piercers, carvers, and jobbing jewellers. A first-rate engraver should be able to make up simple pieces of jewellery, make silver plates, size and repair rings, and do simple jewellery repairs. Men who can do all this, however, are few and far between and commercially are worth very much more to a workshop than the man who specialises in one particular job, because it often happens that the workshop is slack in one class of work but extremely busy in another. An engraver should also be a born artist—but the engraver who can do all these things is, of course, the rare paragon.

POLISHING

After a job has been engraved it is often necessary to repolish the area which has been engraved to remove marking out lines and other small scratches which have been unavoidably made. This is not a treatment to remove mistakes, which will be described later, but a final finish to the job so that it is ready for collection by the customer.

It is not only the engraved part of the article that becomes scratched.

151

When working on small polished articles that are constantly rotated on the sandbag, the underside is easily marred. This can be largely avoided by interposing a piece of soft chamois leather between job and sandbag or pad. Even better is to gum a piece of tissue paper on the bottom of the article being engraved which will prevent any damage at all to the lower surface. Warm water can be used after the job is complete, to remove the paper and gum.

To finish off the engraved work, polishing machines of various sizes are available, depending on the work likely to be done on them. Polishing machines are supplied with electric motors of suitable horsepower and one with a shaft at each end should be chosen. Normally an average-sized machine with mops of about 6 in. diameter runs at about 2,800 r.p.m. It is best, if possible, to have a polishing machine fitted with a resistance box in order to regulate the speed of the shaft. If the polishing mops revolve at too high a speed it is possible to burn the metal, especially if the mops do not contain sufficient lubrication in the form of grease or rouge. One mop on the shaft is used as the grease mop and the other the rouge mop.

THE GREASE MOP

The grease mop is made of calico and so called because grease in block form is rubbed on to the mop while it is revolving. Its principal use is to remove any marks which have been made on the surface during the process of engraving. It is important to add here that if there are any marks on the engraving surface of the article which have to be removed, then this should be done before beginning to engrave. If it is done afterwards it is more than likely that the engraving will be rounded off in the process of polishing and completely ruined. Any marks which are made during the engraving are bound to be of such a minor character that a touch will remove them and do no harm to the article.

Grease is sold in bars like soap, and available in several grades. A wheel is charged by holding the bar beneath it.

The rouge mop is made of swansdown and is used for the final polishing. The rouge is applied to the swansdown mop while it is revolving to ensure that every part of the mop is saturated with jewellers rouge. The rouge is purchased in powder form but before application to the mop it is made up into a thin paste by mixing with water. The rouge will, of course, fly in every direction when the mop revolves but if the machine is fitted with an efficient exhaust fan then it should not cause any discomfort to the operator.

Apart from its convenience, an exhaust fan is in many countries required by law. Some polishing firms fit a fine filter into it and

manage to recover an appreciable amount of precious metal waste that would otherwise be lost.

When going from the grease to the rouge mop great care must be taken to see that all traces of grease are removed from the article, otherwise grease will be transferred to the rouge mop and destroy its efficiency.

POLISHING TIMES

It is impossible to state how much an article should be polished or for how long ; this can only be arrived at from experience. In any case, polishing is an art in itself and the cream of all polishing is hand polishing, but there is no point in discussing it here because it is most unlikely that any engraver will be able to engrave and do hand polishing as well, because the hands get so roughened by handling tools that they would put in far more marks than they would take out !

The motor should be on a small but firm table or stand so that the spindles project over the ends of the table to give as much clearance as possible when polishing engraving on large articles such as salvers. The spindles should be as long as possible, consistent with strength, for the same reason (Fig. 206).

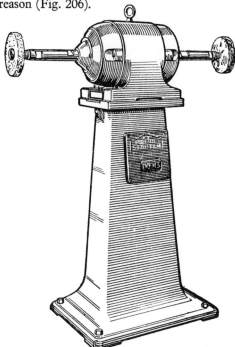

Fig. 206—A typical polishing motor with grease mop on the right and rouge mop on the left.

The motor is mounted so that the top of a mop travels towards the operator when the mop is revolved. The work is held against the wheel near the bottom (Fig. 207).

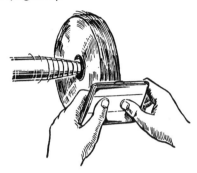

Fig. 207—The top of the mop should travel towards the operator. Hold the job as shown.

Great care should be exercised in attempting to polish for the first time. A number of small snags will crop up at the first attempt, such as not holding the article firmly enough with the result that the revolving mop will take it out of your hands and throw it across the floor. Care should be exercised when polishing small articles such as ash trays with fancy pierced edges, as these are liable to get caught in the mop and be irreparably damaged. It takes a deal of practice to know just how much pressure should be exerted against the mop and how to hold the article efficiently so that it will not get caught and damaged, or, if it does, so that the damage is confined to the article and does not include your hand and fingers. It is a good idea to practice on a good-sized plate which is not mounted on a piece of wood as this will teach you how to hold the job and will give an idea of the amount of heat which is generated by the friction.

Overheating should always be avoided as this will burn the metal and will probably ruin the job. When holding the bare metal in your hand, overheating will naturally be avoided but it sometimes happens that the job is mounted on a piece of wood, as with some small silver plates, to facilitate handling when engraving and polishing. It is not easy at first to know whether the plate is getting too hot. In such case it is better to hold the plate against the buffs for short periods. The object should be to cover as large an area as possible in the shortest time; by that I mean that the whole surface to be polished should receive an equal amount of treatment otherwise it will be found that one piece of the surface which has received more polishing than another will be warn down and will show a distinct ridge. The article should be kept moving all the time, giving it a rotary movement while holding

154

it against the mop. Only experience will tell you how to polish, but these hints will, I hope, put you on the right road to start with.

DANGER OF DRY MOPS

A very important point is to see that the mops do not run dry. Keep them well greased or rouged as the case may be all the time you are polishing, otherwise a nasty blur will appear on the surface called a blush. For the final polish after the grease mop, when the rouge mop comes into play, a similar technique should be adopted. In addition to putting plenty of wet rouge on the mop it is a good idea to rub a good quantity on the article itself. In the case of a small job like a small silver plate this is unnecessary, but in the case of a salver it is essential.

ROUNDING OFF

A learner will find it very difficult at first to avoid rounding off the edges of plates or the edges of, say, the head of a signet ring. Only experience will teach him how to avoid doing this. There is a polishing tool that can be fitted to the average machine for the final polish that will preserve sharp outlines. This is the leather lap which is perfectly flat and has no particle of material sticking out of it as in the case of the ordinary calico or the swansdown mop. It will therefore polish only the area that comes into direct contact with it.

The rounding off that is experienced with cloth mops can often be put to advantage, as in the case of " wiring " a monogram. When it is required to round off the limbs of a monogram after it has been pierced from flat metal, the correct method is to round off carefully with a file and then carry out the usual polishing procedure, i.e., file, pumice stone, Water-of-Ayr stone, charcoal, grease mop, and rouge mop. However, by holding the monogram, or anything that requires to be rounded off, tightly against the grease mop, a similar effect will be achieved, but the quality of finish will certainly be inferior. This again is a time-saver when the question of price is a consideration.

ERASING AND RESTORING SURFACES

However careful a student is in his work of engraving, he is certain to make a mistake occasionally and will want to know how to erase it. Skilful erasing is so effective that only an expert can detect that it has been done. The tools and equipment for erasing and restoring surfaces are : a polishing machine and equipment, scraper, flat file, burnisher, pumice stone, Water-or-Ayr stone, charcoal block, and an emery wheel for attaching to the polishing machine.

Should the mark in the work be a small or shallow one, the easiest way to remove it is to rub it over with a burnisher, which " smears "

the surface of the metal and obliterates the blemish (Fig. 208). If there is no engraving to worry about, the job should be finished by polishing first on the grease mop and then on the rouge mop.

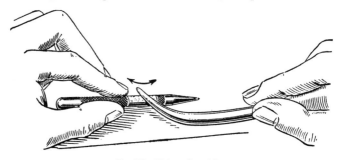

Fig. 208—Using a burnisher.

To remove a deep mark or to remove engraving completely from an article requires a little more hard work and care. First of all the engraving should be removed by filing away the surface. A second cut or smooth file should be used so that the file marks are not too deep. Next the file marks are themselves removed by rubbing the surface with pumice stone. The pumice stone marks are taken out by rubbing the surface of the erasure with Water-of-Ayr stone well saturated with water until a paste is worked up. The result will be a fairly fine finish, but not yet quite fine enough. The next operation is to rub with a piece of charcoal over the whole surface until a really satin finish is obtained.

The article is now ready for polishing first on the grease mop, which will remove the satin appearance, and then on the rouge mop which will give the final smooth bright finish. For perfection, the polish should be finished off by hand, but this must be done by a professional hand polisher whose hand is as soft as or softer than the finest material through constant polishing with jewellers' rouge.

The two main considerations in erasing are, firstly, to remove all traces of the original engraving and to re-surface the article to its original standard. At the same time, as little of the metal as possible should be removed. After much practice, the beginner will find that he is able to gauge just how much of the engraving or marks can be left at each process so that the processes that follow, after each has eliminated its own small amount, will eventually leave the surface perfectly clean. Bear in mind that even a slight rubbing of the polishing mop will always remove a certain amount of metal from the surface. It is possible to remove a small mark on the surface merely by polishing on the grease mop and, in fact, this is often done.

156

A great deal depends on the thickness of the metal when deciding on the method of erasing to be adopted. As an example, when erasing an old inscription from a thin cup, every care must be taken to avoid going right through the metal. The gauge of the metal must be measured first with a gauge or double-ended callipers, as shown in Fig. 209, and more measurement should be taken at frequent intervals during the process of erasing. This is where the expert will be able to judge—in fact, must judge—how much metal each of the processes will remove. It often happens that all the engraving marks cannot be removed, especially the squaring-in marks as they are always much deeper than ordinary engraved strokes. These marks will have to be left in the cup and that is why, when purchasing a second-hand cup, you will probably find a mass of squaring-in marks. They look like small pin-points scattered over the surface.

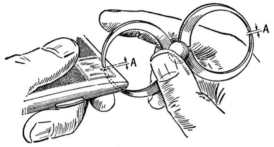

Fig. 209—A double-ended calliper will indicate the thickness (A) of the metal before and after erasure.

The cup inscription is usually erased by the method already described, but there is another method used by the expert—and unfortunately by the not so expert—which is a real time-saver, but in my opinion cannot possibly give the same finish as the method already described. The quick method is to fit a fine grade emery wheel to the polishing machine and very carefully remove the inscription or marks, being very careful because the cutting rate is so high. When this has been done, go straight over to the grease mop and then finish on the rouge. This will certainly remove the engraving in double-quick time, but it will also certainly give the surface a torn or wavy appearance which is fairly obvious on a large surface but would not perhaps be seen by the average person on a small one. In this practical book our object is to try to teach correct methods, but there is no harm in mentioning these quick procedures if only to let the reader know what can be done and what to look for if anyone else has done the job. As far as the retailer is concerned, the price should give a clear indication of the method adopted. Cut prices always mean inferior work.

157

USING THE SCRAPER

No mention has yet been made of the scraper. This is another tool for removing engraving. Sometimes the erasure does not warrant the use of a file, and if this can be avoided, so much the better because no matter how carefully a file is used it is bound to leave heavy marks in the metal. The scraper, on the other hand, although it is not an efficient tool to use for a large area, is the most suitable for removing the engraving on a small surface.

Erasing procedure therefore boils down to this : Use a burnisher if the mistake is local and the burnisher can be used efficiently ; failing the burnisher, use the scraper ; and failing the scraper, use the file. Direct application to the grease mop is where the time is saved after using a burnisher or scraper.

To hold the scraper properly is merely a matter of common sense (Fig. 210). Hold the handle with the palm and three fingers, and the blade with the thumb and first finger. Scrape with a movement towards the body. Do not rub with a backwards and forwards motion. The job is best to be held in a clamp.

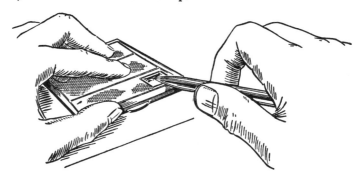

Fig. 210—Using a scraper to remove engraved work.

It very occasionally happens that a word in the middle of an inscription is mis-spelt by the engraver. It would obviously be uneconomical to have to erase, say, a complete Coat of Arms and a ten-dozen word inscription just for the sake of a single letter out of place, because, by the methods explained up to now, it would not be possible to erase the letter itself without erasing the whole or most of the area of engraving, or there would be a definite ridge where the erasure finished. Thus the whole surface would have to be worked over, starting at the mistake and easing up towards the edges until the error has been erased, and the whole process of restoring the surface would have to be carried out before work on engraving could be started again.

There is, however, a short cut, which will work in the case of one or even two letters out of place, but not in the case of a whole word or sentence. Find the exact spot on the other side of the tray, or whatever the article may be, behind the letter to be erased, using marker tongs or callipers. If one leg of the tongs is over the letter, the other will indicate and mark the exact spot behind the letter. Supposing the article is a tray, turn it over and tap on the place marked on the bottom with a hammer and punch. This will make a dent in the tray and raise the incorrect letter above the surface. It will now be possible to file off the letter and then pumice stone and finish this part of the surface as described.

It is essential to confine the operation to as small an area as possible in order to preserve the sharp cut of the surrounding engraving. To assist in this, it is a good plan to cover the other engraving with sticky paper so that the mops will not come into contact with and round off the engraving already done. The indentation in the back of the tray should be finished off by rubbing with a little blue-black paper which will restore the dull finish usually found on the back of a tray or salver.

Best of all is to avoid making mistakes in the first place. This is quite easily done by asking someone to check over the engraving while it is still in the drawn-in stage and before the pointing-in has been done.

MILLING OUT

We are often asked to remove the engine turning on a cigarette case in order to form a panel in say, the top left-hand corner for plain surface engraving, in spite of the fact that it is possible to engrave quite satisfactory straight on to the engine-turned surface. The operation of making the panel is known as milling out. The panel is first outlined and then engraved round the edges. The surrounding area should then be covered with two layers of sticky paper, easily removed later by soaking in water. The paper should come right up to the outline of the panel to prevent damage to the engine turning in the subsequent polishing.

The engine turning on the panel is removed by careful scraping with the scraper until every indentation has been removed. The usual restoring procedure is then carried out, the sticky paper making this possible although the surface level of the panel is below that of the cigarette case. The result will be a flat and brightly polished surface ready for engraving. The panel should be finished off with a graver cut round the outline. Although as a result of the erasing the panel will be below the surface of the surrounding engine turning, it will not be noticeably so, unless the engine turning is unusually coarse and deep, in which case making a panel should not be attempted.

CHAPTER 11

PIERCING METALS AND ENGRAVING IVORY AND INLAYING

By A. Brittain

PIERCING is an essential part of the engraver's business. I do not mean that every engraver should be a piercer but that every apprentice learning the art of engraving should also learn how to outline and pierce; in fact to learn all that goes on in the workshop in readiness for the day when he desires to start up his own business.

Piercing covers a great deal of ground, from piercing sword hilts to delicate monograms in metal or any other material. Piercing means what it says—to pierce or cut with a saw. A jeweller's saw is used (Fig. 211), the blade being inserted in the saw with the teeth of the saw pointing downwards and outwards.

Fig. 211—An Eclipse piercing saw made by James Neill & Co. (Sheffield) Ltd.

A proper jeweller's bench is ideal for the job, if the amount of work makes buying one an economic proposition. A jeweller's bench is shown in Figs. 212 and 213. A special advantage of such a bench

160

Fig. 212—A modern jewellers' bench with three " jamb pegs " and tool drawers.

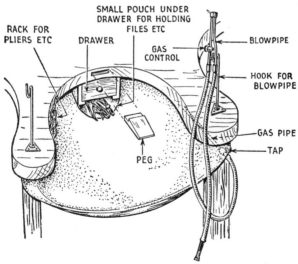

RACK FOR
PLIERS ETC

DRAWER

SMALL POUCH UNDER
DRAWER FOR HOLDING
FILES ETC

GAS
CONTROL

BLOWPIPE

HOOK FOR
BLOWPIPE

GAS PIPE

TAP

PEG

Fig. 213—When working with precious metals, a special apron as shown should be used to
catch the filings. Tools are held in a pouch.

in an engraver's shop is that all the bits and pieces, tools and equipment, blow lamps and so on are all together, easily at hand. The bench should be securely fastened to the floor or wall so that anybody pushing against it will not upset the others working at it. It should be fitted with jamb pegs. The light, of course, should be, as in the case of the hand engravers, a north light, but as the engravers always claim these positions first, the piercers have to make do with what is left. However, a north light is not quite so essential to the piercer as it is to the engraver.

I am going to assume that in all cases we are piercing silver, as this is the most usual metal, in our workshop, at least. The silver should be perfectly flat, and if for the purpose of a monogram, between gauge 10 to 12*, i.e., between approximately one-eighth and one-tenth of an inch thick. The monogram, or maybe two or three initials in a frame, is then outlined on the metal and the holes for the saw blade to enter are drilled. It may be necessary to mark additional small bars as ties between letters and frame, otherwise the monogram will not be a whole and when sawn will fall to pieces. When the monogram is outlined with the graver ready for the saw blade, the next thing is to select the actual blade to be used. Saw blades vary in quality so much that I should hate to recommend any particular quality. A fine grade should be used. As a general rule, use a blade with a tooth pitch much less than the thickness of metal being sawn. For fine piercing it is obviously necessary to use fine blades such as 00 and 000 grades.

Having selected the blade, insert the blade into the far end first assuming that the frame is held with the handle against the body and the end of the frame against the bench. The points of the teeth should be towards you. Thread the monogram on to the saw blade through one of the drill holes with the back of the monogram towards you. Then press against the frame so that is bends slightly, rather like a bow, insert the other end of the blade, screw up tightly and release the frame. This will tighten up the blade rather like a bow string. The saw is now ready for use. The seat where the operator is working should be of such a height that he is sitting with his chin about three inches above the bench as the work can be done better when he is sitting rather low. Always begin by piercing out the centre part of the monogram first and work outwards, as this will maintain maximum strength in the monogram while the work is in progress and will prevent the work from bending or breaking (Fig. 214).

Having pierced out the monogram without breaking too many saw blades and assuming that the monogram is going to be fixed to a wallet

* Birmingham Wire gauge.

Fig. 214—How the plate is marked out for piercing. Holes have been drilled for the piercing saw.

or some other soft article, the next step is to solder on the pins but before doing this it is necessary to use a needle file to file away the saw marks on the sides of the monogram. This is a very important step as it is considered the hall-mark of a good job.

FIXING A MONOGRAM ON LEATHER

Copper wire is used for pinning a monogram to a soft article as this bends easily but is still quite strong enough to stand up to every-day handling of the article. With ordinary care the monogram will certainly outlive the article itself, as we often see by the number of times we have to transfer the same old monogram from an old pouch or case to a new one. Cut the copper wire to suitable lengths, not too short because they can always be clipped down if necessary. It is an absolute waste of time having to take off pins because they are found to be too short and to solder on longer ones.

The pins are then bent to a U shape and the monogram placed on a block of charcoal. The pins are next stuck into the charcoal sur-rounding the monogram so that one end of each is in the position required (Fig. 215). Small squares of silver easy-running solder are inserted between the pins and the monogram and heat applied to the solder by means of a blow-pipe from a gas jet. The solder will run and the job so far is complete.

The solder should be used with a correct flux, such as borax, for silver. The minute particles of solder are impossible to place with the fingers and should be picked up and put in position with a small pencil brush moisted with water or dipped in the borax solution.

The monogram is removed from the charcoal complete with pins and while it is still hot it is dropped into a pickling container. The pickling container is an earthenware pot which contains a solution of

Fig. 215—Soldering on the pins.

diluted cyanide. The action of the cyanide is to restore the original colour of the silver or other metal ; in other words, it removes the fire marks which discolour the metal when heat is applied. The metal is immersed for only a short period and then removed for a wash in clear water to remove the deadly poison.

The monogram is next mounted on a piece of wood, taking great care not to bend the pins during the process (Fig. 216). It is better to make small holes in the soft wood in the positions where you know the pins will enter. This will make for easy mounting without forcing. When the monogram is well down on to the wood there is no harm in giving it a smart tap with a light hammer, having first of all placed a cloth between the hammer and the article. This tap will ensure that the monogram is sitting flush on the wood. The idea of the

Fig. 216—Monogram on a wooden block for polishing.

wood, which is about 6 in. square, is to make it easier to handle the monogram in the next stages. The following stages have already been described in the section on polishing but there is no harm in repeating the description inasmuch as it applies to monograms.

164

Carefully stone the monogram with a piece of Water-of-Ayr stone, keeping the surface moist with water during the process. The idea of stoning is, of course, to remove any marks in the silver which cannot be removed by the ordinary polishing methods. The next step is to use the grease and the rouge mops on the polishing machine and this is where it is essential to have the monogram mounted on something like the piece of wood already described. If it were held in the fingers it would just fly away as soon as it came into contact with the mop. Very great care must be taken when polishing on the grease mop, to see that it does not round off the sharp edges of the monogram, in fact it should only be necessary to give it a second or two on the grease mop if the stoning has been done efficiently in the first place. Equal care must be taken with the rouge mop, although being a much softer material the monogram can stand very much more from the rouge than the grease.

The monogram is now ready for fixing to, shall we say a wallet. Remove the monogram from the wood block by means of a flat thin blade, again taking care not to bend the pins or the monogram. When it is removed it must then be washed with a very soft brush dipped in paraffin and then soap and water. The operator should at the same time wash his own hands ready for handling the case itself. A special bench should be reserved for fixing purposes only and should at all times be kept perfectly clean, because after soiling articles of pigskin or other light coloured leather it is impossible to remove any stain from them. It is a good idea to cover the bench, no matter how clean it appears, with tissue paper as this will not only ensure that the article to which the monogram is to be fixed does not come into contact with grease or dirt but it will immediately indicate any dampness which may lie unobserved on the bench. The tissue paper will absorb the dampness and declare it immediately.

The next step is to place the monogram in the position as instructed by the customer. Assuming the position is to be in the centre of the wallet, then the monogram is placed as near as possible by eye in that position and then corrected by means of a pair of dividers. With the dividers measure off the distance from the edge of the case that the edge of the monogram should be, having made allowances for the width of the monogram itself and then check that the measurement is the same from the opposite side of the case. Repeat the same thing from the top and bottom of the case and the monogram should then be geometrically central. Having done this the monogram should then be moved above the central point by about $\frac{1}{4}$ in. because of the optical illusion that when a thing is fixed geometrically central it does in fact look as if it were below centre.

When satisfied that the monogram is equidistant from each side of the case and looks central, press it firmly on to the leather, taking care not to bend the pins. It will be found that the pins have made small indentations in the leather, so take up a sharp-pointed instrument such as a scriber and make holes in the leather where the pins have left their mark. The holes should be just large enough for the pins to pass through with a fairly tight fit. Enter the pins of one side of the monogram first and bend them inwards between the leather and the lining of the case. Then enter the pins on the other side, bending them inwards at the same time. We now have the monogram standing up on the case with the pins inserted in the holes and slightly bent (Fig. 217).

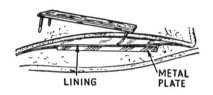

Fig. 217—How the monogram is fastened to leather.

The bending of the pins is facilitated by placing a heavy, flat metal sheet or block under the monogram. If the wallet has a pocket directly under the monogram, then the metal should be of such a size as to be placed inside the pocket. The idea of the metal is to prevent the pins from coming right through the lining and to force them to turn in between the leather and the lining. When the pins have been bent over as far as possible with the fingers, a piece of soft leather should be placed over the monogram and the whole given a sharp tap with a flat hammer. The job is now complete.

FIXING A PIERCED MONOGRAM TO METAL

Fixing the monogram to a cigarette case is different, for the reason that the pins should be of the same material as the case—silver pins for a silver case and gold pins for a gold case. The pins, for obvious reasons, should not be turned over inside the case but are very neatly riveted. The process is as follows : assuming the position to be again the centre of the case. A piece of modelling wax is placed in the approximate area and the monogram, with the silver or gold pins soldered to it and straightened ready for fixing, is placed gently in the position already determined by means of the dividers. When satisfied that the front of it looks central, press the monogram gently so that the pins make their indentations in the wax. Remove the monogram,

and drill the necessary holes in the positions already indicated. The monogram, after removing the wax and cleaning all signs of it from the area, is placed in position so that the pins pass with a fairly tight fit into and through the holes. The pins are then clipped almost flush, with the surface of the case and then by means of a hammer and a fine punch each pin is carefully riveted so that it expands in the hole and grips tightly. The head of the pin itself is almost imperceptibly larger than the hole and it is impossible for the monogram to work loose. When riveting the case it is essential to have a soft leather underneath to prevent the case becoming damaged.

There are forms of piercing other than monograms or initials, such as the piercing of intricate designs in serviette rings, trays and sugar sifters, but these are truly outside the work of the engraving shop and in any case are fortunately now out of fashion.

It is only when the piercer is really proficient that he is able to pierce a small monogram efficiently. Should he be the slightest bit out of line on a letter, the whole monogram would be utterly ruined; whereas in an intricate pattern on a large article it would pass as part of the design and would never be noticed. In fact, the irregularity would be appreciated as being conclusive proof that the article was hand-pierced and not machined.

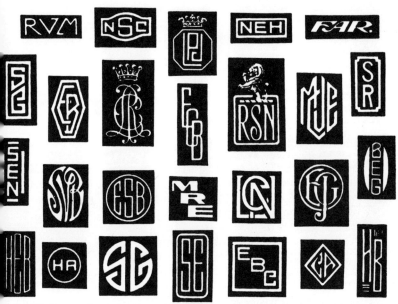

Fig. 218—Some styles of piercing used by G. M. Betser and Co. Ltd. Ties between letters, and letters and frame are not shown.

Care must be taken when designing the pattern to see that the whole thing when finished will hold together ; it is so easy, when designing something elaborate, to make a mistake somewhere in the design so that when the actual piercing is done you may find that one of the main supports has been cut through.

When a pierced monogram or initials are intended for a wallet or other non-metallic article, ties are sometimes essential to keep letters and frame, if used, in one piece. To make them less obtrusive they can be quite thin and the top surface should be removed with graver or scorper so that the ties are thinner than and below the surface level of the monogram. Then after polishing, and before fitting, ties can be painted the same colour as the article to which the monogram is to be fitted to make them unobtrusive, if it is thought desirable.

For metal articles it is not essential to keep the initials or monogram in one piece. Separate parts, however, are much more difficult to rivet accurately into position and are usually best avoided.

ENGRAVING IVORY

Engraving ivory offers many more problems than engraving metal. Even many highly-skilled engravers avoid the task if they possibly can. Others who are successful tend to make a secret of their methods, because a skilled ivory engraver is very much a master of his craft.

The trouble with ivory is that it has a grain. Metal is comparatively homogeneous and cuts equally well (or badly) in any direction, but a piece of ivory which can be cut smoothly and evenly in one direction —usually with the grain—will sometimes chip in another—usually across the grain. It will even cut differently in opposite directions whether along or across the grain. Moreover, every different piece of ivory presents different problems and old material often requires to be handled quite differently from new material.

Most successful ivory engravers—and there are few left because it is an art on its own—say that it must be cut fast to produce the best results. It is, therefore, very important to have an accurate drawing on the job. A design can be reproduced well on ivory by using yellow gamboge, dabbing it on the surface with a wet finger. A pencil drawing will show up well on this yellow surface.

There is another method of transferring designs to ivory which is used by some engravers and it has certain advantages. This is to cover the surface of the ivory with printing ink and then place over it a thin sheet of paper on which the design has been drawn. The design is gone over with a scribing point which will cause the paper to stick to the ink. The paper is then pulled off the ivory and takes some ink with it, thus leaving behind a tracing of the design in white on a black

surface. The advantage of this is that a design can be accurately followed and also that shading can be done accurately. It is difficult to cut the lines that comprise shading at equal distances apart when working on white ivory because of the reflections and eye strain. There is one big disadvantage of using printing ink, however, which is that it will find its way into tiny cracks some of which are too small to be seen by the naked eye, and will be very difficult to remove. Printing ink which has dried on a flat surface can be removed by rubbing it with a soft cloth soaked in paraffin.

The graver should have an acute face as shown in Fig. 219. The tool will then cut quickly but it will have to be used at a steep angle to the work and therefore tends to run out of the cut, so that very great care must be taken not to lose control of it.

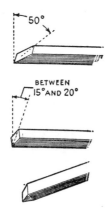

Fig. 219.—Top: A graver with large face angle for precious metals. Centre: a graver more suitable for ivory and bone. Bottom: The ivory graver backed off.

Most ivory engravers also back off their tools, kept of course for ivory alone, to give the cutting angle as shown in Fig. 220 or steeper.

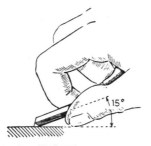

Fig. 220—The graver should be backed off until it cuts at about this angle.

169

The object of this is to reduce the risk of the graver digging in. A graver backed off in this way will tend to run out of the work. Care has to be taken, however, to avoid " skidding."

It is important to avoid digging in with the graver as the more it digs in the more chips are likely to form. These chips cause a ragged untidy edge to the cut, as shown in Fig. 221. The disfigurement is accentuated when the work is finally filled with a black or dark-coloured filler. The way of the grain should be studied in relation to the design and the cuts that have to be made, as chipping is obviously more likely to occur when cutting across the grain. There is, in fact, some similarity between ivory engraving and wood engraving and it is the practice of most ivory engravers to make a very fine shallow outline cut to sever the fibres (Fig. 222). Deeper cuts are then carried out within the limits of the fine cuts, and the chance of splintering is considerably reduced. When a circle is being marked the dividers will usually cut deep enough to sever the fibres so that the graver can be used normally.

Fig. 221—Grain causing ragged cuts.

Fig. 222—Outlining the work.

Some practice work on ivory should give the engraver a feel for the material and as soon as he becomes aware of any tearing of the ivory under the graver he should stop and cut in the opposite direction to avoid furry edges. In fact, a lot of skill of the ivory engraver comes in this feel that he acquires in cutting and an experienced craftsman will always be able to stop before a disaster occurs, because he can tell when the material is not behaving as it should under the cutting edge.

170

Because of the treacherous nature of the ivory, it is advisable to stick to a familiar sharp graver and not to experiment with other tools on customers' property. Another difficulty is that ivory is usually hollow because it is cut from a tusk that has a nerve running down the centre. This can give rise to trouble if it is not remembered, but in any case, one should never tackle ivory without the utmost delicacy of touch.

As almost all ivory engraving is filled, it is waste of time making flange cuts, because the filler will not remain in such a cut as it has one very shallow edge (Fig. 223), whereas it will remain in ordinary cuts (Fig. 224). Also a skilful craftsman alters the depth of his cut

Fig. 223—Unsatisfactory filling in a flange cut.

Fig. 224—Normal cuts partly filled.

Fig. 225—A filled threaded cut.

Fig. 226—A double outline.

to suit different shading effects because the deeper the cut, the blacker the filler appears to be. Wide cuts should therefore be threaded, and the cuts should overlap to give a comparatively rough base for the filler to adhere to (Fig. 225). Sometimes a double cut is made for edge shading, as shown in Fig. 226, as this gives a good effect of heightening.

171

It must also not be forgotten that even the finest lines will show up quite strongly when filled with black. Many types of shading can be used on ivory as the cuts are filled. Some suggestions are contained in Fig. 227.

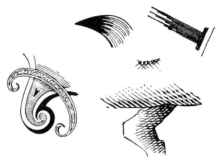

Fig. 227—Some types of shading possible.

Hard heel ball is commonly used for filling ivory. This can be softened by warming and is worked in by using some material that will not harm the ivory. When filling old ivory, great care should be taken to avoid the filler going into any natural cracks because filler is extremely difficult to remove from fine cracks. If names or initials are being engraved it is sometimes possible to use a different colour of filler for the initial letter or for part of the design, but the engraver must be careful not to offend against good taste and in heraldic engraving colours should always be shown by the correct shading. There is more about fillers on pages 202 to 204 in the chapter on machine engraving.

BONE

Bone presents much the same problem as ivory. It has a grain and different types of bone, and different ages of bone each present new problems to the craftsman. The technique of engraving and preparation of the graver are similar, but even greater care should be taken when filling, because bone has a thin pattern of dots or holes (which, in in fact, are used by gemmologists as a means of identifying bone from ivory), and these will fill up with heel ball if it is rubbed indiscriminately on the surface.

PLASTICS

Plastics are comparatively easy to engrave and usually cut well if the right type of plastic is chosen. Plastics are usually used when making templates for the engraving machine. Often, of course, there is no opportunity for the engraver to choose his own material when it is

172

part of an article, but in general, if the material has been used for manufacturing purposes in the jewellery trade, by its nature, it can be cut without difficulty. The softer and more " soapy " types of homogeneous plastics are favoured against the harder materials, like Bakelite, which has a skin and is almost impossible to engrave satisfactorily by hand.

WOODS

Occasionally the engraver is faced with a wood to engrave and here problems of grain arise again. Generally speaking, the graver is sharp enough to cut without trouble, especially if it is a wood graver of the appropriate size, as shown in Fig. 228 which is recommended for most hardwoods such as those used for brush backs. Ebony is sometimes stained, however, and the varnished surface finish given to this flakes off as a graver cuts through it. Trouble then arises when filler is used because the flaking and cracks immediately show up. White wax is used for filling. White enamel is unsuitable as it is impossible to remove if it runs in the grain. Several other colours of wax are also obtainable, if required.

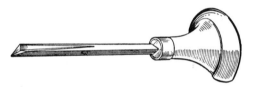

Fig. 228—Type of graver sometimes used for wood.

Some woods engrave very well, and a good natural unstained ebony is included under this heading. Thuya is another that cuts well, and so is iron wood.

INLAYING

Much patience is required to carry out good inlaying work in ivory. Probably the best method is to cut the ivory first, having produced the design on it, and then to take a print of the engraving on the ivory and transfer the design to the metal to be inlaid. The metal is then pierced and fitted very carefully into the ivory, trying it in place after each adjustment for size (Fig. 229.).

If the pierced work has been carried out first, the design can be transferred to the ivory (or, of course, wood, or other material), by going round the edge of the pierced work with a very fine needle point and then recessing the ivory inside the lines made by the needle.

Fig. 229—Pierced letters and their recesses for inlay.

It is difficult to find just where an inlay is binding if it will not enter the recessed ivory, but the temptation to tap the inlay must be resisted, otherwise some damage will result and probably the edge of the ivory will be chipped. When recessing ivory, the edge of the recess should be as square as possible and not sloping, otherwise the inlay will not stay in place ; also, if the edges are not square, any final polishing that is to be done might reduce the surface sufficiently to show irregularities along the edges of the inlay. Great care must be taken to preserve the walls of the recess otherwise any irregularities will be emphasised.

For the same reason it is important to get an inlay as flush as possible to the surface. If it is proud, the polishing operation may cause it to be rubbed through or will round the edges and spoil the clean-cut appearance that a good inlay should have (Fig. 230). If it is proud, it must be filed and stoned down to the surface and the material finished and polished with the inlay.

Fig. 230—On the left is a flat inlay in a slightly curved surface. It must be properly sunk as at B. The inlay at A would be damaged in polishing. On the right the edges of the inlay for a more curved surface should be as at B, not A.

When inlaying a curved surface the metal inlay must, of course, be curved also, and its edges cut so that they are parallel. Cutting the edges of the inlay parallel when the inlay itself is flat will cause them to be out of parallel when it is curved and so might cause it to spring out of the setting (see Fig. 230). To-day the process of inlaying in a curved surface is an expensive one, and as a result is not very popular. The chances of an inlay going straight in at the first attempt are very small. It is a case of trial and error all the time.

DESIGNS

The nature of the material always influences designs to some extent and owing to the fact that cuts in ivory are invariably filled this means that the bottoms of cuts will not be seen. The very fine cuts that can be made in ivory will show up well, however fine they may be, and shading can be much more contrasting than shading on metal. These facts make antique forms of lettering much more attractive than modern ones for ivory, and well-designed entwined ciphers are very suitable for such work. In general, it is a safe plan to keep styles as flowing as possible, because graceful curves are suitable for the material but rigid straight-line forms are not. An outline style of lettering in which the middle or swelled portions of the letter are left untouched, is particularly suitable for ivory engraving (Fig. 231). Gothic or Old English also looks well because of its exaggerated thick and thin strokes.

𝕲𝖔𝖑𝖉𝖘𝖒𝖎𝖙𝖍

Fig. 231—A style of lettering very suitable for ivory.

SHARPENING TOOLS FOR IVORY

Considerable care and skill are needed to sharpen a graver so that it will cut fine lines cleanly through ivory without causing chipped edges. The backing-off angle has already been mentioned. Good Arkansas stone of the right hardness is the best material for sharpening, using olive oil as a lubricant and employing the usual technique. Turkey stone is used sometimes and Norton India stone—a very fine grade of stone, but the right type of Arkansas stone that can only be found by experience is best.

CHAPTER 12

ORNAMENTAL ENGRAVING

By S. Wolpert and A. Brittain

WITH all that has been described in handling of graver, orna-
mental engraving should not prove difficult to any student who
has artistic ability. It is not necessary here to go into the
intricacies of geometric designs as the laying out and cutting of them
is fairly obvious. In jewellery, however, designs from nature are com-
monly employed, based on flowers, leaves, animal figures, and so on.
Balanced designs should, of course, be drawn in part and the design
repeated when transferring it to the metal. An even better way is to
engrave the repeat portion of the design and then to transfer impressions
of this to the other parts. Fig. 232 illustrates the type of design in
which this method is particularly successful. Here is the complete
procedure for a 4-part design as shown :

Fig. 232—Producing a pattern in three stages from a drawing of a quarter of it.

176

Smear a thin coat of Chinese white on the surface of the object being engraved and when it is dry draw a vertical line, and horizontal line across it at right angles. Draw the design in one of the sections with a lead pencil (as shown in a heavy line in the diagram) then scribe and engrave it.

After this quarter of the pattern has been engraved, make a paper impression of it as described on page 187 and let the paper dry on the plate. If it is removed before it is dry, it will shrink and therefore be of no value. When the impression is dry lay it on a flat surface such as a piece of glass *with the hollow side uppermost* and rub a soft lead

Fig. 233—Suggested engravings based on the acanthus leaf.

177

pencil gently over the whole surface. Now trim the impression with scissors along the straight lines so that it can be laid closely alongside the part engraved. Smear a little Chinese white on the quarter of the plate next to that engraved and a little wet soap as well, working the two together into a paste. Before the mixture has had time to dry lay the impression on the plate with the pencil side downwards. Make sure the design is exactly in place and rub over the paper with a burnisher. This will transfer the pattern to the other quarter and at the same time reverse it, leaving the lines of the design in white. This can be engraved right away, without scribing.

To complete the other half of the design it is not necessary to reverse the pattern. Take a new impression of the engraved half in exactly the same way, but powder this impression *on the embossed side* using a powder pounce. Smear some engraver's wax on the part of the design to be engraved and lay the impression on this exactly in position. Hold it firmly and rub it over with the forefinger. The result will be a transfer of the design in white which should be scribed before being engraved.

If the whole design is to be repeated, then an impression can be taken of it and used in the same way as just described.

The design illustrated in the previous figure was based on the acanthus leaf, which lends itself admirably to engraved decoration. Other acanthus designs are shown in Fig. 233, some of them being balanced about a centre line so that they may be transferred to the article to be engraved by the method just described.

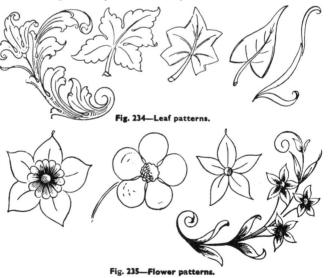

Fig. 234—Leaf patterns.

Fig. 235—Flower patterns.

178

Some other patterns from nature are given in Fig. 234—leaves, Fig. 235—flowers, and Fig. 236—stems. It is not suggested that these be slavishly copied; they are just to illustrate the kind of pattern that is appropriate to engraving.

Fig. 236—Stem patterns.

When a design has to be transferred to an article, it is sometimes necessary to reduce or enlarge it for the sake of appearance or even as part of a pattern with a repeat design. This may be done by a method commonly employed by artists. Rule a grid over the original drawing and then make an open grid on a fresh piece of paper to the new scale. By drawing the pattern in the new grid, square by square, the job is made easy and the result is truly proportionate. Fig. 237 illustrates this.

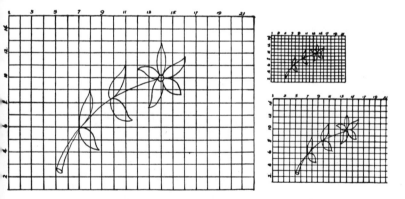

Fig. 237—How to scale a drawing up or down.

Borders are occasionally demanded of the engraver; their nature sometimes makes the work more carving than engraving. Geometrical patterns are often relatively easy to do. Leaves and flowers, particularly the popular orange blossom, are appropriate symbols. Some suggestions for borders are contained in Figs. 238 and 239.

179

Fig. 238—Popular borders, top left, orange blossom ; top right, blossom ; lower left, Fedelis or Lily of the Valley ; lower right, acanthus.

Fig. 239—More borders. Top, two types of scroll ; middle, two types of wreath bottom, a twist or rope, baguette, and zigzag.

CLOCK PLATES AND DIALS

From the earliest days of clockmaking, the craft has been associated with that of the engraver. Many master clockmakers engaged the

Fig. 240—Part of the engraving on the back plate of a Thos. Tompion clock of 1680-90.

finest engravers to embellish their work, not only on the dial, but on the back plate of the movement and elsewhere. On antique watches particularly can be found some extraordinarily fine examples of the engraver's art. The piercing, carving and engraving of watch balance cocks was a specialised trade in the 17th and 18th centuries.

The earliest engraved designs for the brass back plates of clocks when the big clockmaking industry was beginning to grow up in England often employed the tulip as a motif (Fig. 240). This was because of the influence of the Dutch clockmakers. But towards the end of the 17th century, floral scroll designs became more popular (Fig. 241). It is by no means common for the back plates of commercially produced clocks to be engraved to-day, but the commercial engraver is very occasionally called upon to engrave a special handmade clock. Back plate designs are not always exactly symmetrical. Some past engravers liked to avoid the precision of repeated designs.

On the other hand, simple engraved patterns on the dials of modern clocks (Fig. 242) are popular in some quarters and high class clockmakers frequently employ an engraver to do this work.

The dial of a high grade hand-made clock whether antique or new is usually engraved. The chapters or numerals of the brass dial are normally in Roman style with four strokes, thus IIII, instead of IV,

Fig. 241—Floral scroll design on a Tompion and Banger clock of very early 18th century.

Fig. 242—Engraved pattern on a modern clock dial.

because this more evenly balances the VIII on the other side of the dial. The Roman figures are arranged radially, i.e., the bottom of the number is always towards the centre of the dial. Arabic figures are invariably used for the minutes of a fine dial with Roman chapters and also disposed radially (Fig. 243). Arabic figures when used for the hours, on the other hand, are usually all the same way up.

The hour circle and minute divisions and their numerals are often engraved on a separate ring attached to the dial itself. The numbers are sunk slightly by the engraver and filled with black wax or enamel (see page 202) as are all the other engraved lines on this ring (see Fig. 243), and the ring is usually silvered.

The dial plate itself is engraved with a design or else it is matted by using a hard steel roller with knurling, run in all directions over the surface of the dial centre, or by the more modern method of acid etching. The corners are either engraved or decorated with applied cast spandrels. Any engraving on the dial plate itself is not filled. For very high grade work threaded cuts should be made to produce swelled lines, but in general the flange cut is suitable.

182

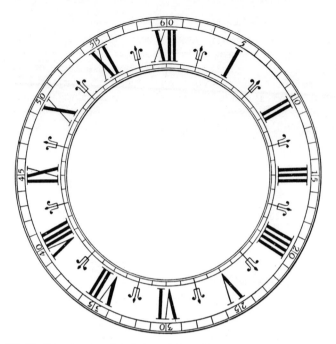

Fig. 243—Traditional engraved clock chapter ring. This is of a Tompion clock of 1693.

Watch engraving was usually finer and more elaborate than that on clocks (Figs. 244 and 245). The balance cock on the back of the watch became so elaborate during the decorative period of watches some three centuries ago, that collectors sometimes seek these pieces alone, unfortunately for the survival of many valuable old watches. It has been authoritatively stated that some of the old pierced, carved, and engraved watch cocks would entail about a month's work!

Among designs that were common on watch cocks are : grotesque heads (probably associated with charms to avert the " Evil Eye "), vases (the emblem of truth,) birds (usually swans or birds of prey), baskets of fruit or cornucopias (symbols of abundance), radiating star-like patterns with the sun at the centre, dolphins, lyres and crescents and discs (often on old watches intended for the Turkish market). Symmetrical and asymmetrical designs were used in about equal numbers.

Watch movements are engraved but not silvered or filled. Engraved decoration on the cases was occasionally filled and niello work was also occasionally employed.

PICTORIAL WORK

Some wonderful pictorial work has been produced and is still being produced by top engravers, often on specal pieces in gold or silver for presentation. Sometimes a reproduction of a house or building is required, or a country scene ; sometimes a horse or a dog or even a vintage motor-car or a bulldozer. Success in engraving these subjects demands a high degree of artistic ability as well as the necessary engraving skill, as might be expected.

Figs. 244 and 245—Early pierced and engraved watch cocks.

SOME WORKSHOP HINTS

By S. Wolpert

WHAT TO DO IN CASE OF SLIPPING

MANY hints have been strewn through the pages of this book as each stage in learning how to engrave has been described.

Here are a few more, from American workshops, that may find a use elsewhere.

The beginner may ask what to do when the graver slips and a line is made in a place or direction where it is not wanted. If the graver is in perfect order it will seldom slip. If, however, the point breaks off the graver when in the metal, unknown to the operator, the tool will slip. A graver in the hands of a skilled operator will not slip far enough to do any damage as a rule, as the delicacy of touch of the skilled engraver is such that the moment the point of the graver is broken off and the tool deviates a little in its course, he knows that there is something wrong. If he does not realise it before the graver does slip out, he is so skilled and so sensitive in its use that the slip will be a very slight one, in which case it can be burnished with a hand burnisher. Always bear in mind that burnishing should be done lengthwise of the incision and never crosswise.

Sometimes a slip will be too deep and long to burnish out completely. In such a case a scraper can be used. (See page 158). If the article has a special finish that cannot be restored, the engraver would be obliged to allow the slip to remain as it was made and ornament the monogram regardless of it, not attempting to make an ornament out of the cut unless its shape suggests it.

One tool for removing slips is the Arkansas engravers' chuck and hard stone points. Marks can be removed by rubbing the area with these stone points. The chuck is especially made to hold them.

METALS FOR PRACTICE WORK

Britannia metal is an alloy, consisting principally of tin and antimony. Many varieties contain only these two metals, and may be considered simply as tin hardened with antimony, while others contain, in

addition, certain quantities of copper, and sometimes lead. Britannia metal is always of a silvery-white colour, with a bluish tinge, and its hardness makes it capable of taking a high polish, which is not lost through exposure to the air.

It is a fine metal for the student engraver to practice on. It is soft enough, yet not too soft, to enable one to make the most beautiful cuts. It is especially good for bright cutting. Before using any other kind of metal for practice work, try using Britannia metal. It is used in the manufacture of silver plated trays, tea sets, coffee sets, prize cups, and so on.

After acquiring some experience in cutting on soft Britannia metal, a harder metal like copper can be used. The engraver must be careful to buy a good quality of copper. There is a great deal on the market that has not been properly annealed.

After the student has become sufficiently skilled as an engraver on Britannia metal and copper, he has reached the point where he is ready for the precious metals, and also for most of the non-ferrous metals, those metals without iron content. There are some comments about the British view on metals for beginners on page 21.

Practice plates 2 in. by 3 in. are a practical size and are neither too large not too small. They are conveniently handled.

TRANSFERRING DESIGNS

Chinese white can be used for planning purposes. It is a water colour paint which, when painted on the metal with a brush, can be sketched upon with a pencil after it dries.

Chinese white is employed as a temporary covering to carry a pencilled design during the " laying-out " procedure before engraving. It is sold in two forms : dry stick, to be moistened and applied by brush, rag or finger ; and in tubes, similar to an ointment and ready for use. The tube form has the better body and does not wipe off as easily as the dry stick. The stick form is made in England and in China ; the paste is made in the U.S.A. and England.

If it becomes necessary to make a correction in the design, after the Chinese white is dry on the plate and the design has been drawn over it, rub a little powdered magnesia over the design. The magnesia will bring out the design in white delicately and more distinctly. Powdered magnesia can be bought at any chemist's shop or drug store. If it is cake, it can be made into a powder by crushing.

For laying out work on metal, a good mixture for painting white on the surface is a marking fluid, which is a whiting mixed with benzine or gasoline (petrol) to the consistency of paint. This mixture should be applied with a brush. In a few minutes, the benzine or gasoline

will evaporate, leaving a white surface ready for scribing lines. However, Chinese white is preferable to this substitute.

TAKING COPIES OF DESIGNS

The burnisher can be used for impressing paper into the engraving for the purpose of duplicating designs. Illustrated in Fig. 3 are two types ; an oval steel burnisher with a curved blade and an oval steel burnisher with a straight blade.

In normal use the burnisher is for polishing by friction. The surface metal is rolled over by compression, toughened and hardened, and polished, all at the same time. The proper lubricant is of importance in all burnishing operations. A lubricant may be soap and water or ale.

The use of the engravers' wax in the cuts of the engraved plate will, with the described method below, produce duplicates of the finished design.

Mix three parts of beeswax, three parts of tallow, one part of Canada Balsam, and one part of olive oil. Rub this mixture on your plate after it has been engraved, remove any superfluous quantity (leaving the wax in the cuts only), then moisten a piece of paper with the tongue and press it evenly upon the engraving. Lay a dry piece of paper over it, hold both firmly with the thumb and forefinger of the left hand, and rub over the surface with a burnisher. The wet paper is thereby pressed into the engraving, and, with care, a clear impression is made on it. The same impression can be used twenty times or more if so desired for transferring a design to another job, thus duplicating the same design that many times.

After taking a wax impression on paper as described, a powder bag may be used to whiten it so that the whitened design will reproduce itself on another piece of metal.

The powder bag (pounce bag) is made of two pieces of cotton material about six inches in diameter which are cut circular and one placed over the other. Sprinkle some French chalk or powdered magnesium on the cloth. Fold the cloth like a pouch and bind it. Powder permeates through the material when you gently pat the impression with the bag, and sticks to the paper. The impression is then ready for printing on the plate, which has been covered with engravers' wax. A thin coat of liquid soap may be used instead of engravers' wax.

Paper impression duplicates of a design are useful in making a number of articles of the same design. The method described below is that I use.

Moisten a piece of paper about the size of the engraving to be duplicated. Saliva is the best liquid, as it is slightly adhesive. Bond

paper is preferred for these impressions, because the paper does not become too limp. Lay the moistened paper, wet side down, on the engraving. The paper must be made very wet to get the best results. Over this moist paper, a dry piece must be placed, holding it down with the thumb and forefinger of the left hand so that it will not move. Then rub over the entire surface with a burnisher until the design shows on the top. By doing so you will have impressed the bottom, or wet piece of paper, into the cuts. After this operation is completed, remove the bottom paper and you will observe an embossed design on the paper.

This is an impression with which you can duplicate the engraving over and over again, by powdering the embossed side with the powder bag and laying it on the other article to be engraved, which has been smeared with some engravers' transfer wax or moistened soap with your finger. The raised side of the impression must be put downward and rubbed or pressed. The design transferred will show up white. Scribe round the design to prevent its being rubbed off while engraving.

Transfer wax is used principally for duplicating lettering with a printer's roller.

Use either prepared wax or sheep's tallow. Take some on the finger and rub it into the engraving of the letter you wish to transfer. Wipe off the surface of the metal perfectly clean and pass the roller (printers brayer) with firm pressure over the wax filled letters. A light passing of the roller over the article to be engraved will then yield an outline of the letter. Generally several impressions can be made without cleaning off and rewaxing the roller, which must be done whenever the transfer wax becomes blurred.

Should you be unable to buy this wax, it can be made in this way : Take three ounces of beeswax, three ounces clean tallow, one ounce Canada Balsam, and one ounce olive oil. Melt the tallow, add the beeswax ; after melting remove from the fire and add the balsam and olive oil. If black wax is wanted, add lamp black ; if red, Indian red. Stir well.

Another use for engraver's wax is to spread it on the surface of an article to be engraved and sketch through the wax. The surrounding surface of the work will be protected and you can do your engraving without scratching.

MILLIGRAIN TOOLS OR BEADING ROULETTES

Milligrain tools, or beading roulettes, are a desirable accessory to an engravers' kit of tools. They are used to make the very small beads on the edges of wedding rings, and on marcasite and other jewellery. (See Fig. 253). By cutting a line on the edge of the ring with a graver

188

and rolling the wheel back and forth along the cut line, you will produce these little beads. A milligrain line on flat surfaces of jewellery may also be made by cutting two lines closely together, making a track on which to roll the wheel. (*See* Fig. 256).

Milligrain wheels can be used on gold, silver and all other metals. The forks, holding the wheels which do the beading, are trimmed very closely, so that you can get into corners and narrow places. Milligrain wheels are made in ten sizes.

Single beaders to match the milligrain wheels are punches with a single bead only and are also made in ten sizes. They are used in corners and other parts not accessible with a milligrain wheel.

LUBRICANTS FOR EASIER AND BRIGHTER CUTTING

For easier and brighter cutting of fine lines into copper, brass or bronze, use paraffin or mineral oil as a lubricant. For chromium alloys, stainless steel, and tool steel, use mineral oil.

Palladium is a rare metal of the platinum group. It is used extensively in the manufacture of jewellery, and often for ladies diamond rings. To enhance its beauty, the ring is often engraved on the sides with ornamental designs. Inscriptions are also engraved on the insides of these rings. Palladium is a tough metal, ductile and mallable, and is beautiful when made into jewellery.

When palladium is to be engraved, use a lubricant as an aid to cutting. A good lubricant is a mixture of lard oil 5 per cent, peanut oil 10 per cent. and the balance kerosene (paraffin) or fuel oil (derv). If a water soluble lubricant is desired, use paste oil soap diluted with water.

A bright cutting lubricant for engraving on aluminium may be made by mixing twelve parts naptha, one part oil of wintergreen (synthetic will do), and one part kerosene (paraffin). Engraving tools to be used on aluminium must have a little more clearance than for harder metals. It is not possible to cut bright on aluminium unless you use a lubricant. If none is used, the cuts will be dull and ugly. Another suitable lubricant is turpentine.

For lubricant, make a small cup that will not upset on the workbench, by soft soldering a piece of brass or copper tubing on to a flat plate. Insert a piece of absorbent cotton into the cup and saturate it with the lubricant. Dip the graver point into the cotton and engrave. The cutting will be smoother and brighter.

MISCELLANEOUS HINTS

When filling letters on silver so that they will show up black, rub a mixture of lamp black and beeswax over the letters until they are

filled. Wipe off the excess with a piece of cloth. The remaining wax in the cuts will show the letters up in black.

To remove finger prints from highly polished precious metal, apply pearlite, a form of precipitated chalk, and rub with soft cloth.

The fogging of eyeglasses or goggles is a common occurence with some people, particularly in the summer months, owing to perspiration around the eyes. As good vision is of obvious importance to the engraver, this formula should be used to prevent fogged glasses: Make a mixture of equal parts of rubbing (surgical) alcohol, water, and glycerine and apply it to the lens. Ready made preventatives are also available.

CHOICE OF OILSTONES

The condition of the graver for engraving on polished metals, which is the condition it is in as it leaves the oilstone, has already been mentioned. Some engravers, however, use an oilstone that is altogether too coarse. A fine Arkansas must be used, because if the stone is too coarse the condition of the cutting edge of the graver will be such that it will be almost impossible to hold it into a piece of highly polished gold. It will be so grooved that the extreme point of the graver will break off very quickly. A fine Arkansas stone will leave the cutting edge of the graver in condition to cut a line giving an appearance of a dull finish.

CLEANING AN ENGRAVED PLATE

Any wax that remains on a job that has been engraved should be washed off with a brush and soap and very little ammonia. If fixed with sealing wax, heat the plate by holding it with the engraved side just above the alcohol lamp. Detach the plate by levering gently with a small screwdriver. The wax that adheres to the plate cap can be removed by boiling it in methylated spirit (wood alcohol) or in water to which a little borax has been added in the proportion of a teaspoonful to a glass of water. But even twice this amount of borax would do no harm. The advantage of using this amount is that there is no danger of it catching fire. After the wax has been boiled off from the plate in this manner, the plate is thoroughly washed and dried with a towel, after which it is ready to be polished.

The polishing should be done very carefully and accurately, the polishing spindle or lathe running at as high a speed as possible and the pressure on the plate being uniform. The plate should not be held in one position for any long period. It should be constantly changed. The ordinary felt buff should be used first, after which a very fine cotton buff should be used.

REMOVING ROUGE

After the plate has been polished, if there is any rouge in the engraving, as there often is, it should be washed by pouring several drops of ammonia on to a brush which has previously been drawn across a bar of soap ; then a little water may be added to the brush and the surface of the plate washed by giving a circular motion. The ammonia will cut the rouge very quickly.

The piece is now thoroughly rinsed off in clear water, and then a little alcohol should be poured on to the surface or the piece may be dropped into a dish of alcohol. Afterwards it is placed in boxwood sawdust and dried. After removal from the sawdust, the dust that adheres should be brushed off with a very soft brush or very clean chamois leather.

ACID ENGRAVING

Acid engraving may be performed on silver, bronze, brass, nickel-plate, etc., by immersing the entire article in molten " denatured " beeswax. When the wax coating has cooled, the design is scribed on the metal through the wax. Care must be taken not to allow the wax to become scratched or cracked so that the acid will seep through. The waxed article should then be immersed into an etching acid so that the scribed lines may be bitten deeper. The etching acid should be placed in a glass dish for safety reasons. It can be made up of two measures of water, one of nitric acid, and a trace of tri-sodium phosphate—about 3 ounces per gallon.

The longer the immersion of the article in the acid, the deeper etched the lines will be. Upon the completion of the etching process, the article should first be rinsed in water, being careful not to touch it with bare hands. Next the wax should be removed with alcohol. The finished article can be improved by brushing the piece with a permanent oxidizer or a coloured lacquer to fill the engraved lines.

CHAPTER 14

MACHINE ENGRAVING

By A. Brittain

MACHINE engraving (two words which should be mentioned in the merest whisper in the hand engraving workshop) is extremely useful for engraving certain articles in positions where it is almost impossible to engrave by hand. No engraving workshop is complete without the engraving machine as it is such a time saver in many respects. Many times have I heard a hand engraver sigh with relief when told that a cup made of a particularly hard metal was to be machine and not hand engraved, or a stainless steel watch, chrome lighter, steel-handled knives, or other hard metal objects, were to go on the machine. These articles can, of course, be engraved by hand, but in my opinion it is a waste of time and effort. The machine does the job far more efficiently and is much quicker.

The machines in our workshops are all equipped with special master lettering designed by the hand engravers so that the machine will engrave an inscription as well balanced as a hand engraved job. It must be emphasised before going any further that the machine will never be able to supplant the hand engraver. The machined effect, although good, is completely lacking in character. The hand engraver can improvise and amend his design at any time while in the course of engraving, but the machine once started must carry on with the style and type which has been decided for it at the start. Do not misunderstand the words " machine engraving "; *it has no connection with the electric needle* which is indeed a terrible weapon, and is also termed an engraving instrument but is nothing of the sort. I do not propose to deal any further with that subject so long as the reader's mind is clear about the term " machine engraving."

Our workshops have always laid down the same type of machines, and they have always been found entirely satisfactory. The make is British; its work of the finest. In the past other types have been tried but they have not been quite so versatile. It works on the pantograph system. See Fig. 246 for the complete machine. The pantograph controls the horizontal movement of the cutter, causing

it to reproduce faithfully, on a reduced scale, the movement of the style over the copy. In other words whenever the style is moved, the cutter moves at the same time and traces exactly the same lines but at whatever reduction has been set on the pantograph arm. The reductions range from 2½ to 16. A general description of the machine follows :—

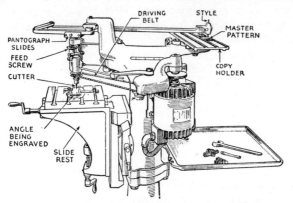

Fig. 246—Taylor, Taylor & Hobson engraving machine.

A copy of the engraving required is arranged on the copy holder and the article to be engraved is held upon the work table of the slide rest beneath the cutter. The slide rest has both vertical and horizontal movements. The cutter made from high speed steel or other substance depending on the material to be engraved is rotated at a high speed by the driving band, and then lowered on to the work or lifted from it by the operator, who controls the feed screw with the left hand, while the right hand guides the pointed style along the lines of the copy. This action moves the cutter, which produces the required engraving. The style is connected to the cutter by means of the pantograph whose slides can be set along their graduated bars to vary the size of the engraving. There are variations of the machine which can operate on a one to one basis up to 6 reduction and then another pantograph has to be fitted to take the reduction from 2½ to 16. The cutter spindle, feed mechanism, pantograph, cutter frame, frame link, head and copy holders are similar on all models but with a difference as will be described later.

The best position for the machine is in front of a window preferably with a north light. Electric light should be provided to illuminate the work when required and be placed behind and slightly above the cutter, and shaded so that it does not shine directly in the operator's eyes.

The operator should be seated on a stool about 2 ft. high with the copyholder on his right. A convenient foot rest is attached to the machine pedestal.

An adequate supply of machine type should be provided for the required work, with an assortment of suitable cutters. A workpan is provided to hold cutters and tools in an orderly manner.

The machine is driven by a $\frac{1}{4}$ h.p. electric motor which being only small and neatly fitted to the machine does not interfere in any way with the operation of the machine. The belt drive is so situated that there is no danger of personal damage whatsoever and although the cutter is revolving at from 3,000 to 15,000 r.p.m. it is quite possible to ease the motor down by hand.

The spindle which holds the cutter is run in ball bearings in order that it may run dead true. The design is such that radial and end shake are eliminated and it never requires adjustments. The quill is provided in the first instance with a suitable lubricant and sealed at one end by a cap and at the other end by the pulley, so that no dirt can enter the bearings. This method of lubrication ensures considerable use without further attention. The spindle has a truly concentric conical hole for cutters and its two step pulley is grooved for the endless fabric driving belts already referred to. When desired, usually on

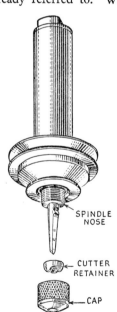

Fig. 247—Rotating cutter mounted in the engraver spindle nose.

194

heavy work or engraving with a parallel sided cutter, cutters can be locked in the spindle with a cutter retainer and cap which screws on to the spindle nose (Fig. 247). The cutter is inserted firmly with the cutter wrench in the ordinary way before fitting the retainer and the cap. The cap should then be given one or two preliminary tightenings before the final one to ensure that the retainer locates correctly.

A word now about the cutters : They are of two main types as shown in Fig. 248. Although the shaft of the cutters is necessarily of a standard size, the blades are of various sizes and the particular size is selected according to the work which has to be done. High speed steel cutters are used for engraving on materials such as stainless steel, tool and other alloy steels ; in fact on all materials which will heat the cutter when they meet. In order to avoid overheating, the article should be well oiled over the engraving area, which ensures constant lubrication of the cutter. For engraving materials such as plastics and other easy cutting surfaces the cutters known as Talycut should be used. Bakelite is a very tough material to cut and therefore the high speed cutter should be used for this. When a cutter is ground it appears as in Fig. 249.

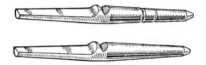

Fig. 248—Cutters before grinding cutting edges. That with the two rings on a shank is Talyspeed steel and that without rings is special high speed steel. A Speedicut cutter is intended for stainless steels.

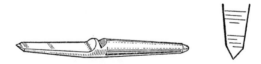

Fig. 249—Cutter after the end has been ground. The small drawing shows the cutting edge (right) indicating it is backed off.

Care must be taken to use the correct cutter for the job and also to adjust the driving belt of the machine so that the cutter revolves at the correct speed for the material to be cut and the depth and width of cut required. A few examples will make this point a little clearer. For cutting brass, use a Talycut cutter with a clearance angle of say 32 degrees, set the driving belt for a speed of 1,500 r.p.m. and use no lubrication, this is for a width of cut of approx. 0·10 in. For cutting mild steel, use a Speedicut cutter with, say, a clearance angle of 24

degrees and for a width of cut of 0·01 in. set the r.p.m. at 8,780 and use soluble oil as a lubricant. For copper, use a Talycut cutter and for a width of cut of say 0·01 in. set the revs. at 8,780 and use paraffin as a lubricant. This I think is sufficient to indicate the importance of studying the job before picking up just any old cutter and going straight in to engrave.

I do not propose to lay down the law in respect of cutters and lubrication but the little information I have given above is the result of many years' experience and research. A table indicating such points is usually supplied by the manufacturer of the machine together with a handbook giving all the necessary information with regard to the principle of the machine and its care and maintenance.

The next important point is the sharpening of the cutter. This operation is made much easier to-day by the advent of the cutter grinding machine with all the necessary attachments to ensure accuracy and perfection. It was a very different story a few years ago when the cutter had to be ground on an ordinary grindstone attached to the machine. Then it was not a case of accurate grinding but a question of whether one was going to be lucky enough to grind the cutter so that it cut well. To-day one can grind a cutter so that the width of cut is exactly the same as before.

Fig. 250 shows the actual cutter grinding machine with the few tools and attachments. A locating cam and a locating pin limit the rotation of the cutter holder, thus controlling the clearance angle on the cutter. Different shapes may be ground on the machine to suit the particulars of various jobs. The cutter holder is rotated in the vee whilst the end of the cutter to be ground is brought into

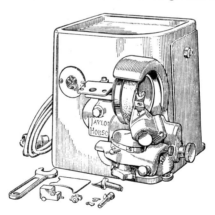

Fig. 250—Cutter grinding machine. The cutter is set in a special clamp on the right and can be set and rotated to give correct cutting angles and clearances when the end is ground by the precision grinding wheel.

196

contact with the grinding wheel. The tool rest can be indexed to a suitable angle to produce the required shape on the end of the cutter and a special cutter setting gauge and holder are supplied to assist the correct setting and control of the cutter during grinding.

For complete accuracy of grinding and finishing of a cutter, a cutter measuring microscope may be obtained. It is invaluable for checking the shape and dimensions of cutters and guaranteeing exact duplication on subsequent grindings. Illumination is provided by means of a 12 volt lamp and green filter. Such accuracy as described is not essential for the routine engraving as met in the luxury trade, but there are times when it is essential after grinding a cutter that the width of the cut should be exactly as it was before regrinding became necessary. For example, if in the act of engraving an inscription on a brass plate it became necessary to regrind, it would ruin the whole effect if the width of the cut after resumption, was obviously different. The microscope is really intended for use in precision machine engraving, i.e., engraving vernier scales and other instrument scales where accuracy is essential. When contracting to machine engrave a number of dials or verniers, the contract usually stipulates that the width of cut should be of a certain dimension with a very minute tolerance plus or minus, and this is where a microscope is really essential. I must add that we do not find the microscope necessary in our workshops as the type of jobs which we get do not call for it.

The reader should by now have a working knowledge of the machine. so I will now describe a simple straightforward job such as a steel watch back which has to be engraved with an inscription. Assuming the inscription is to read something like this : " Presented to Mr. A. N. Other by Sonavati & Co. Ltd., for 25 years, loyal service, 25th May, 1980," there are two sizes of lettering to be considered. The most important parts are the donor and the recipient, which should be engraved in larger lettering. The remainder of the inscription should be of a smaller size.

There are two ways of doing this. One is to set up all the type on the copy holder of the machine (Fig. 251) if it is large enough to take it all, and then reduce the size of lettering by altering the reduction on the machine where necessary. The quicker and in my opinion the easier way is to set up two different sizes of type, i.e., $\frac{3}{4}$ in. type for the large and $\frac{1}{2}$ in. type for the smaller lettering. Different size types can be obtained from the machine manufacturers but we make most of our own type not only in different sizes but in various styles in an attempt to give the machine cut letters a better flavour. Having set up this type on the copy holder (if it will take it all at one setting) we decide that the size of lettering should be such as to take the longest

line comfortably on the watch back, without its looking too small or cramped. The machine is then set to the number which will give us the required reduction. Make quite sure that the reduction set is exactly the same on the three arms of the pantograph, otherwise the engraving will not run straight and true.

Fig. 251—Copy holder with separate letters set up as a template for engraving. Hand cut templates of all types can be used with the machines.

Having carefully checked the type, spacing and punctuation and of course the reduction numbers, the job itself is prepared for engraving. We will assume that the watch back is a round one. A suitable chuck should be attached to the machine table by means of the bolts supplied or secured by means of the dogs. Wax the engraving area with modelling wax and dab with powder as described for hand engraving. Mark a centre line down and across by means of a piece of orange stick fitted into a pair of compasses and set the back into the chuck. Place the style in the centre of the type and move the table by means of the three handles until the point of the cutter is directly over the centre point of the watch. According to all the rules we are now ready to engrave, but it is essential to run over the whole length and breadth of the inscription to ensure that it will all go in the available space, because once the engraving is begun it would be rather difficult to rearrange the spacing between the lines.

It is quite a simple matter, when all the type is on the copy holder, to measure by ruler or dividers the length and breadth of the type and calculate the reduction required to ensure that it all goes in the available space. It frequently happens that the amount of engraving is such that it will not go in the available space by the machine spacing alone, so that it becomes necessary to arrange the spacing between the lines by drawing the lines by hand as is done in hand engraving and to bring the letters into the respective lines by moving the table by means of the appropriate handle. It frequently happens that the table has to be altered at every letter in addition to every line, in order to squeeze the lettering into a very small area. We call this " pulling in the lettering." If this is not done and a larger reduction is used instead, the machine spacing makes the lettering look small and out of proportion.

There are several methods of reducing the size of lettering. One is to employ compressed or elongated letters, another is to " pull in the lettering " as already explained, and make a special template from the standard lettering for future use. For example, should a 1/16 reduction (the biggest reduction on the machine) of the smallest standard type still be too large, then it is quite a simple matter to engrave the inscription deeply on a piece of brass or Perspex and use that as a template by setting it up on the special copy holder which is obtainable for this purpose. There really is no limit to the size of lettering which can be engraved by the machine except of course, the width of the cutter. I think I am safe in stating that with great care the Lord's Prayer could be engraved on a flat piece of metal less than the size of a sixpenny piece or a dime.

To return to the watch back, we have started to engrave, having satisfied ourselves that all is well, with regard to spacing. The actual engraving, I regret to say, can only be done after a great deal of experience and training. One has to move the style with the right hand without looking at the copy holder and bring the cutter up or down as required with the left hand so that while the style is being moved in a letter with the right hand the left hand must keep the cutter on the metal with sufficient pressure to ensure uniformity of cut. This uniformity of depth and width of cut can only be achieved after considerable practice, especially when engraving on a surface which is far from flat, when the cutter has to be fed up and down the hill as the other hand guides the style. This is done by eye and touch. The depth of cut can be quite accurately gauged by the slight vibration of the cutter and in many cases by ear.

Should the surface be perfectly flat, it is a simple matter to bring the cutter down as far as it will go, bring the job up to the cutter by elevating the table, raise the cutter very slightly and again bring the job up to the cutter. This will ensure that the cutter will not cut deeper than intended, and is a method usually adopted by learners, but would not be used by anyone with experience. After much practice, one can use the machine almost as freely as a hand engraver can use a graver and take liberties with it.

The machine can engrave any form of lettering or design. Providing that one has the necessary template to work from, there is almost no limit to what a machine can do. This of course is where the hand engraver comes in to the picture. He is the one who makes the template and without him one would be restricted to whatever types or patterns the manufacturer of the machine could supply.

We have found the machine most helpful in engraving certain hardcutting plated cups and other sports trophies. The fact that

these articles are plated and therefore much cheaper to buy than silver trophies calls for a much cheaper type of engraving. If they were engraved by hand the engraving should cost very much more than if they were made of silver simply because of the comparative hardness of the basic material. The answer is the machine and a good style of lettering such as Trajan Roman mixed with a good italic style.

To engrave a cup or any other round object on the machine calls for a different technique and certainly a great deal of experience. A great deal of feeding down with the cutter has to be done on this very rounded surface and in order to obtain perfection of alignment, the cup should be turned at every letter. When the usual procedure of setting up the type, setting the machine reduction and marking the spacing on the cup has been carried out, a special chuck with a rotating head is set up on the table and secured by means of the special bolts already fitted to it. The cup is then placed in the jaws of the chuck after carefully padding and the whole job lined up in the manner already described. A locking lever secures the job in the desired position.

Many engravers are inclined to allow the cup to remain in a certain position and engrave two or three letters before rotating the chuck head. This is a little dangerous, especially with a small cup because the lettering is inclined to fall out of line and because the cutter being vertical, the strokes of the letters, through excessive feeding down, are inclined to become distorted. Again it is a question of price. If a cheap job is required then feed down as much as possible to save time, but for a perfect job then rotate the cup at every one or at the most, two letters.

I must emphasise again that a machine will never be able to take the place of a hand engraver. It is and always will be impossible for a machine to give character to engraving that a hand engraver can give. It is impossible to produce that beautiful light and shade effect of hand engraving. A hand engraver can, with a touch here and there bring a crest almost to life, but the machine, although it will engrave the same number of lines in exactly the same place, cannot give life to it. Nevertheless, the machine is an essential part of the engraver's outfit but it should only be used on metals and other materials that cannot be engraved by hand, or where the price of the engraving does not warrant a hand job.

ENGRAVING IVORY, PLASTICS AND BRASS

The machine is very useful in the matter of ivory carving or inlaying in wood and other materials. Although it is essential that the carving or inlay be finished off by hand, the machine can be depended on for

doing a great deal of the donkey work in digging out the mass so that the hand engraver or carver can give it the final finish. The art of carving is not in digging out the main part of the material but in the final shaping and finishing up of the letters. Again in the matter of inlaying, the finishing of the recess has to be completed by hand although the machine has done most of the donkey work. It must also be appreciated that it is the hand engraver who has made the template to make it even possible for the machine to do the digging out and without him the machine would be useless in this respect.

The machine has superseded the old brass plate engraver to a great extent. Invariably when a brass plate is engraved the engraving is filled with a coloured hard wax and providing the corners of the letters (left rounded by the rotating cutter) are finished off or squared-in by

Fig. 252—Cutter marks in the bottom of a machine cut engraving. This is much enlarged. Very fine engraving can be done by machine.

Fig. 253—Filling the engraving disguises the fact that it is machine cut.

Fig. 254—Points cannot be cut by machine, but the work may be finished by hand, as shown in the lower part of this enlarged letter.

hand I will defy anyone to state whether the work has been hand or machine engraved, because the wax hides that tell tale mark in the bottom of the cut left by the rotating cutter Figs. 252-4. In the case of large memorial plates or bronze and enamel-filled door plates, the machine is far more efficient and labour saving even if a template has first to be cut by hand on a piece of Perspex.

I am not going to say that the machine can cut a monogram on ivory as nicely as a hand engraver—in fact there would be all the difference in the world—but I will insist that the machine can cut a monogram into wood far better than the hand engraver simply because of the usually very coarse grain that he is up against. The vertical rotating cutter can cut away the wood much cleaner than a tool which is pushed by hand. The job must be finished off by hand be squared-in at the

corners where the rotating cutter is inclined to leave them rounded or be done by changing the cutter for a very fine one and finishing off with that on the machine. Although the corner affect would still be rounded it would be so slight as to be hardly noticeable.

FILLING ENGRAVING

Trouble is always experienced in filling wood after engraving, because of the very course grain. But if one is careful to get as little filling as possible in the grain, then it is not too much of a job removing it. This has to be done carefully by using a fairly fine point, or preferably a pointed orange stick, to avoid making any unnecessary marks on the wood.

Filling engraving with coloured materials is quite a problem and one must be careful to use the correct materials and the correct method for the particular job in hand. For example, I cannot imagine anything more unpleasant than attempting to fill engraving on wood with ordinary quick drying enamel. The result would be worse than the best futuristic paintings one sees in Bond Street. For wood filling, a soft filling wax must be used. This is obtainable in handy stick form and is gently rubbed into the engraving. The surplus wax is removed by gently rubbing with a soft cloth, such as a piece of artificial silk. Do not use a fluffy cloth because this tends to remove the wax from the actual cut without rubbing it in. A fine textured cloth will remove the surplus and at the same time will give a nice polish to the wax in the cut.

For filling engraved Perspex and other non-porous plastics, the most satisfactory filling is the ordinary quick drying enamel. The method is to smear the paint over the engraving and immediately remove the surplus paint by wiping over the surface with a perfectly flat piece of cardboard covered with a piece of rag. Again do not use fluffy material for obvious reasons. The reason for the flat edge covered with cloth is because it will remove the surplus paint and ride over the engraving without removing the filling. If you wipe over the engraving with a cloth without the flat edge, the cloth will enter the cuts and smear the paint until it is all removed from the cuts.

Filling engraving on metals is another story. There are many materials and methods for this such as vitreous enamel, which leaves a surface as hard as glass, and soft enamel or any quick drying paint as already explained for Perspex. Dark bronzing the whole plate and polishing off the bronze from the surface and to leave it dark in the engraving, is very effective.

Filling with a hard wax is probably the most popular method for filling the ordinary plate. The plate should be warmed over a gas

jet and good quality sealing wax melted into the engraving until the cuts are filled. The surplus wax is wiped off with a flat piece of card while the wax is still hot and easy running. The plate should then be left to cool and the wax to harden. The next step is to remove any remaining film of wax which is always found on the surface by wiping over the whole plate with a cloth soaked in methylated spirit. This will have the tendency to dull the surface of the wax so the final step is to heat the plate gently again over the flame until the wax begins to move. When this happens, remove the plate from the flame and allow it to cool. You will then find that the glossy surface has been restored to the wax.

Should a matt surface be required to the plate, the process is much quicker and simpler. Fill the engraving with wax as explained and allow it to cool. When cool, simply surface the plate with fine emery, which will remove the surplus wax and leave a matt finish to the plate at the same time. The gloss is restored to the wax as explained above.

I do not propose to discuss the filling with vitreous enamel, this is a job for the enameller. It calls for the expert and is a different part of the trade altogether.

There is only one satisfactory method for filling ivory and that is with the very best quality, semi-hard heel ball (wax). It is supplied in handy form either in sticks or slabs and is rubbed into the engraving and the surplus rubbed off by means of soft non-fluffy material. A good hard rub is essential as this not only rubs off the surplus wax but gives the wax remaining in the cuts a fine gloss. There are several varieties of wax on the market but most of them we find are not suitable for the job. They are either too soft, too hard, or too gritty. A really excellent wax was the best quality pre-war heel ball.

Great care must be taken when filling that no grit or other foreign matter is adhering to the wax or to the surface of the article which has to be filled. If such foreign matter is not removed before rubbing then large, deep and disfiguring scratches will be the result and these will be impossible to remove without ruining the engraving and some-times the article. When the filling is done on the engraving bench, keep a sharp look out for metal chips which are always present on the bench. It is wise always to keep the wax in tissue or other suitable paper and, when you have finished with it, put it straight back into its covering.

The article on which engraving has to be filled should be carefully studied before a decision is made with regard to the method to be employed. For example, be careful not to rub hard wax on to a surface which has already been lacquered. This will damage the lacquer beyond repair. Do not attempt to fill an engraved plate

which has already been bronzed and lacquered unless you know the quality of the lacquer. Even then, heat of any sort should not be employed. Do not attempt to rub any sort of filling into the engraving if the plate has been bronzed but not lacquered. The rubbing will remove the bronze. The answer to this is to start afresh, remove the bronze and lacquer, fill with vitreous enamel, then bronze and lacquer again. The idea of the lacquer is to bind in the bronze so that it does not wear off so quickly. My idea of an attractive office or door plate is a pleasant colour of vitreous enamel on a natural bronze plate. This has to be cleaned occasionally but the general effect is well worth the trouble.

Sometimes customers ask for the ordinary hand engraving on silver articles to be filled with black. This is usually done by filling with ordinary printing ink. Rub the ink into the cuts, wipe off the surplus, just as if taking a print for record purposes. The ink will dry quite quickly and will stay in the deep narrow cuts for a considerable time until it is slowly replaced by the residue from the various metal polishes used in routine polishing.

I prefer to see some kind of filling left in the engraving, even on small hand-engraved articles. I do not mean a heavy filling of hard or soft wax but just a suggestion of darkness, which may even be induced by a little printing ink, quickly wiped out. This will leave just sufficient in the cuts to throw the shading up to advantage. This is especially so in the case of engraved portraits or other subjects. Subjects such as a dog's head or a building engraved on the lid of a cigarette box I would like to see lightly oxidised, and the oxidisation cleaned off, leaving just a suggestion in the cuts.

The brightness of the engraved cuts tends to confuse the eyes and one has only to breathe on the engraving to show it up to advantage, something I always do when examining engraving before despatch to the customer.

MARCASITES AND THE MACHINE

The engraving machine can be of great assistance in the setting of marcasites in such things as monograms (Fig. 255) and specially designed brooches. I say " specially designed " because we are not considering in any way the ornaments and articles which are mass produced by a process of casting or die stamping. Obviously, the specialist could not and would not hope to compete with such processes.

Assuming that the monogram has been designed and approved by the customer, the next step is to outline the monogram on a piece of silver and pierce in the ordinary way, as would be done for an ordinary silver monogram. In designing the monogram, allowance must be

made in the width of the strokes for the eventual setting of the stones, in fact, the stones would be shown on the sketch for position and size. After the monogram is pierced, the fixing pegs are soldered in position before setting and it will be noted that polishing is unnecessary if parts of the monogram are to be set. Polishing is only necessary if parts of the monogram are to be left bright. These points are mentioned now because no soldering cr mop polishing can be done after the stones are set.

Fig. 255—A pierced and marcasite-set silver monogram.

The monogram is now mounted on a wooden block (see Fig. 216) for easy handling and to prevent the pegs from getting damaged and out of shape. It is now ready for the machine to take over and do the drilling of the circular recesses in which the stones will sit. The position of each stone is carefully marked on the monogram by means of a sharp point and the wooden block is clamped to the machine. The correct size of parallel cutter is selected and inserted in the cutter holder. The stylo is clamped firmly in the centre of the copy holder and the table moved into position by means of the two handles until the cutter is directly over the point previously marked, indicating the setting position of the first stone. The cutter should first of all be brought down to the maximum extent and then the table should be raised slowly until the monogram is brought right up to the cutter. The cutter should then be withdrawn vertically to a distance equal to the depth required for setting. This may sound a little complicated but it will avoid the possibility of the cutter drilling right through the metal or not drilling far enough, in fact, it is a foolproof method of controlling the depth of the drilling.

The rest of the machine operation is quite simple and that is to position the cutter over each point and drill until all the drilling necessary is completed. It is obvious of course that in the case of graduation the cutter will have to be changed according to the size of stone required to be set. In these days of purchase tax the graduation should be kept to a minimum in order to keep the cost of production as low as possible.

It will be noted that in this operation the stylo remains in the same position, i.e., in the centre of the table, and all movement is done by the two handles which control the position of the table, in a transverse and longitudinal direction.

The reason for the parallel cutter is because the wall of the circular recess should be vertical to match the shape of that part of the stone which sits in the recess. The diameter of the recess should be such as to allow the stone to sit comfortably without being too loose or too tight. The stones are very brittle and any pressure exerted to force them into the setting will break them. A number of cutters should be made ready for use of a size to match the range of the stones which are held in stock for the setting of monograms or brooches. There is no need to carry a vast range of sizes because the article can be designed to take a moderate range normally carried. Three or four sizes should be ample.

The next step is to run a milligrain tool (Fig. 256) along both sides of the strokes of the letters which are to be set and along the centre of the very thin strokes which are too narrow to take the stones. This gives a very good looking finish to the monogram and should be done before the setting. The stones should next be prepared for insertion. This is quite a simple matter because they are normally contained in small envelopes or packets with the sizes clearly marked on the outside. The first stone is now placed in its recess and spiked securely with a graver in two positions as indicated in Fig. 257. The "spikes" should run at the same angle along each side of the stroke in order to maintain a symmetrical appearance. Carry on until each stone has been securely set in the manner described and the monogram is now ready for fixing to the article. This process is carried out as already described on pages 163 to 168.

Fig. 256—Using the milligrain tool round the edges of the monogram.

Fig. 257—The two "spikes" that hold each marcasite are at the same angle for every stone.

206

EXAMPLES OF LETTERING

OVER the centuries that the alphabet has been in use by engravers and penmen and in recent days by lettering artists and typographers, there have been many thousands of variations of the basic shapes of letters. In this chapter are given some examples that may be used as models by engravers on precious metals or as an aid to those keen and able enough to develop their own characteristic lettering.

The examples are also intended for the use of jewellery retailers, to show to customers who wish to select their own style of lettering. This book can only do good if it is handled by customers, because then they may come to appreciate the considerable training and the high degree of skill needed by the successful engraver and the true merit of his work.

A fairly large size of letter is shown for the benefit of the engraver. The lettering he will use will be in scale with the article being engraved.

Style 1

A B C D E F G H I J K L M N
O P Q R S T U V W X Y Z
a b c d e f g h i j k l m n o p q r s t u v w x y z
1 2 3 4 5 6 7 8 9 0

A moment's insight is sometimes worth a life's
experience

A B C D E F G H I J K L M
N O P Q R S T U V W X Y Z

abcdefghijklmnopqrstuvwxyz

1 2 3 4 5 6 7 8 9 0

Admiration praises, love is dumb

A B C D E F G H I J K L M N O P Q R S T
U V W X Y Z

abcdefghijklmnopqrstuvwxyz

1 2 3 4 5 6 7 8 9 0

A banker lends you his umbrella when the sun is shining
and wants it back the minute it begins to rain

A B C D E F G H I J K L M N O
P Q R S T U V W X Y Z

abcdefghijklmnopqrstuvwxyz

1 2 3 4 5 6 7 8 9 0

If you want to kill time try working it to death

Style 5

A B C D E F G H I J K L M N O P

Q R S T U V W X Y Z

a b c d e f g h i j k l m n o p q r s t u v w x y z

1 2 3 4 5 6 7 8 9 0

A high-brow is the kind of person who looks at a sausage and thinks of Picasso

Style 6

𝕬 𝕭 𝕮 𝕯 𝕰 𝕱 𝕲 𝕳 𝕴 𝕵 𝕶 𝕷

𝕸 𝕹 𝕺 𝕻 𝕼 𝕽 𝕾 𝕿 𝖀 𝖁 𝖂

𝖃 𝖄 𝖅 abcdefghijklmnopqr

stuvwxyz 1 2 3 4 5 6 7 8 9 0

Strange how much you've got to know, before you know how little you know

Style 7

A B C D E F G H I J K L M N

O P Q R S T U V W X Y Z

a b c d e f g h i j k l m n o p q r s t u v w x y z

1 2 3 4 5 6 7 8 9 0

Better a diamond with a flaw than a pebble without

A B C D E F G H I J K L M N
O P Q R S T U V W X Y Z
abcdefghijklmnopqrstuvwxyz
1 2 3 4 5 6 7 8 9 0

Poise is the ability to keep talking while the
other fellow pays the bill

A B C D E F G H I J K L M N
O P Q R S T U V W X Y Z
abcdefghijklmnopqrstuvwxyz
1 2 3 4 5 6 7 8 9 0

Without denying that tact is a talent of itself,
it will suffice if we admit that it supplies the
place of many talents

A B C D E F G H I J K L M N
O P Q R S T U V W X Y Z
abcdefghijklmnopqrstuvwxyz
1 2 3 4 5 6 7 8 9 0

It is unquestionably true that wealth produces wants,
but it is still a more important truth that wants
produce wealth

ABCDEFGHIJKLMN
OPQRSTUVWXYZ
abcdefghijklmnopqrstuv
wxyz 1234567890

Audax ad omnia fœmina, quæ vel amat vel odit

ABCDEFGHIJKLM
NOPQRSTUVWXY
Z abcdefghijklmnopqrstu
vwxyz 1234567890

Successful modern business is no battle
of wits. It's an offer of service
with a pledge of good faith

ABCDEFGHIJK
LMNOPQRSTU
VWXYZ
1234567890

ABCDEFGHIJK
LMNOPQRSTUV
WXYZ
1234567890

*ABCDEFGHIJKL
MNOPQRSTUVW
XYZ abcdefg
hijklmnopqrstuvwxyz
1234567890*

*One good way to test your memory
is to try to remember the things
that worried you yesterday*

*ABCDEFGHIJKLM
NOPQRSTUVWX
YZ abcdefghijklmnopqrstuvwxyz
1234567890*

*Lots of people know a good thing the moment
somebody else sees it first*

212

ABCDEFGHIJKLM
NOPQRSTUVWXYZ
abcdefghijklmnopqrstuv
wxyz 1234567890

Talk that does not end in any kind of
action is better suppressed altogether

ABCDEFGHIJKLM
NOPQRSTUVWXY
Z *abcdefghijklmnopqrst*
uvwxyz 1234567890

*A taxpayer is one who does not have to
pass a Civil Service examination to work
for the Government*

ABCDEFGHIJKLMNOPQRSTUVWXYZ

abcdefghijklmnopqrstuvwxyz

1234567890

There is a majesty in simplicity which is far
above the qualities of wit

ABCDEFGHIJKLMNOP
QRSTUVWXYZ
abcdefghijklmnopqrstuvwxyz
1234567890

Genius is an infinite capacity for picking brains

ABCDEFGHIJKLMNOPQ
RSTUVWXYZ
abcdefghijklmnopqrstuvwxyz
1234567890

Nothing is so dangerous as wrong-
headed efficiency

ABCDEFGHIJKLMNOPQRS
TUVWXYZ 1234567890
abcdefghijklmnopqrstuvwxyz

Why be disagreeable when with a little
effort you can be impossible

ABCDEFGHIJKLMNOPQRSTUVWXYZ

abcdefghijklmnopqrstuvwxyz

1234567890

For every youth with a spark of genius there are
dozens with ignition trouble

ABCDEFGHIJKLMNOP

QRSTUVWXYZ

abcdefghijklmnopqrstuv

wxyz 1234567890

*A good journalist is one who invents a
story and lures the truth towards it*

ABCDEFGHIJKLMNOPQRST

UVWXYZ

abcdefghijklmnopqrstuvwxyz

1234567890

*Adam was all right when he kept on working in the
garden. It was when he stopped to gossip that the
trouble started*

ABCDEFGHIJKLMNOPQRST
UVWXYZ
abcdefghijklmnopqrstuv
wxyz 1234567890

Middle age is when you begin to
exchange your emotions for
symptoms

ABCDEFGHIJKLMNOPQRSTUVWXYZ
abcdefghijklmnopqrstuvwxyz
1234567890

ABCDEFGHIJKLMNO
PQRSTUVWXYZ
abcdefghijklmnopqrstuvw
xyz

The art of medicine consists of amusing
the patient while nature cures the disease

ABCDEFGHIJKLMNOPQRS
TUVWXYZ
abcdefghijklmnopqrstuvwxyz
1234567890

Always behave like a duck—keep calm and unruffled on the surface but paddle like the devil underneath

ABCDEFGHIJKLMN
OPQRSTUVWXYZ
abcdefghijklmnopqrstu
vwxyz 1234567890

ABCDEFGHIJKLMNOPQRS
TUVWXYZ
abcdefghijklmnopqrstu
vwxyz 1234567890

Horse-sense is something that prevents
horses betting on men

Style 32

ABCDEFGHIJKLMNOPQRSTUV
WXYZ 1234567890
abcdefghijklmnopqrstuvwxyz

All the things I really like to do are either immoral,
illegal, or fattening

Style 33

ABCDEFGHIJKLMNOPQRSTUV
WXYZ 1234567890
abcdefghijklmnopqrstuvwxyz

It is a great nuisance that knowledge can
only be acquired by hard work.

Style 34

ABCDEFGHIJKLMNO
PQRSTUVWXYZ
abcdefghijklmnopqrstuvwxyz
1234567890

It is better to trust the eye than
the ear

Style 35

ABCDEFGHIJKLMNOPQR
STUVWXYZ 1234567890

abcdefghijklmnopqrstubwxyz

It is very easy to find reasons why other people should be
patient

Style 36

ABCDEFGHIJKLMNO
PQRSTUVWXYZ

abcdefghijklmnopqrstuvwxyz 1234567890

Wenn du eine weise Antwort verlangst, Must du vernünftig
fragen

Style 37

ABCDEFGHIJK
LMNOPQRSTU
VWXYZ

abcdefghijklmnopqrstuvwxyz
1234567890

Nothing is so dangerous as wrong-headed efficiency

ABCDEFGHIJKLMN
OPQRSTUVWXYZ
&abcdefghijklmnopqr
stuvwxyz,1234567890

Style 39

AaBbCcDdEeFfGgHhIiJj
KkLlMmNnOoPpQqRr
SsTtUuVvWwXxYyZz

Style 40

Gg

Style 41

AaBbCcDdEeFfGgHh

Reproduced from a plaque of engraved lettering and numerals designed by Eric Gill for the Worshipful Company of Goldsmiths for the benefit of the silversmith's craft in 1934. It was engraved by G. T. Friend.

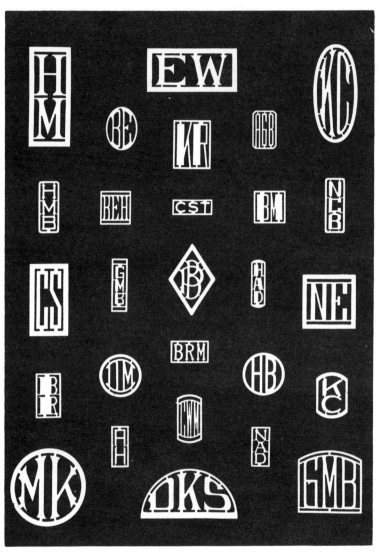

Styles of pierced monograms.
(See also page 167).

The examples of engraving styles on pages 207 to 221 may be used by retailers to show their customers. Every style is numbered so that the engraver can be told to use, say, Style 7 upper and lower case letters, or Style 38 capitals.

It should be noted that styles like the shaded letters No. 12 and outline letters No. 26 are more expensive to engrave because there can be at least twice as much work in each letter.

For some lettering we are indebted to the Worshipful Company of Goldsmiths and the Monotype Corporation.

EPILOGUE

THE commercial engraver must seriously consider whether he is charging enough for his work. The customer pays not only for the skill but for the knowledge and artistic ability. A great deal is left to the judgment of the engraver, but, because of competition, good prices ensure good work otherwise the engraver would not continue to make a profit.

It is a strange fact that the highly skilled craftsman very often under-estimates his own knowledge and skill and demands and receives too little for his work. This is because there are so many one-man engraving businesses where the engraver has to collect his own work, engrave it, invoice it and deliver it back to the customer, who on receipt of the article invariably tells the engraver that he has charged too much. The engraver, who is certainly no business man and probably suffers from a strong inferiority complex, wishes heartily that he was back in the homely atmosphere of his workshop, and agrees hastily to reduce the cost, beating a retreat out of the shop.

It is indeed a great pity, because the really great craftsmen of to-day are worth their weight in gold and their work is priceless. Certain pictorial engravings that have been made recently by outstanding craftsmen will become museum pieces in time. They are works of art which in my opinion are well ahead of the work of some of the best painters in the country. The prices which were paid for these artistic achievements were really pitiful. One must remember that an engraver cannot stand back while he is engraving and correct his work as a painter does by touching up here and there with a bit of colour. He must be correct in every detail the first time and if he is not quite satisfied with the job he has just completed, there is nothing he can do about it—it must stand as it is. There is no question of flooding out here and there and doing some fiddling. The job is finished and if the man is a good craftsman then the job is invariably a good one.

One should not be expected to price a piece of engraving as one would an article produced by a machine. How much is a piece of engraving worth? Why should one dozen letters engraved by a good craftsman be the same price as a dozen engraved by an inferior craftsman? A painter who paints a horse which looks more like a goat would not expect to receive the same price for it as for one painted by Sir Alfred Munnings.

It is most difficult to try to instruct the average shop assistant along these lines; he is invariably only interested in selling the article and the engraving to him is just a necessary evil. There are some assistants. of course, who appreciate good work and who co-operate most helpfully and indeed have even gone to the trouble to telephone and offer their congratulations, but these are few and far between. The ignorance of a number of shop assistants with regard to the art of engraving and allied trades is really deplorable.

On one occasion we were asked at 5 p.m. one day to carve a monogram on five pieces of ivory and to complete the work by 10 a.m. the next day. The request was, of course, ridiculous, but the assistant was most upset because we told him that we had no intention of working our craftsmen right through the night. I doubt whether he had ever given the work involved a single thought. In fact, he probably imagined that the job would be turned out in a similar manner to the aluminium name strips that one used to be able to obtain from a machine on the railway stations for a penny.

In my opinion it is essential that every shop assistant should go through a period of apprenticeship and a course of instruction should include information on the practical manufacture of every article that he is likely to sell in his shop. I do not mean that he should be able to make the article himself but that he should be able to discuss intelligently with the customer how the article was made and why one article is superior to another.

One can only assume that the average assistant has no real interest in his job and as long as he sells fairly well that is all that is required of him. His main interest is to keep his job and collect his pay at the end of the week. If assistants were really interested they would make every effort to learn more about the trade and even attend evening classes once or twice a week. There are, of course, exceptions who do take an interest in the trade and in fact, I know of one shop where it is insisted that assistants visit various workshops to see work in progress. This concern even goes as far as to send employees to other parts of the country and pays all expenses. This policy must pay dividends because I am quite sure that the average purchaser much prefers to be served by someone who appears to know what he or she is talking about.—A.B.

INDEX

226

227